BEYOND

How to Take That Fancy DSLR Camera Off "Auto"
and Photograph Your Life like a Pro

SNAPSHOTS

BEYOND

How to Take That Fancy DSLR Camera Off "Auto"
and Photograph Your Life like a Pro

SNAPSHOTS

by RACHEL DEVINE *and* PETA MAZEY
with TARA AUSTEN WEAVER

Amphoto Books /////////// an imprint of The Crown Publishing Group /////////// New York

Published in the United States
by Amphoto Books, an imprint of the Crown
Publishing Group, a division of Random House,
Inc., New York
www.crownpublishing.com
www.amphotobooks.com

AMPHOTO BOOKS and the Amphoto Books
logo are trademarks of
Random House, Inc.

Library of Congress Cataloging-in-Publication
Data

Devine, Rachel.
 Beyond snapshots : how to take that fancy
DSLR camera off "auto" and photograph your
life like a pro / by Rachel Devine and Peta
Mazey with Tara Austen Weaver. —1st ed.
 p. cm.

 Includes bibliographical references and
index.
 ISBN 978-0-8174-3580-6 (alk. paper)
1. Photography—Digital techniques—
Amateurs' manuals. 2. Digital cameras—
Amateurs' manuals. 3. Single-lens reflex
cameras—Amateurs' manuals.
I. Mazey, Peta. II. Weaver, Tara Austen. III.
Title.
 TR267.D482 2012
 771.3—dc23
2011020986

ISBN 978-0-8174-3581-3
eISBN 978-0-8174-3581-3

Printed in China

Cover and interior design by La Tricia Watford
Front cover photograph by Rachel Divine
Back cover photographs by Peta Mazey
Back cover author photographs by Linda Nguyen

10 9 8 7 6 5 4 3 2 1

First Edition

ACKNOWLEDGMENTS

We want to take a moment to thank the many people who have contributed to our journey.

Thank you to Danielle Svetocov and Amit Gupta for believing in the idea and in our work, and to Julie Mazur and Tara Austin Weaver for helping us craft this book into something much bigger and better than we had ever imagined.

Thank you to our first muses, Harper Cullen and Imogen and Ashton Hetariki and their families. You will forever be the ones who started it all.

A special thank-you to Tyke, Jon and Monty O'Brien Leaver, Ann, Chris, Indra and Arlo Wicke, Karin, Chris, Natalie and Allie Hawk, Leah, Ron, Ben, Kate and Joe Zawadzki, Deb, Steve, Kiele, Skyler and Ryder Schwedhelm, Kate, Nathan, Maya and Pepper Vale, and all of our other friends who have generously shared themselves, their lives, and their families so openly with our cameras, time and time again, and whose love and support has been unwavering.

To the many friends who have not graced our lenses as often, but who have been there when we actually do put the camera down, thank you for helping us stay well rounded. And to those special people who just knew when we had a lot on our plates, thank you for picking up the slack (and the kids!) when deadlines loomed.

To the kind supporters of our photography, whose comments and encouragement have pushed us through all the hard work to realize our dream of publishing this book, thank you.

Without our wonderful assistants over the years, Meredith Magnusson, Rebecca Sanabria, and Linda Nguyen, we would still be procrastinating.

A big thank-you to all of our clients for trusting us to represent your families, stories, and products alike in images.

Finally, to our families, this is for you:

Alec, thank you for being the logical left brain to my artistic right-brained self—you keep me grounded. To my three wonderful children, I thank the universe for every single day I have with you. Gemma, Clover, and Kieran, you each inspire me to see in a different way and the world looks more vibrant and beautiful now that you are in it. Deepest gratitude to my parents for footing the photo lab bills for me as a teenager so that I could start chasing my dreams early; I hope there is a bookstore in heaven because I really want my dad to read this. –*Rachel* R

So much love and thanks to all my family. Mum and Dad, a girl couldn't ask for two more loving and supportive parents. Thank you for always believing that I could do anything I put my heart into. To my little sister, Tasha, thanks for all of your support, for stepping in front of the camera when I was in need of a model, and for helping out behind the scenes when I was in need of a hand. –*Peta* P

CONTENTS

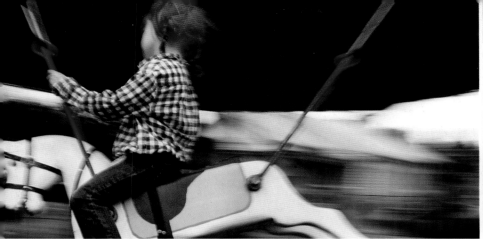

INTRODUCTION

These days almost everyone has a digital camera. People are e-mailing photos, posting them online, and recording their lives in ways unimaginable just ten years ago. As photographers, we find this exciting. Photography is storytelling, and everyone has a story worth telling.

The drawback to everyone having a camera is that now, more than ever, people don't know what to do with the nice cameras they have. You take your new digital SLR (DSLR) out of the box and, without the constraints and expense of film, just shoot away and hope you've caught a few good images. There's a better way to do this!

The other danger, we find, is that you might think you should be able to take great photos right from the start. If you fail to do this, or get overwhelmed by the camera dials and options, you either go back to the auto setting, or put the camera on the shelf and pick up your trusty old point-and-shoot. Sound familiar? We'd like to change this.

Almost anyone can learn to take good photos by investing a little time in understanding the simple controls of the camera. And by going just a bit further, you can take *great* photos. We want you to understand how your camera works, so we've broken it down in the simplest way possible. We've read numerous photography books that are technically overwhelming, or as dry and dull as the camera manuals themselves. We've tried to make sure this book is neither.

Being a photographer—whether you are shooting for yourself or have aspirations of going pro—is about more than just camera settings and equipment. We'll explain about light, composition, ways to improve your photos on the computer, and how to avoid making the common mistakes we see all the time. Most of all, we are going to challenge you to become a better observer, to see the world in a new way.

While the two of us are both photographers, in some ways the similarities stop there. Peta is from New Zealand, while Rachel is American (though married to an Australian with three dual-citizen kids). Rachel is in the family stage of her life; Peta is more than a decade younger. Rachel shoots Nikon; Peta prefers Canon. Rachel works on a PC; Peta loves her Mac. Rachel started shooting with film; Peta is a child of the digital age, trained in design as well as photography. These differences allow us to cover the full spectrum of equipment and options. What we share is a passion for photography and how it can enhance your life. We met posting our photos online, became close friends, and started teaching photography workshops together. Our combined forty years of experience—thirty as professional photographers—means we have plenty of insider tricks to share.

Photography is an art and a science, but it's also a way of life. Taking photographs nurtures your ability to see detail and appreciate beauty in both obvious and unlikely places. Our hope is that as you read this book and spend time with your camera, you will see how extraordinary your world is.

We are often asked if being behind the camera takes us away from the events of our lives, but the truth is just the opposite. Photographing your experiences gives you a greater appreciation for all that you have—friends and family, quiet moments and celebrations. Your story is worth telling, and worth telling well. We think you will be amazed at what you discover when you go beyond snapshots.

—Rachel and Peta

GETTING
OFF AUTO

Sure, you can take pictures with a point-and-shoot, or even with your DSLR on auto, but you'll never have the control, the creativity, the ability to craft an image exactly the way you want it. Much like driving a sports car, getting off auto will allow you to experience the full range of possibility and the sheer joy of making the pictures you want. You may begin to wonder why you ever let your camera drive.

chapter one
PICK UP YOUR CAMERA

So you bought a camera and have taken it out of the box. You've attached the lens and put the memory card in. What next? At this point, you have two choices. You can put your camera on auto and let it be in charge—and maybe you'll like your pictures and maybe you won't. Or you can learn some photography basics and become the boss of your camera. We suggest you do the latter. There's a whole world you can capture, in exactly the way you want, if you only step away from the auto setting. It's really not as intimidating as it seems.

NUMBERS: THE BIG THREE

Photography is about light, and cameras are the tools we use to capture that light. The amount and quality of light that enters your camera determines what your picture will look like. As photographers, we like to think we're in charge of the image, but in most cases it's the light that calls the shots. We learn how to work with it to get the effect we want. There are three settings on the camera that relate to light—ISO, shutter speed, and aperture—and a good photographer becomes adept at using all three. Let's take them one at a time.

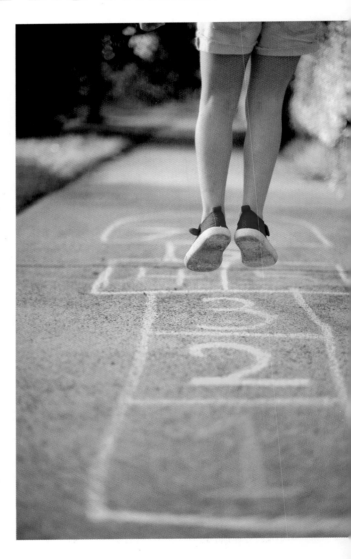

R Because I knew how to control the settings on my camera, I could catch my daughter in midair with the focus falling sharpest on her jump.
▶ Nikon D3 with Nikon 50mm F1.4G lens | ISO 400 | f/1.4 for 1/4000 sec.

ISO

ISO stands for International Organization for Standardization, but the name doesn't matter. What you need to know is that ISO allows you to control how sensitive your camera—or, more specifically, your camera's digital sensor, the computer inside the camera—is to light. Think of the sensor as digital film.

Before digital cameras came on the scene, each roll of film you bought was marked with a certain ISO, like 400 or 200. If you were shooting outside on a sunny day, for example, you picked film with a low ISO that was *less sensitive* to bright light. If you didn't, your pictures would appear washed out. Alternately, if you were shooting at dusk, you'd pick a higher ISO so your camera would be *more sensitive* and maximize what little light was there. The drawback is that you were stuck with one ISO setting until you were done with that roll of film.

Now, with digital, you can choose the ISO for each shot you take. To make this decision correctly, you need to look at the light. Here's what you should remember:

- Low ISO, such as 100 or 200, helps *limit* the light; use it under bright conditions.
- High ISO, such as 800 or 1000, helps *maximize* the light; use it in low-light situations.

There are a couple more things to remember about ISO. Because a higher ISO makes the camera more sensitive to light, you can capture images faster, often with less blur. So why not just leave your camera on a high ISO all the time? This may be tempting, but the goal is actually to use the *lowest* ISO you can under the circumstances. (Entry-level DSLRs give you an ISO range of 100–1600, and expensive cameras go even higher.)

Yes, a high ISO makes for a speedier shot, but going above ISO 400 on most consumer-level cameras will cause the sort of graininess photographers call "noise." Sometimes this adds to the charm of an image and makes it feel like a vintage picture (those pictures of your grandparents and great-grandparents have a lot of noise), but often it just appears messy.

There are always exceptions in photography, and there are situations where higher ISO is useful. In a low-light situation, for example, such as indoors or at dusk, the camera shutter will need to stay open longer to capture the image. If you don't have a tripod to keep the camera still, you might want to bump up your ISO. This lets the camera record the image faster and avoid the dreaded blur. In general, however, try to keep your ISO below 400. You won't see the noise on your camera display, but if you want to print the shot, or enlarge it, you may be disappointed.

ISO 100	› Daylight: Full sun
ISO 200–400	› Daylight: Dull overcast sky, full or open shade › Indoors: Well lit or flash
ISO 800–1600+	› Indoors or outdoors: Low light, no flash

This chart gives a general indication of which ISOs work best in different lighting scenarios. It is just like those handy ones that used to come on film packs. You do remember film packs, right?

SHUTTER SPEED

The next part of the formula is *shutter speed*. This is the speed at which the camera's shutter opens and closes to take an image—sort of like the blinking of an eye. The shutter allows light into the part of the camera that interprets images, the sensor. A *slow* shutter speed means the shutter is open for a longer amount of time, letting more light hit the sensor. A *fast* shutter speed means the shutter opens and closes quickly, allowing less light. Slow shutter speeds are especially helpful in low-light situations, like a candlelit dinner or outdoors at dusk.

The faster the shutter speed, the easier it is to freeze movements. Slow shutter speeds can mean blurry pictures, especially if there is motion in the image. If you are shooting a sporting event or an active toddler, you'll generally want to use a fast shutter speed.

In other words:
- To let more light into the camera, use a slow shutter speed.
- To let less light into the camera, use a fast shutter speed.
- To blur movement, use a slow shutter speed.
- To freeze movement, use a fast shutter speed.

Shutter speed is expressed in fractions of a second. This is where it can get confusing. With fractions, the larger the denominator, the smaller the number, and the shorter the amount of time the shutter stays open (a faster shutter speed). The smaller the denominator, the bigger the number, and the longer the period of time the shutter stays open (a slower shutter speed). For example, 1/250 of a second is slower than 1/1000 of a second. The standard settings for shutter speed are 1/1000 of a second (the fastest), written as "1/1000 sec.," to 1 second (the slowest).

SLOWER = BLURS MOTION ← → FASTER = FREEZES MOTION

| Bulb | 1 | 1/2 | 1/4 | 1/8 | 1/15 | 1/30 | 1/60 | 1/125 | 1/250 | 1/500 | 1/1000 |

(in seconds)

▲ This chart shows the effect shutter speed has on capturing motion. The faster the shutter speed, the better motion is frozen. The slower the shutter speed, the more motion is blurred.

P Here is the same image shot with two different shutter speeds. The image below was taken with a relatively slow shutter speed of 1/125 sec. The image on the right shows the same subject with a faster shutter speed of 1/1000 sec. Notice how the first image blurs the motion, while the second one freezes it? Keep your shutter speed above 1/250 to get sharp images and avoid camera shake (the blurriness that results when a camera is moved while the shutter is open). In situations like the one with the spinning top, however, you may choose a slower speed to show blur and movement.

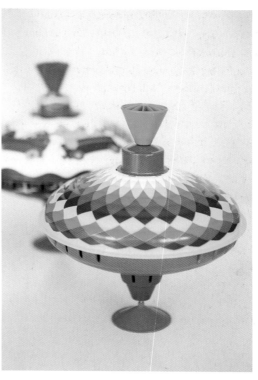

▲ Canon 5D with Canon 24–70mm F2.8 L lens at 70mm | ISO 800 | f/2.8 for 1/1000 sec.

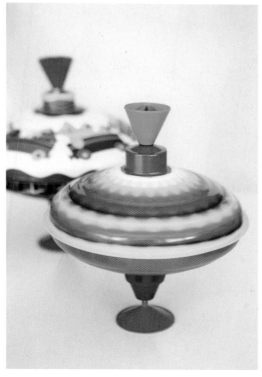

▲ Canon 5D with Canon 24–70mm F2.8 L lens at 70mm | ISO 400 | f/4.0 for 1/125 sec.

APERTURE

The hero of the photography numbers, in our opinion, is the *aperture*. The aperture is the size of the opening in the lens, and is yet another way to control how much light enters the camera. If the shutter functions like an eyelid blinking, the aperture is like the pupil of the eye. It gets larger or smaller depending on how much light there is in a given situation. Unlike our eyes, however, the aperture does not adjust automatically—that's up to us. If you want to let in more light, choose a larger aperture (or lens opening). If you want to let in less light, go smaller. That part is pretty straightforward. If it's bright, go smaller. If it's dim, go bigger.

Like any good hero, however, aperture is mysterious and complicated. Changing your aperture also gives you a powerful tool in deciding how you want your images to look. Aperture controls something called the *depth of field*. The depth of field is the amount of your image that is in focus. Let's say, for example, you are taking a portrait of your child. You want his face in sharp focus but the background to be blurry. This is called a *shallow depth of field*. Now let's say you're photographing a beautiful view, like the Grand Canyon, and you want the entire image in focus. This is called a *deep depth of field*. Here is another one of those equations that is reversed: The larger the aperture, the smaller the area in focus. We know it's confusing at first. Make a cheat sheet. The size of the aperture is measured in units called *f-stops*. F-stops are yet another unit expressed backwards: For the *largest* aperture opening, you choose the *smallest* f-stop number. This regularly confuses beginning photographers, and no wonder! It would make more sense if the largest opening was the largest number, but unfortunately that's not the case. The largest aperture—where the most light is coming in—has an f-stop of 1.0 (written as f/1). The smallest aperture—where the least light is coming in—has an f-stop of 22 (written as f/22). See, we told you it was confusing!

Here's what you need to remember:

- A *large* aperture (smaller f-stop number) gives you a *shallow* depth of field (less in focus).
- A *small* aperture (larger f-stop number) gives you a *greater* depth of field (more in focus).

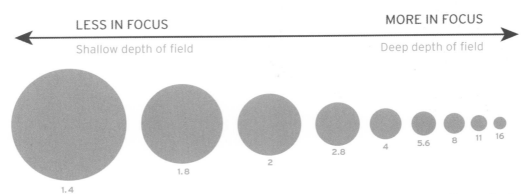

▲ This chart shows the relative size of different apertures. The smaller the "f" number, the bigger the aperture and the more light let into the camera.

R These two images show how changing the aperture can transform the look of your shot. The background in the photo below is blurred and indistinct (a *shallow* depth of field), while in the shot at right, it stands out crisply (a *deep* depth of field). It's just a matter of taste and what you want to show.

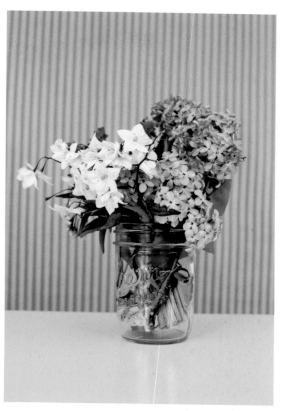

▲ Nikon D3 with Nikkor 50mm F1.4 lens | ISO 400 | f/8.0 for 1/30 sec.

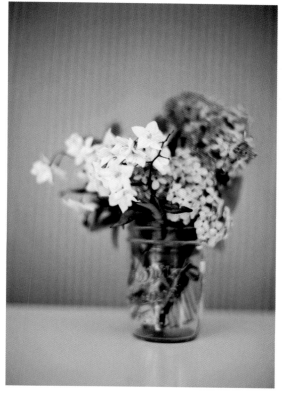

▲ Nikon D3 with Nikkor 50mm F1.4 lens | ISO 400 | f/1.4 for 1/1000 sec.

THE EXPOSURE TRIANGLE

These three elements—ISO, shutter speed, and aperture—are the three variables that make up the exposure triangle, or "equation." This equation is fluid, and depending on the result desired, you as the photographer need to pick the variables. In other words, just as 2+3+2=7, so does 5+1+1=7. To explain this in photography terms, look at the two images below. They both have the same overall exposure, but we took each in slightly different ways.

In the image on the left, a slow shutter speed allowed more light to be recorded in the shadows. To balance that out, the aperture had to be fairly small, resulting in a deep depth of field—notice how sharp the background is. But I was after a softer portrait to match the quiet moment with my tired daughter. To get that soft effect, I needed a shallow depth of field, with aperture leading the way. In the image at right, taken with a wide aperture, the blinds are now a lovely blur and the focus falls right on my daughter's eyes. To compensate for the wider aperture, the shutter had to be quicker, resulting in darker shadows. Luckily, in this case, it just adds to the mood of the shot.

▲ (left) Nikon D3 with Nikon f/1.4G lens | ISO 400 | f/8 for 1/30 sec.; (right) Nikon D3 with Nikon f/1.4G lens | ISO 400 | f/1.4 for 1/1000 sec.

CHOOSING A LEAD SETTING

All this information is great, but we know some of you are shutting down from photography tech-talk overload and wondering where to begin. How do you decide which ISO, shutter speed, and aperture to use? The trick is to figure out where to start, then let the other two settings take supporting roles. Which setting is most important to take the kind of image you want?

Aperture usually takes the lead when you are photographing something still, such as a portrait, still life, or landscape. If this is the case, ask yourself:

* Do I want a blurry background? If so, use a large aperture (small f-stop number), such as f/2 or f/4.
* Do I want the entire image more in focus, including the background? If so, use a small aperture (large f-stop number), such as f/16.

Why take charge of your camera?
Most cameras do an okay job on auto, but remember, the camera is just a tool. The camera can't think or create—that is why you must take charge. The goal of taking the camera off auto is not just to take a correct exposure, but to create an image that conveys certain feelings and emotions. By choosing the combination of camera controls, you become the artist.

Shutter speed normally takes the lead when you are photographing motion. When this is the case, ask yourself:

* Do I want to freeze the motion? If so, use a fast shutter speed, at least 1/500 sec.
* Do I want to blur the motion? If so, use a slower shutter speed, such as 1/30 sec.

Once you've picked your lead setting, you'll need to adjust the other two settings to create balance. See page 22 for a cheat sheet of sorts until balancing the exposure triangle becomes second nature. The first column lists various effects you may want to achieve. Do you want to freeze motion? Take a portrait with a blurry background? If you need ideas, the second column offers subject examples that tend to work best with each effect. Once you choose an effect, look at the third column for the lead setting—which part of the exposure triangle needs to be set first. The fourth column then gives you the final two settings, and the order in which they should be set. Lastly, we have added tips to consider for each effect. Learn the chart by heart or make a copy to keep with you in your camera bag.

CHOOSING A LEAD SETTING

EFFECT YOU WANT	EXAMPLE SUBJECTS	LEAD SETTING	THE NEXT TWO SETTINGS	SCENARIO NOTES
Freezing motion	› Sports › Active toddlers	› Fast shutter speed: 1/250 sec. or faster	› Aperture and then ISO	› With a wide aperture, make sure you double check your focus.
Showing motion: Panning	› Carnival rides › Bike races	› Slow shutter speed: 1/50 sec. or faster	› Aperture and then ISO	› Lock the focus on your subject and follow its movement as you press the shutter.
Showing motion: Blurred movement	› Waterfalls › Fireworks	› Very slow shutter speed: 1/10 sec. or slower	› Aperture and then ISO	› You will need to mount the camera on a tripod to keep it steady and avoid camera shake.
Portrait: Blurry background	› Single person	› Wide aperture: f/1.2–f/3.2	› Shutter speed and then ISO	› Use the smallest f-stop number available on your lens and focus on the eyes.
Portrait: Sharp background	› Groups	› Small aperture: f/5.6–f/8	› Shutter speed and then ISO	› Watch that the shutter speed does not slow too much or you will need a tripod.
Landscape	› Urban or nature	› Very small aperture: f/11–f/22	› ISO and then shutter speed	› Try to keep the ISO as low as possible for the brightest color and least digital noise.
Handheld portrait in low light	› No flash › Rainy days › People who move	› Shutter speed: 1/125 sec.	› ISO and then aperture	› The higher the ISO, the more digital noise you will have to embrace.
Still life in low light	› No flash › Flowers › Non-moving objects	› Wide aperture: f/4	› ISO and then shutter speed	› Use a tripod and a low ISO to keep the image as grain- and blur-free as possible.
Flash (if you must)	› Parties › Events	› Shutter speed: 1/60 sec.	› Aperture and then ISO	› Diffuse your flash or bounce the light.

▲ Use this simple chart to help you choose your "lead" setting. Exposure is a fluid equation, and you must adjust all three variables (ISO, aperture, and shutter speed) when you shoot in manual. To begin, it is just a matter of deciding what is most important to you in each image.

TRAINING WHEELS: USING SCENE AND PRIORITY MODES

If the jump to putting your camera on manual seems too big, there are some training wheels to work with until you get comfortable. Point-and-shoot cameras and entry-level DSLRs have *scene modes*, such as Portrait, Snow/Beach, Landscape, Backlight/Night Portrait, and Close-up, that are found in the shooting menu and automatically trigger certain combinations of settings. These are your first step off full Auto mode, as they allow you to guide the camera by telling it what you are photographing.

You can take even more control by selecting one of the *shooting priority modes* labeled with letters. Here's how they work:

P mode: The camera picks the shutter speed and aperture, just like in full Auto, but you can change the ISO and other image effects like color saturation. (*Saturation* refers to the intensity of color. A highly saturated image is very vivid and intense, while an image with low saturation is more subdued.) You can also change the settings that the camera has picked by scrolling the shutter and aperture dials. The camera will automatically adjust and keep proper exposure. P stands for Program mode, but think of it as Partially Auto.

S mode: With this mode, also called Tv mode (depending on camera brand), you pick the shutter speed and the camera chooses the proper aperture. This is good when you want to capture the action of sports, or a busy toddler— any time shutter speed is the priority.

A (or Av) mode: Choose this setting if you want to select the aperture and let the camera decide the proper shutter speed, such as if you're shooting a close-up of a flower and know you need to use a large aperture for a blurry background (shallow depth of field), but aren't as concerned with shutter speed. This mode tells the camera that the aperture you chose is the priority in the exposure.

These are easy ways to start taking control of your camera. Use them as learning aids, instead of a crutch, by observing the settings chosen and deciding what you feel worked best.

P Scene and priority modes won't do much to prevent bumps and bruises, but they can prevent frustration as you gain confidence as a photographer.

▲ Canon 5D with Canon 24–70mm F2.8 L lens at 24mm | ISO 160 | f/3.2 for 1/1600 sec.

METERING THE LIGHT

In the digital world, exposure is a recording of light by the camera's sensor. Proper exposure allows the camera's sensor to gather information from light that is reflecting off your subject—the brightest highlights and the darkest shadows. If an image is not exposed well, it will appear too dark (*underexposed*). If it is too bright or white, it will look too light (*overexposed*). A great deal of photography has to do with the various ways you go about achieving proper exposure.

In order to make the best choices for proper exposure, you need to evaluate the light and see how to best work with it. If you've decided you want to freeze the action on the soccer field, or capture the tranquil river along your hiking trail, the way you go about it will depend on the light conditions and how your camera reads them. You won't know what ISO, shutter speed, or aperture to pick until you get a sense of the light. You may think that photography is about the camera, but it's actually all about light.

The way your camera evaluates light in a scene and translates that to camera settings is called *light metering.* There is a light meter built into your camera that evaluates the light in every situation. It's a great tool to use, but in-camera light meters are limited due to how they are designed.

In-camera light meters are known as *reflective* light meters, because they take a reading of light bouncing off the subject and back into the camera. Do you see the problem? Depending on what you are shooting, there may be more or less light reflected (think of a white beach compared to dark woods). Or what if you are shooting something that has patches of light and dark? How can the camera deal with that?

Since the camera cannot think and accommodate, it has been programmed for a standard setting. Your light meter is set to work best if everything you shoot is a nice medium gray (18% gray, to be exact). Unfortunately the world doesn't come in medium gray (and it would be boring if it did), so how do we compensate? There are a couple ways. In Auto and Program modes, your camera will pick a combination of shutter speed and aperture that it figures will provide a proper overall exposure. The camera does not think or see, so Auto mode is a "best guess." When you take your camera off Auto, however, you have more control over telling your camera how to read the light in a scene.

Your DSLR has a few different *light metering modes*, which you select using a lever on the camera or in the menu. The two modes you should become most familiar with are Evaluative/Matrix and Spot/Partial.

Evaluative, or Matrix, mode (the name is different, depending on your camera brand) is the most comprehensive way to meter a scene. It takes information from the entire frame and picks an exposure that will generally work. If the overall image has nice, even light throughout, you camera will do a good job when set to Evaluative.

Spot, or Partial, mode is better for tricky lighting situations, when there are areas of light or dark. When using Spot metering mode, you tell the camera where to take its reading by selecting where you want the image to focus, and the camera will ignore the rest of the image. When you press the shutter button halfway, the camera focuses and locks in the exposure for that point. You can either take the photo there, or keep the button depressed and move the camera slightly to where you want it. Either way, it's a way to get the right exposure when the light is uneven.

This mode is best used when the light is stronger behind your subject, for example, or when a scene is composed of large areas of light or dark. (*Center Weighted* metering is another option that is close to Spot metering, but it assumes that whatever is in the middle of the frame is the area to be metered.)

There is another option: Purchase a handheld light meter. These measure the actual light falling on a scene and, as a result, are much more accurate. This may be an option you want to consider over time.

R For the first shot above, my camera was set to Evaluative metering mode, and it misread the light in the large open sky and underexposed the foreground. This is a perfect example of how your camera is just a tool and cannot actually "see" the scene like you can. The second time I reset the camera to Spot meter and selected the sheep as the area to meter. This is now closer to what I saw.
▲ **Nikon D200 with Tamron 17–50mm F2.8 lens at 50mm | ISO 500 | f/5.6 for 1/500 sec.**

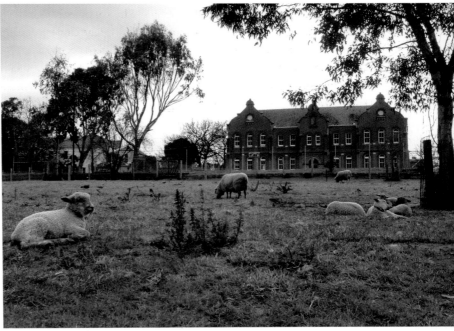

▲ **Nikon D200 with Tamron 17–50mm F2.8 lens at 50mm | ISO 500 | f/5.6 for 1/100 sec.**

CHOOSING AN EXPOSURE

You've selected a lead setting and the best light metering mode for your scene. How do you now determine a proper exposure?

Take a look in your viewfinder while you are composing a shot. In the center of the bottom display you will see a gauge that begins at –2 and goes to +2; this is your light meter. In the middle of the light meter there is a solid bar that marks zero; this is where correct exposure is found. If the flashing light below the gauge is too far to the right, your shot will be too light (*overexposed*); too far to the left and it will be too dark (*underexposed*). You can adjust this by changing any or all of the big three variables: ISO, aperture, or shutter speed.

Let's say, for example, you'd like to take a portrait of your partner. You're after a crisp portrait with the background blurred to bring attention to your subject. To get that blurry background, your lead setting has to be aperture—and a wide aperture (low f-stop number) at that. So you set your camera to f/2.8. The light is nice and even, so you choose Evaluative metering mode, which takes into consideration the light in the overall scene. Your two remaining settings are ISO and shutter speed. Since you are inside, but your subject is near a window with nice soft light, you set your ISO to 400. Now how about your shutter speed? Compose your photo and press the shutter release button halfway down. Look at the light meter. Where is the flashing light? If it's to the left of zero, decrease your shutter speed for more light. See how the flashing light gets closer to zero? If it's to the right of zero, increase your shutter speed for less light. Either way, adjust your shutter speed until your light meter indicates a correct exposure, then take the shot.

What if, instead, you are photographing your children at play and your priority is freezing motion? In that case, shutter speed is your lead variable. Set your camera to a fast shutter speed, such as 1/500 sec., to freeze motion. Then set your metering mode and ISO, and this time adjust your aperture until the light meter indicates a correct exposure.

As you gain experience, you'll learn how to adjust all three settings to get the exposure you want. You may even decide to ignore the light meter altogether for creative purposes (see pages 32–33). But in general, it is a reliable way of checking exposure.

Here are some examples of images we took, and how we determined the exposure.

P My favorite type of portrait is one with a blurry background, which draws the viewer's eye right to the subject. So for this close-up of Rachel's baby girl Clover, I knew a wide aperture had to be my lead setting. I chose the lowest f-stop my lens offered: f/2.8. While the light in the room was lovely, it was also quite low, so next I chose a shutter speed of 1/200 sec., which is the slowest I will go for portraits of babies and children. Lastly, I set the ISO to 400, which was low enough to avoid significant grain. The white walls provided nice clean tones, so auto white balance worked well.

▶ **Canon 5D with Canon 24–70mm F2.8 L lens at 70mm | ISO 400 | f/2.8 for 1/200 sec.**

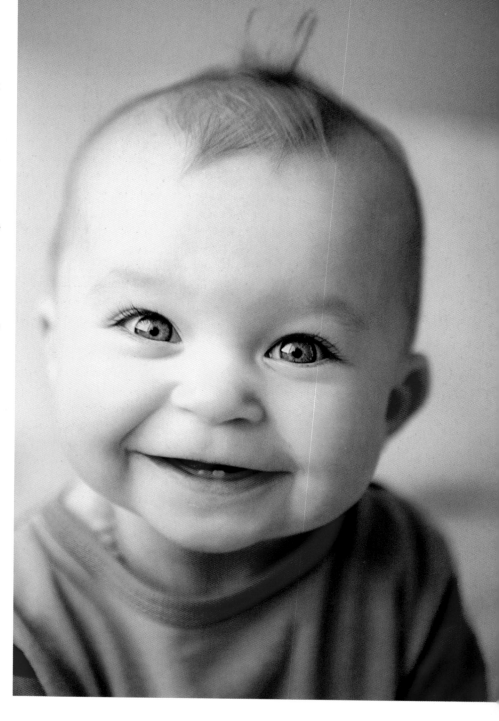

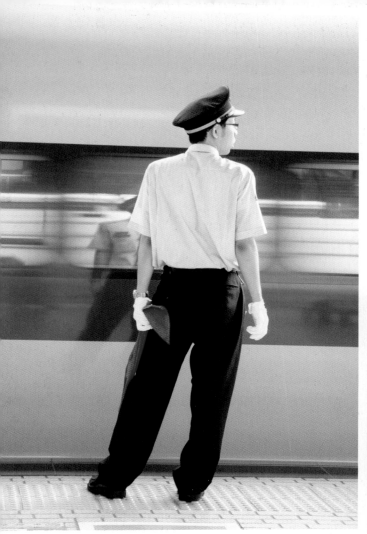

To freeze motion, a fast shutter speed should be your lead setting. It's best to use as high a shutter speed as possible while still maintaining the best aperture and ISO for your light. This day was bright and sunny, allowing me to use a really high shutter speed of 1/1250 sec. and still keep a nice low ISO of 200 to avoid digital grain. For my aperture, I selected f/3.5, my go-to aperture for casual shots of people interacting as it allows detail to be captured but still gives a nice blurred background.

▼ Canon 5D with Canon 24–70mm F2.8 L lens at 24mm | ISO 200 | f/3.5 for 1/1250 sec.

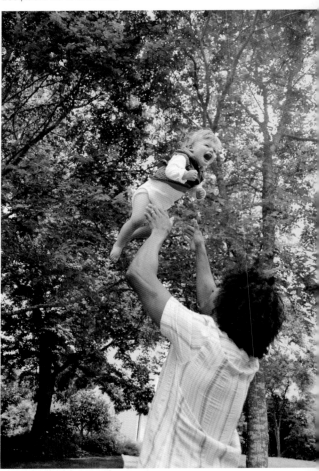

For this shot, I wanted to represent the speed of the bullet train as it left the station in Japan. A slow shutter speed had to be my lead setting, so the train's motion would appear as a blur. I set my camera to 1/30 sec. The lighting in the station was even but dim, so I relied on Evaluative metering and set my camera to ISO 800. To compensate for all the light being captured by the slow shutter speed and high ISO, I used a small aperture. I had been watching the conductor and knew he would stand very still as the train departed, which is why he remains sharp.

▲ Nikon D100 with Tamron 17–50mm F2.8 lens at 50mm | ISO 800 | f/11 for 1/30 sec.

R Gazing out over the Italian landscape, I wanted to capture every little detail in the view
 before me, so my lead setting had to be a small aperture to get the deepest depth of field
possible. To get the least amount of digital noise, I set my camera to a low ISO of 250. Finally,
using my light meter, I saw that a shutter speed of 1/640 sec. would give me the best exposure.

▲ Nikon D3 with Nikkor 24–84mm F3.5–4.5 lens at 42mm | ISO 250 | f/13 for 1/640 sec.

TROUBLESHOOTING

So you've taken your shot and you review it on the LCD screen—the liquid crystal display that shows your images. Is it too light, or too dark? Did it turn out differently than you'd envisioned? If so, simply adjust your settings and take the shot again.

How do you adjust your settings for a better exposure the second time? Here is a little cheat sheet to help you.

Your photo is too dark

- Solution #1: Choose a larger aperture to let in more light. This will also make your background blurrier.
- Solution #2: Slow down your shutter speed. This will increase blur for any motion.
- Solution #3: Choose a higher ISO. This may result in a grainier (or noisier) image.

Your photo is too light

- Solution #1: Decrease your aperture (make it smaller) to let in less light. This will also make your background sharper.
- Solution #2: Choose a faster shutter speed. This will also decrease blur and freeze motion.
- Solution #3: Choose a lower ISO. This will result in less grain/noise.

Your photo is blurry

- Choose a faster shutter speed, then check your light meter. You will have to adjust your aperture and/or ISO to account for the difference in light or your photo will be too dark.

Your photo isn't blurry enough

- Choose a slower shutter speed, then check your light meter. You will have to adjust your aperture and/or ISO to account for the difference in light or your photo will be too light.

Your *background* is too blurry

- Choose a smaller aperture, then check your light meter. You will have to adjust your shutter speed and/or ISO to account for the difference in light or your photo will be too dark.

Your *background* isn't blurry enough

- Choose a larger aperture, then check your light meter. You will have to adjust your shutter speed and/or ISO to account for the difference in light or your photo will be too light.

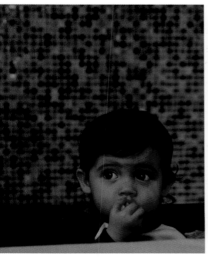 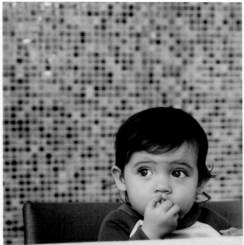 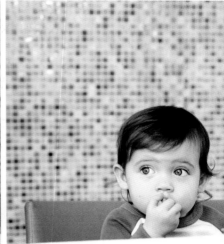

For this photo, the aim was a portrait with a blurred background (shallow depth of field) to reduce the distraction of the tile wall behind the subject, and minimal digital noise while hand-holding the camera in a dimly lit restaurant. For my first shot (far left), I set my ISO at 200 to get the least amount of digital noise possible, but the image came out too dark. Next, I chose the widest possible aperture on my lens, f/2.8, for a shallow depth of field, but the image came out too light (far right). The compromise was to use a slightly smaller aperture (f/3.5) with a shutter speed of 1/80 sec. to avoid camera shake while holding the camera. To get a correct exposure with those settings, I had to raise the ISO to 400. The middle image shows the correct exposure, a nice balance of shallow depth of field and acceptable digital noise.

▲ (middle) **Nikon D100 with Nikon 60mm F2.8 lens | ISO 400 | f/3.5 for 1/80 sec.**

WHEN WRONG IS RIGHT

Sometimes, when you want to create a certain feeling in a photograph, you may decide to ignore the light meter. Instead of a balanced exposure across the entire image, you may purposefully over- or underexpose. For example, moody sidelight depends on very deep, dark shadows to convey drama. Conversely, high-key images (where the dominant tone is white) need a lot of bright, airy light to set the subject off in a clean and stark frame. This is the joy of manual control— you are the artist, and you decide how the photo will look.

R This moment I caught of my son immersing himself in the imaginary land of dinosaurs would not be as dramatic if the light had been flat and all the shadows removed. I chose to expose for his face, knowing that the result would be this moody contrast of lights and darks.
▼ Nikon D200 with Tamron 17–50mm F2.8 lens at 17mm | ISO 160 | f/2.8 for 1/50 sec.

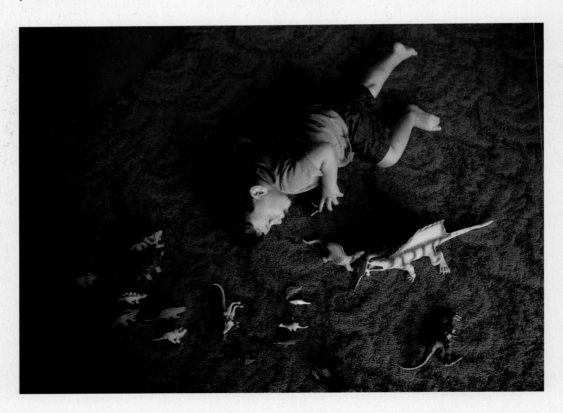

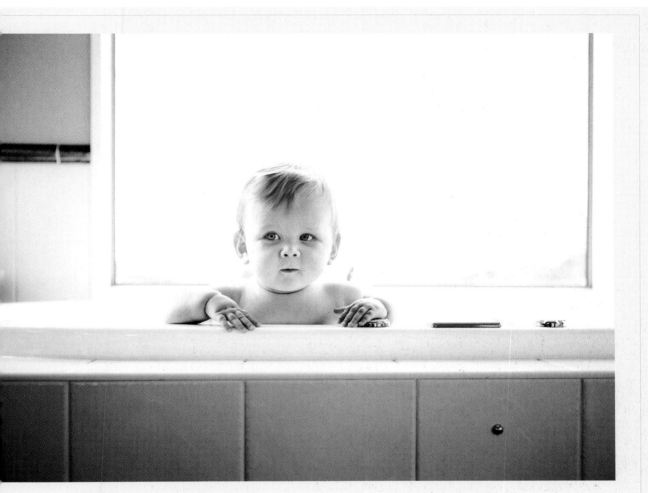

P The sun was streaming in behind this cute bathing baby and I wanted to capture the glowy, airy light, so rather than expose "correctly," I chose to overexpose the image. I spot metered for the baby's skin, and instead of using the aperture deemed "correct" by the camera's meter, I went one full f-stop larger. Exposing correctly wouldn't have been too dark, but the feel of the image would be different.

▲ **Canon 5D with Canon 24–70mm F2.8 L lens at 42mm | ISO 320 | f/2.8 for 1/200 sec.**

LENS AND FOCAL LENGTH

Another choice in your photographic toolbox is lens and focal length, which means how much your camera can see. The choice of lens has quite an impact on the look and feel of your images. You may have heard people talking lens numbers and not known what they meant, or maybe you had to select a certain lens when you bought your camera. Most beginners use the kit lens that comes with their camera, which is a fine place to start.

As with aperture, the numbers used for lenses are misleading. A lens with a *smaller* number (21mm–35mm), or focal length, will give you the *widest* view. That is why a 35mm lens is used for landscapes, while a 300mm lens is better for close-ups of birds, flowers, food, and so on. The 300mm lens has a very narrow view and is considered a telephoto lens. The 50–120mm range is best for portraits, depending on the distance you are shooting from and how many people are in the frame, even though by definition a portrait lens is 85–105mm.

Here is the range of lenses to choose from:
- super wide (10mm–16mm); this includes the fish-eye lens
- wide (20mm–35mm)
- normal (50mm–60mm)
- portrait (85mm–105mm)
- telephoto (120mm–210mm)
- long telephoto (anything from 250mm on up)

A term you may hear a lot is "prime lens." This is a lens with a *fixed* focal length—meaning a lens that does not zoom. Prime lenses are sharper than zoom lenses, as there is less glass and fewer parts between the scene and your sensor. The best prime to start with is a 50mm. Almost every camera brand makes an inexpensive, fast 50mm. It's a great all-around lens.

This does not mean you should rule out zoom lenses. They are a good way to capture many different views of a scene without having to change your position. A zoom lens also allows you to test different focal lengths and see which suits your vision best. If you can invest the money, get a top-of-the-line zoom lens. Zoom lenses on the lower end of the cost scale will also have a variable maximum aperture. That means the aperture changes as the lens zooms from its shortest to longest focal length, limiting your ability to photograph in low-light situations.

Lenses in low light
If you're in a low-light situation, a lens with a wide focal length set to a large aperture will help you maximize the light. Just remember this one rule: Your shutter speed must be faster than your focal length or you run the risk of blurred images and camera shake. For example, if you are shooting with a 50mm lens, you need to set the shutter speed to at least 1/60 sec., or mount the camera on a tripod.

P This series was taken from the same spot using different focal lengths: 24mm for the first image, 50mm for the second, and 105mm for the third. The choice of lens impacts how much or how little is in the frame.

▲ Canon 5D with Canon 24–70mm F2.8 L lens at 24mm | ISO 250 | f/3.2 for 1/200 sec.

P ▲ Canon 5D with Canon 24–70mm F2.8 L lens at 50mm | ISO 320 | f/3.2 for 1/200 sec.

R ▲ Nikon D3 with Nikon 105mm F2 lens | ISO 500 | f/2.2 for 1/1000 sec.

WHICH LENS SHOULD YOU BUY?

When it comes to upgrading or adding to your lenses, make sure you buy a lens specifically made for your type of camera. DSLRs come in two varieties, those with a digital sensor (DX) and those with a full-frame sensor (FS). Don't buy a DX lens for a full-frame camera. It *is* possible to use a FS lens on a DX camera, but your focal range will be off (a 35mm lens on a DX sensor becomes roughly a 50mm lens).

You also want to buy a lens that fits your make of camera. A Nikon lens will only fit a Nikon camera—same with Canon—but there are companies like Tamron and Sigma that make lenses for all brands of cameras. Fortunately it is possible to rent lenses, so you can experiment and see what you like before purchasing.

Less expensive lenses are limited in how wide the aperture can go, which makes it harder to throw something artistically out of focus with a shallow depth of field. They also limit your ability to take photographs in low-light situations—since you won't be able to

go super wide with your aperture, you'll have to raise your ISO and lower your shutter speed to compensate. These lenses also tend to have plastic casing and lower quality glass.

Which are our favorite lenses? Rachel's favorite lens for portraits is the Tamron 90mm macro. *Macro* means that it can focus at very close distances. The 90mm focal length is very flattering because the longer the lens, the flatter the image (noses and such will appear smaller), and the macro feature means you can get in super close to photograph tiny details like eyelashes and baby toes. Peta often uses only one lens on her shoots: the Canon 24–70mm F2.8 L. It is pricey, but it is very sharp for a zoom and allows a great range of looks in just one lens.

As you add lenses, get to know them. You want to be able to grab the best lens for a particular scene without much thought. You should also swap lenses and focal lengths often as you learn, so your work does not all look the same. It is easy to leave one lens on your camera all the time and get into a rut.

PUTTING IT ALL TOGETHER

Photography is a fine balance, and with time, the exposure triangle will start to make sense. Having a clear vision of what you want the image to look like, and understanding how the various exposure variables affect the outcome, will help you make decisions as you shoot.

Let's look at some more images and explain how we made the exposure decisions we did, and why.

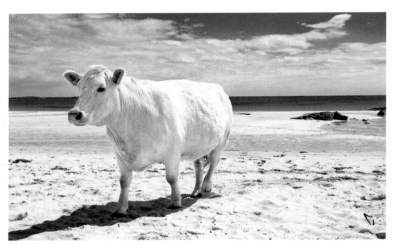

R To isolate this pear from the mess of overgrown branches and background, I needed to start with a wide aperture (f/1.8) for a shallow depth of field. It was quite overcast, so I raised my ISO to 400, and then selected the right shutter speed for a correct exposure (1/250 sec.). Since the focal length of this lens is fixed at 50mm, I walked close to the pear and framed it where the greenhouse posts intersected to draw the viewer's eye to the subject. Because it was so overcast, I set my white balance to Shade to warm up the entire scene.
▼ **Nikon D3 with Nikon 50mm F1.4G lens | ISO 400 | f/1.8 for 1/250 sec.**

R Coming across a white cow on a white sand-covered beach in Ireland was a surreal experience, and I wanted to capture the scene as crisply and accurately as possible. This was tricky as the high sun, white subject, and bright beach meant there was a great chance for overexposure. I began with a small aperture for a deep depth of field, so everything would be in focus. I then set the ISO at the lowest option (ISO 250) to both get the best color saturation and reduce my chance of overexposure. I picked a fast shutter speed to further reduce the light hitting the sensor. To include as much of the scene as possible, I chose a wide focal length and focused on the cow's eye. Luckily, auto white balance resulted in a true-to-life rendition of the colors.
▲ **Nikon D200 with Tamron 17–50mm F2.8 lens at 29mm | ISO 250 | f/14 for 1/640 sec.**

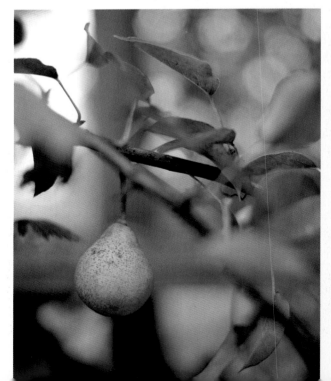

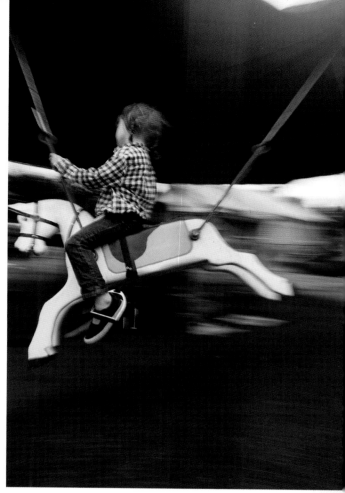

R I wanted to create an ethereal feeling with this shot, so aperture led the equation. The shallow depth of field created by a wide aperture of f/1.8 keeps just the lovely details of the flower face in focus, while the leaves, stem, and vase fall into blur. The room was a bit dark, and I was worried about inadvertent blur since I didn't have a tripod. Using a high ISO allowed me to use a fast shutter speed to eliminate any concern over camera shake. The grain from the higher ISO adds a bit of texture to the image. While you would normally avoid grain, in this case it creates an almost painterly quality. My 50mm prime lens was wide enough to include the entire arrangement without including distracting elements from the background.

▼ **Nikon D3 with Nikkor 50mm F1.4 lens | ISO 1000 | f/1.8 for 1/200 sec.**

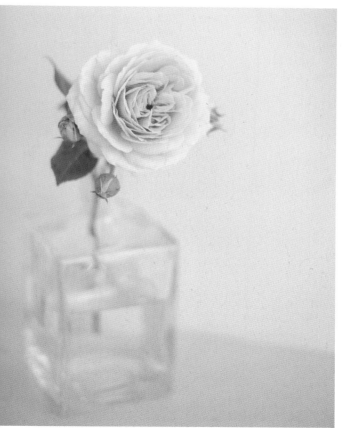

P I wanted to capture the feeling of watching this child whizzing past on a merry-go-round. To record the motion, I chose a slow shutter speed of 1/100 sec. I then chose an aperture of f/3.2—wide enough to blur the background while allowing me to keep my ISO at only 100 to avoid grain. As it was outside and an overcast day, I trusted my camera's auto white balance. I then moved the camera along with the moving subject as I pressed the shutter release (known as *panning*), a technique used to record background motion while keeping the subject recognizable.

▲ **Canon 5D with Canon 24–70mm F2.8 L lens at 30mm | ISO 100 | f/3.2 for 1/100 sec.**

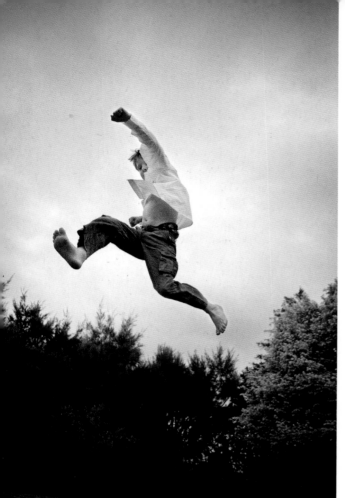

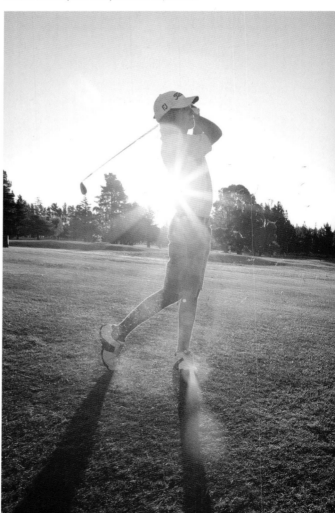

P I was enchanted by the beautiful light during a summer twilight round of golf and wanted to capture the mood of the moment. To freeze my cousin's golf swing as well as the flying grass, a fast shutter speed (1/320 sec.) was my lead setting. I then chose a small aperture of f/13 to capture the detail of the grass and the sun flare. Something had to give, however, given the low light, and a high ISO of 800, with a bit of added grain, was the price paid to get the shot. The golden hour before sunset provided beautiful warm light that the camera was able to capture on auto white balance.

▼ **Canon 5D with Canon 24–70mm F2.8 L lens at 30mm | ISO 800 | f/13 for 1/320 sec.**

P For this jumping shot, I wanted to freeze the motion in midair without any blur, so my lead variable had to be a fast shutter speed. Unfortunately, the light was also getting low. I chose 1/300 sec., fast enough to freeze the jump but slow enough to allow me to avoid raising my ISO too high. To let in light and prevent the ISO from going too high, I used an aperture of f/3.2 With these settings in place, I had to settle for a high ISO of 640. It added some grain to the shot, but in this instance I prefer grain over blur.

▲ **Canon 20D with Tamron 17–50mm F2.8 lens at 17mm | ISO 640 | f/3.2 for 1/300 sec.**

GETTING YOUR CAMERA READY

Great photography is often about being prepared, and getting your camera properly set up is a big part of that. Make sure you have everything you need ahead of time, and keep it maintained. All of the technical knowledge in the world won't do you any good if your camera is not ready to go when the moment is right.

Memory cards

The camera needs memory to record all those great photographs you are going to take. Make sure you have at least one memory card ready to go, although having a handful is not a bad idea. If your camera can take video, buy a large card for videos and keep it separate from your image card. Buy the best brand and fastest recording card you can afford. Even the best card can fail at some point, so buy multiple smaller cards rather than one giant memory card. It is much less painful to lose 4GB of images than a full 32GB card.

To keep your memory card happy and healthy, format it each time you download your pictures. We use a card reader to transfer our images to the computer. Card readers are inexpensive devices that connect the cards to the computer. They are often faster than the camera/cord combination. They require no external power, so they won't run down your camera battery. Also, you can continue to shoot even while the memory card is

downloading images by simply putting a fresh card in the camera. Once the card has finished downloading and the images are safe, replace the card in the camera and format it.

To format your memory card, follow the directions in your camera manual (often there is a shortcut button to format a card, but you can also just find it as a menu option). Instead of erasing all images, just reformat to clear the card. If you continue to erase images, small bits of information get left behind, like chalk on a blackboard. These can build up over time, making the card less efficient and possibly leading to corruption and loss of data.

To camera strap or not to camera strap? Some professional photographers find camera straps awkward and opt out of using them. We do not suggest this, since dropping and breaking your camera is much worse than an itchy neck. There are some great companies out there making pretty camera straps and covers. There are also straps that expand and retract, and some that have heavy-duty bounce to take the strain off your neck. You can even buy a wrist strap, if you are sure you will never want to hang the camera around your neck.

Color space

Let's talk about color. Not the colors you're photographing, but the way color is generated in your images. When shooting digital, this is another decision to make.

A *color space* is the number of individual colors available to create an image. There are many color spaces available these days. The two you will hear about most are AdobeRGB and sRGB. The RGB stands for red, green, and blue. Adobe is an industry standard for pros, designed by Adobe Systems, and sRGB is a standard color space, created by HP and Microsoft, with a slightly smaller scope. We recommend you start out shooting in sRGB. You can select your color space from the shooting menu settings on your digital camera, and later in the photo editing software that you use. In Photoshop it is found under Edit > Color Settings. Most consumer labs print in sRGB, and it is what the Web assumes everyone is using. You can shoot in AdobeRGB and convert the image to sRGB in processing, but why not make it easy? When you are ready to move up, you can switch

R Color space is like those giant packs of crayons: You might use the rare colors once in a while, but the box of sixty-four is fine for everyday use. When you are ready, you can move up.
▲ **Nikon D3 with Nikkor 60mm micro F2.8 lens | ISO 640 | f/5.6 for 1/100 sec.**

to AdobeRGB. Most cameras come set up to shoot in sRGB out of the box, but a quick scroll through the menu can confirm your selection.

Image format

One more thing to talk about as you are setting up your camera is image format. In the days of film, this decision was easy—you either shot transparency or negative film. Using a digital camera, however, you get to choose what kind of images will end up on your card. When the shutter opens and takes an image, we call that image *raw*. The raw image retains none of the settings you have programmed into your camera; it is as the camera and your eye see it. You can choose to leave the image that way, or you can tell your camera to save the shot as a JPEG (pronounced jay-peg).

While there are benefits to shooting raw, we recommend you shoot JPEG. We know that somewhere a pro photographer just read that sentence and cried, but it really is the most practical way to start. JPEGs are a common file type, universally recognized by editing and image sorting programs, and they take up much less room on your hard drive. If you have lots of digital storage (hard drive space) and your camera allows for it, you may want to shoot both raw and JPEG. The raw files will give you more options in editing, since they contain all the information recorded by the camera, but in terms of getting comfortable with your camera, JPEG is the place to start.

When shooting in JPEG, set the file size to the largest available and the compression to the finest level as this will ensure you end up with the highest-quality JPEG your camera can produce. These options can be adjusted under the in-camera shooting menu under image quality and image size. Unlike raw images, JPEG files have camera settings applied to them—settings you get to choose. It is the camera's way of deciding a few things for you ahead of time, like saturation, sharpness, and contrast. You can customize your JPEG settings via the camera's menu.

Within the camera menu under picture controls (refer to your manual for camera-specific names of this feature), you can select a quick preset to determine the look of your JPEG images. The options range from neutral to extra vivid. Standard is a good place to start, because if you are photographing people, vivid will result in unflattering super-saturated skin tones. Conversely, the neutral setting may not give your landscapes the pop of color that you are after. As with all of these fancy camera controls, you can adjust your selection according to the scene. While they may seem daunting at first, these customizable options are among the many reasons a DSLR trumps your old point-and-shoot for mastering your photographic vision.

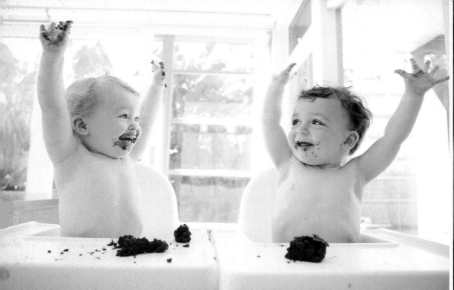
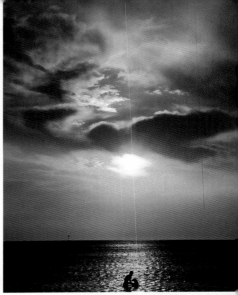
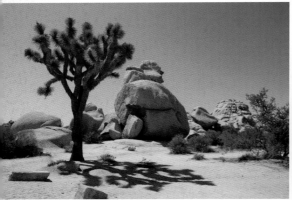
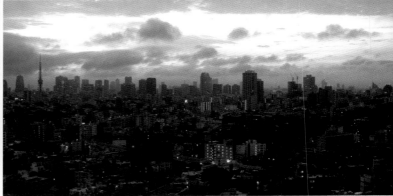

chapter two
GET TO KNOW THE LIGHT

Light is one of the biggest variables for any photographer. It influences almost every choice you make in regards to your photograph; it is the starting point for all decisions. As photographers, even before we pick up our cameras, we are looking at the light—and we're not just talking about the light you see on a sunny day. Even gloomy, gray days have light; it's just of a different quality. In the following pages, we'll go into greater detail on how light influences your photographic choices and helps you decide what ISO, shutter speed, and aperture to select, but the first step is to look around you. Look at the light.

OBSERVE THE LIGHT AROUND YOU

Over years of practice, observing light has become second nature to us, but what does it really mean? When we say we are looking at the light, we are actually looking at five different things.

Amount: Is there a lot of light or are we losing the light? The amount of available light helps us determine the proper ISO. Remember: Lots of light requires a low ISO; minimal light requires a high ISO. Do some test shots, adjusting the settings, until you are happy with the results.

Quality: The quality of light is determined by its brightness. For example, there may be a lot of light on an overcast day, but the quality may be dim and flat. Or a dark room may have one light that is concentrated and harsh. The quality helps determine the shutter speed and f-stop. If there is one bright light in a room, I may slow the shutter speed down so I can record the ambient light as well. Or I may stick with a faster shutter speed, knowing the dimmer areas of the room will be thrown into darkness.

Direction: By "direction" we mean the location of the subject in relation to the light, not the direction the light is coming from. Is the subject lit from the side or the front? Or is the subject backlit, with light glowing from behind? The choices we make here will influence the mood of the shot. Light coming from the side can add drama, while light from behind lends an airy quality. The direction of light is something you can (usually) control and change to suit your goals.

Angle: Where is the light coming from? Is it a high midday sun that causes a lot of harsh shadows, or is it coming in low along the horizon at sunset, creating wide, flat light? Is it bouncing off a white wall and filling the space with diffused light, or is it a concentrated stream illuminating one spot? Knowing the angle helps us decide where to place our subject, based on the sort of atmosphere we want to create. It also helps us decide if we need to modify the light, using a flash or reflector to fill in shadows. We'll be talking more about all of these choices later in this chapter.

R Jet lag had us up early in Tokyo, and the sun rising over this view from our hotel room was too good to not photograph. The blue tones almost make the city seem part of the sky, with the yellow lights of the waking buildings like tiny stars. The high ISO does contribute to digital noise in the shadow areas, but the detail and light visually break up the large areas where that noise would be most apparent.
▶ Nikon D100 with Tamron 17–50mm F2.8 lens at 24mm | ISO 800 | f/3.5 for 1/20 sec.

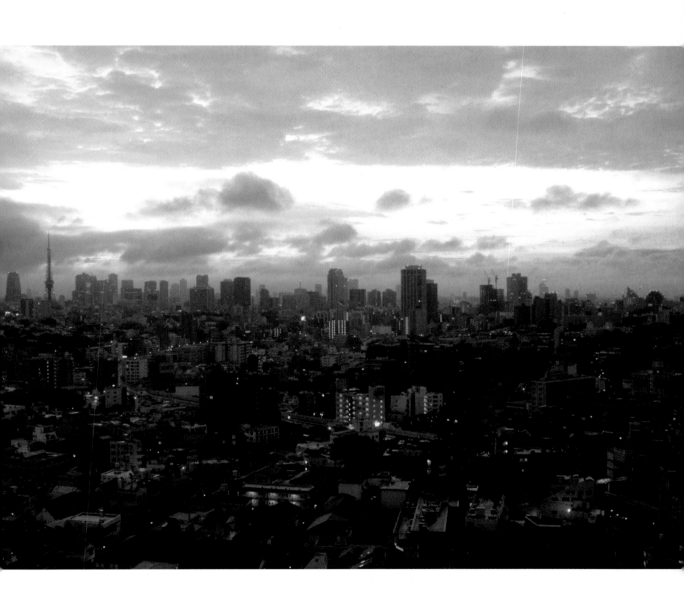

Color Temperature: All light has color, and we're not talking about colored light bulbs. If you travel, notice how the light runs cooler or warmer in different locations, tinged either blue (cool) or gold (warm). Even in the same location, the color will change throughout the day, becoming more golden at sunset. This colored light can alter the way your photograph appears—whites may appear too blue or too gold. We can compensate for this through clever use of the white balance (see page 48).

It all comes down to what light situation you're working with, and what outcome you are trying to achieve. There are many variables you can choose to create the picture you want. This may feel overwhelming at first, but play around with your settings and experiment until you're pleased with the image.

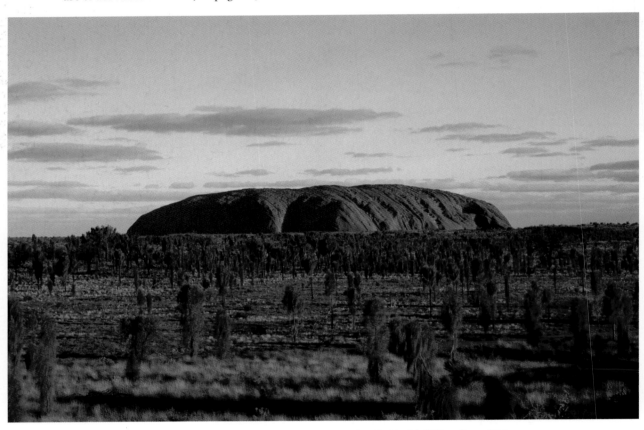

▲ Nikon D100 with Nikkor 60mm F2.8 lens | ISO 200 | f/9.0 for 1/320 sec.

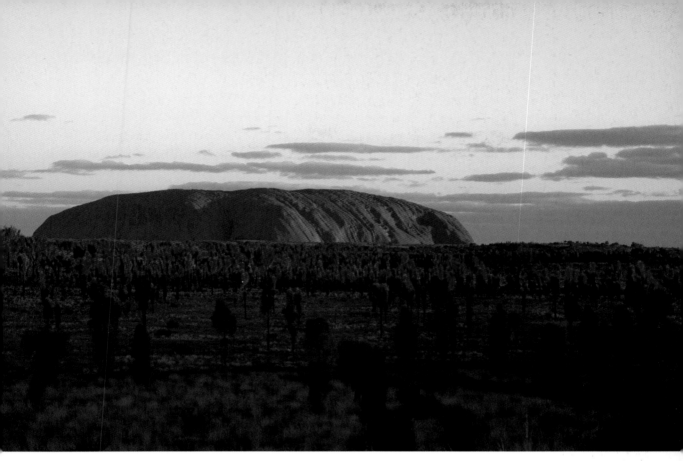

R These two images of Australia's famous Uluru, taken from the same vantage point on the same day, but at different times, show how light changes in color and angle as it moves toward the horizon. No color enhancements have been done to these in postprocessing; it is just the intensity of the light coming at a low angle in the second photo that makes everything so red.

▲ **Nikon D100 with Nikkor 60mm F2.8 lens | ISO 200 | f/6.3 for 1/160 sec.**

WHITE BALANCE

No light is created equal, and neither are the "whites" in your image. We've already discussed how light has color. That color impacts how your camera sees and records white. Blue light will tinge your white a cold blue; the golden light photographers love so much has the opposite effect. If you like the way it looks, great. If not, you can compensate for it by adjusting your white balance.

As beginning photographers, most of the time you will do just fine leaving your camera's white balance setting on auto. But if you are unhappy with the results and want more control, switch to one of the preset white balance modes. These tell the camera to compensate for certain situations, such as a cloudy sky, shade, daylight, fluorescent lights, tungsten lights, and so on. For example, if you're shooting outside in shade, which tends to have a bluish cast, the camera's Shade setting will add warm tones to your image. If you are shooting in a room lit by a tungsten light, which tends to result in overly warm, yellow images, the Tungsten setting adds cool tones to compensate. These settings are on your camera's white balance menu options. Just be sure to change your white balance back to auto or Daylight when you are done so you don't end up with oddly colored photos the next time you pick up your camera and the light conditions have changed.

An advanced solution is to set a custom white balance, which you may want to do if your images consistently have a cold or warm color cast. How you do this varies from camera make and model, but basically it involves taking a photo of a white sheet or a fancy calibration target/gray card that you can purchase in photography stores. You can even buy lens caps and glass filters that are made for shooting with a custom white balance. If you find you are having real struggles with consistent color casts, these easy and very portable tools may be good investments.

Auto

Shade

Tungsten

Cloudy

Custom

R Here you can see the results of various white balance settings used for a portrait of a friend's daughter, who was standing in a doorway. The Cloudy setting was the closest I could get with the camera's white balance presets. Since I wanted a true rendition of colors, I opted in the end for a custom white balance.
▲ **Nikon D3 with Nikon 105mm F2 lens** | **ISO 640** | **f/4.5 for 1/200 sec.**

P Sometimes Rachel uses a white balance tool that fits over her lens (an ExpoDisc in this image). Buy the largest one available so it will fit over all of your lenses and you won't have to buy multiple sizes.
◀ Canon 5D with Canon 24–70mm F2.8 L lens at 24mm | ISO 200 | f/3.2 at 1/200 sec.

THE NITTY-GRITTY BEHIND WHITE BALANCE

In photography, people refer to the *Kelvin scale*, which defines where light falls on the color spectrum between blue and orange. Color is measured in degrees of kelvin and stated as temperature. Bluer light (overcast days or shade) is considered "cool," while redder light is "warm." The Kelvin scale helps us determine the white balance of our images. The camera's white balance settings compensate by adding cool tones to balance out an overly warm image, and warm tones to a cool image.

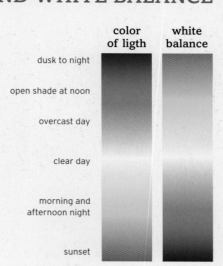

color of ligth	white balance
dusk to night	
open shade at noon	
overcast day	
clear day	
morning and afternoon night	
sunset	

WORK WITH THE LIGHT YOU HAVE

Photographers tend to have preferences for certain types of light. Most professional shoots are scheduled for early morning or late afternoon to take advantage of a soft, flat light. Of course, it's not always possible to choose your ideal light conditions. Because of this we learn to work with the light we have, either using it to our advantage or modifying it to suit our needs.

While the biggest light source is the sun, the type of light it produces varies due to time of day and weather. The morning and late afternoon sun can appear huge on the horizon, but it casts a soft light. Noontime sun is small in the sky but creates hard light and shadows. When it is overcast, the clouds filter the sun to create a much more even light.

R Harsh midday sun in the desert east of Los Angeles casts wonderful shadows from the amazing trees and cacti, adding visual interest to what would otherwise be blank space in the foreground.
▼ **Nikon D100 with Tamron 17–50mm F2.8 lens at 17mm | ISO 200 | f/11 for 1/500 sec.**

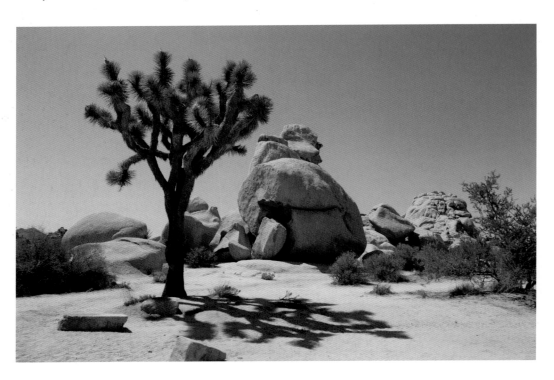

One of the biggest challenges when shooting in natural light is that it can be uneven. We often have to balance between areas that are too bright (hot) and areas that are too dark (shadow). Here is where a careful study of light turns to your advantage.

If you don't have enough light and you want to brighten up shadow areas, white is your friend. Light bounces off white surfaces, so you can reflect light into areas you want illuminated. You can buy reflectors that do this from photography supply stores, but you don't need fancy gear. Any solid white surface will work—a piece of paper, Styrofoam, poster board, a sheet, a white wall, even wearing a white shirt while shooting can help. Just put the white object opposite the light source. The light will hit the white and "bounce" back onto your subject. If you are shooting a portrait and want more illumination on the face, use this technique to bounce the light on it.

Sometimes you may have the opposite problem—too much illumination. The trick then is to *diffuse* the light, or make it softer and more even. Photography stores sell commercial diffusers, but there are other creative solutions as well. If you are shooting outside and the sun is too bright, seek shade. A large tree provides an umbrella of sorts to block the light. Just make sure to watch the color. Light under the tree will be cooler and may have some green reflecting up from the grass. You can solve this by putting something neutral or white—like a sheet or a reflector—between your subject and whatever is reflecting the color (such as

P I love the joy in this little friend's face as he sits on his skateboard. This was shot between two white exterior walls that acted as natural reflectors, creating a lovely, even light.

▲ **Canon 5D with Canon 24–70mm F2.8 L lens at 60mm | ISO 200 | f/3.5 for 1/500 sec.**

putting a white sheet on the grass and having your subject stand on it). The light under a tree can be dappled as well, with bright light getting through some of the branches. You can check for this by scanning the ground first and making sure there are no "hot spots," hallmarks of this direct light. Hot spots are spots where the light is so intense that those areas of the scene become white and lose all detail.

You can also "flag" the light, which means you create shadow by blocking the directional light. To do this, rig up a white sheet blocking the sun and shoot under it. Or have someone hold a white poster board over the subject to block out harsh light; use white to take advantage of any extra light it might reflect.

A more advanced suggestion is to adjust your image in postproduction editing. You can take two separate shots of the same scene and combine them in your editing program. Set one shot to expose for your subject, the way you would in Spot metering (see page 25), and another to expose for the background, then layer them so you have even exposure across the entire image (see page 103 for how to blend two images). This is an advanced, technology-assisted workaround, but sometimes it can be just the ticket.

A final way to overcome lighting challenges is to use a flash. Some photographers don't use flash (Peta doesn't, though she's curious about trying it). Flash is a big topic, so for our purposes we'll keep it short and easy. The most important thing to know about flash is to diffuse it so the light is less harsh and your image isn't washed out. You want to avoid obvious flash images with overexposed bits and unattractive shadow.

There are a lot of products on the market that diffuse your flash, from funny plastic cones to actual soft boxes (Rachel has tried them all). If you have a pop-up flash on your camera body, you can try Professor Kobré's Light Scoop. If you have an external flash unit, you have many more options, from the simple Omni-Bounce to the larger Gary Fong Lightsphere favored by professionals. You don't need special products, however, to successfully diffuse your flash. The solution can be as low-tech as a few tissues, white paper, or a translucent sheet of white cloth held over your on-camera flash. If you create a bubble by "poofing" out the cloth or tissue, the light will be better diffused than if the material is tight across the flash. The point is to increase the size of the light source.

Another great way to use flash is to *bounce* the light. If you have an external flash unit that attaches to your camera (not pop-up), chances are the flash will pivot and face a different direction. A simple way to use this technique is to leave the flash on auto or TTL ("through the lens") and point the flash straight up so it fires at the ceiling, which will create soft yet directional light. Or turn the flash completely backward and bounce it off a white wall behind you to provide a flat, even illumination. As always, you need to bounce the flash off a white wall or ceiling, or you'll end up with light tinged the color of the surface you use.

You can also use a flash outside in daylight, when you want some help brightening faces. This is called *fill flash,* because it's "filling in"

extra light. Again, you'll want to diffuse the flash to avoid harsh shadows. If it is not possible to diffuse the flash, you can manually reduce the flash output on most cameras and flash units, telling it to send out less light than it thinks you need. To reduce (or increase) your flash's output, press a button near the flash marked with a zig-zag arrow icon, scrolling from -0.3 to -3.0. External flash units have a similar function, but due to the huge variety of makes and models on the market, you should refer to your manual for more specific instructions. Reducing your flash's output can create more balance between the existing light and the flash.

R Caught in a hotel room with terrible lighting, I brought out my flash to photograph my toddler frolicking in the closet. I turned the flash head around to point directly at the light-colored wall behind me. Using the wide-angle end of the lens, I was able to capture myself in the mirror, recording a moment of pure fun.
▲ Nikon D100 with Tamron 17–50mm F2.8 lens at 17mm | ISO 400 | f/4.0 for 1/200 sec.

PLAY WITH THE LIGHT

Each type of light has its own strength, often conveying a certain sort of emotion. With practice, you'll become skillful at using the light you have to your advantage.

When shooting portraits, *sidelighting* can be used to create soft shadows that define the subject's features and reveal character and personality. To get sidelight, place your subject near a window and photograph him with the light at a 90-degree angle to your line of sight.

For a more flattering light—especially for adults who may not want that much definition—use *frontlight*. Keep the light source behind you and shoot toward the subject to produce a nice flat light. Placing your subject in an external doorway is ideal for this, as your subject will be protected from direct sunlight by the roof over her head.

A third type of light, *backlight,* can be used to create glowing images, like the ones on pages 56–57. To get backlight, place your subject with the light behind him. This means you'll be shooting into the light, which creates a glow around the subject and draws attention to it. Backlighting creates a very flattering, even light, especially when the foreground is open and acts as a natural reflector. You may want to use some sort of bounce to reflect even more light onto the subject (see page 51 for more on bouncing light).

The one thing to know about backlighting is that you need to expose for your subject, not the background. You may need to use a Spot meter (see page 25), so you can base your settings on the light meter reading for the subject instead of the sky behind her. Because the background will be overexposed, you will lose some of what your eye sees there, but that is part of the charm. Shooting at maximum aperture (low f-stop) helps blur the background and lets the loss of detail create a dreamy mood for the image.

For a more dramatic image, take backlighting to the extreme and shoot a silhouette. This is when the shape of the subject is black against a bright background. Silhouettes are great for showing mood or getting artsy; just make sure the outline of the subject is completely visible and identifiable or it may look like a black blob. The best times to shoot silhouettes are sunset and sunrise, when the light is bright and low. For a silhouette, unlike other backlighting situations, expose for the background and not the subject. It also helps to use a small aperture, like f/22. You can bump up the colors in the background and deepen the contrast with postprocessing.

P I took these two head shots at the same time and in the same general area, but with different lighting approaches. The shot below is sidelit, accentuating the subject's features and creating dimension. The shot at right is frontlit; the subject was placed at the edge of open shade with a high sun reflecting off the ground onto his face, providing a clean, bright, even light that flattens features and draws focus to the eyes.

▲ Canon 5D with Canon 24–70mm F2.8 L lens at 70mm | ISO 250 | f/2.8 for 1/640 sec.

▲ Canon 5D with Canon 24–70mm F2.8 L lens at 70mm | ISO 250 | f/2.8 for 1/500 sec.

P Filtered light streaming in through the windows behind Rachel's twins made a perfect backdrop to capture their excitement at a tasty treat. A large white kitchen in front of the babies acted as a natural reflector, creating the creamy skin tones.

▶ **Canon 5D with Canon 24–70mm F2.8 L lens at 24mm | ISO 800 | f/3.2 for 1/250 sec.**

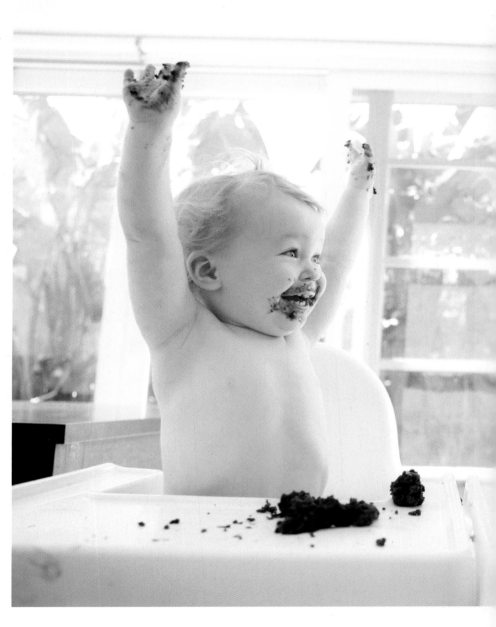

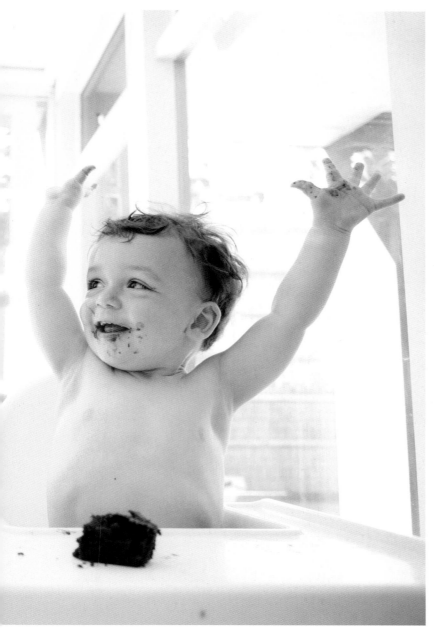

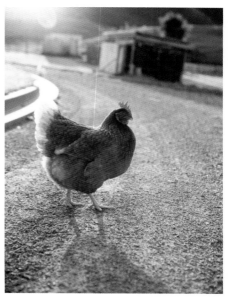

P I was walking down my neighbors' driveway after photographing their granddaughter when a friendly hen showed interest in my camera and started parading back and forth in front of the lens. The golden hour backlight added a touch of magic to the moment.
▲ **Canon 5D with Canon 24–70mm F2.8 L lens at 24mm | ISO 250 | f/3.2 for 1/400 sec.**

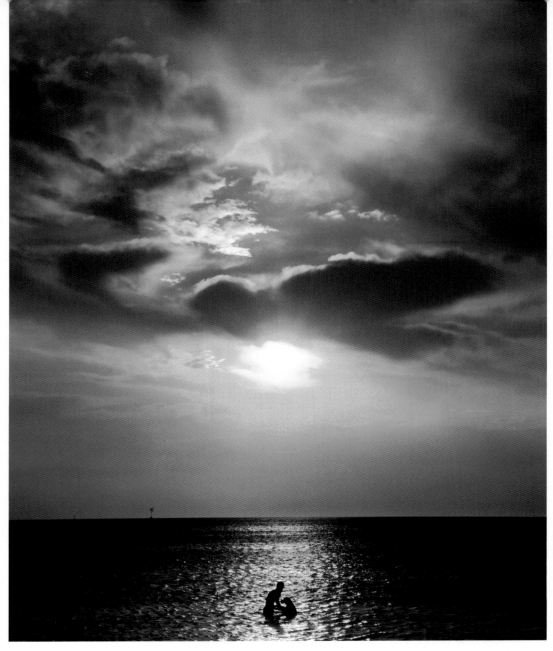

Sunset on New Year's Eve in Australia is a perfect time to go to the beach, the weather usually warm enough for a swim. By moving just a bit, I was able to get this dog and his owner directly in the orange light of the setting sun. A small aperture of f/18 ensured a deep depth of field. The image would not be as powerful if the silhouetted figures were not clearly defined.

▲ **Nikon D100 with Tamron 17–50mm F2.8 lens at 50mm | ISO 200 | f/18 for 1/200 sec.**

LENS FLARE

When you photograph your subject in backlight, with the light behind him, you may encounter lens flare. Lens flare is the term for those sunburst or star shapes you sometimes see when people shoot into the light. Some people go to great lengths to avoid lens flare, but many of us have embraced the magical mood flare can create.

If you want to avoid flare, invest in a lens hood or cup your hand over the lens while shooting. If you would like to encourage flare, try shooting when the sun is low and shoot directly into the light. This is not the same as shooting into the sun—you want to be at a slight angle to the sun, or have your subject blocking the light. What you're trying to capture are the rays, not an actual image of the sun.

You will need to expose for your subject and accept that much of the background will be thrown into white, and you'll probably end up using a fairly small aperture. (Remember: A large amount of light calls for a small aperture.) Because the camera has trouble focusing when shooting directly into light, you may need to switch to manual focus.

You should be able to get an idea of the amount and intensity of flare when looking through your viewfinder. Change your angle until you are pleased with the results, and shoot a lot. Flare is unpredictable—for every image with great lens flare, there may be at least fifteen that did not work.

You can also position your subject with the light just behind her and then move to the left or right slightly until the light peeks out, and you can catch that star glow in addition to the flare. Play around and have fun, but please protect your camera and your eyes and don't shoot directly into the sun. The sensor (and your eyes) can be damaged by this sort of exposure.

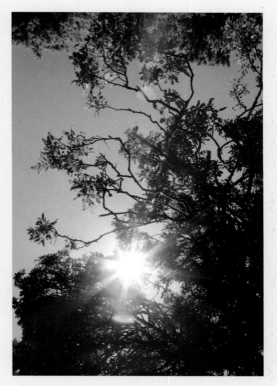

P I took this shot while lazing under a tree during a picnic—it was all about capturing a feeling of peace and the warmth of a spring day. To photograph lens flare, use a small aperture to define the rays of sunlight. Here, I used f/13. Even a millimeter's movement can make the difference between a blob of light and starry rays.
▲ Canon 5D with Canon 24–70mm F2.8 L lens at 28mm | ISO 800 | f/13 for 1/800 sec.

chapter three
NOW SHOOT
SOMETHING

You have some working knowledge of what your camera can do and how to make it happen. You've become friends with light of all kinds and you are ready to go—there's a big, wide world out there for you to capture! We know you may be chomping at the bit, but before you head out, there are a few more things to talk about to give you your best start.

GET INSPIRED

With your camera now ready, it's time to start thinking about what to shoot. How do you see the world, and how do you want to share that vision in your images? These days, people grow up with cameras, and it's easy to assume you just pick it up and press the button. But while most of us are used to having cameras around, few spend much time really *looking* at photography. Many people can't identify what is "wrong" in a photograph, even if they know it is not right. At the same time, people know what they like, but often can't translate that into their own images.

We encourage you to keep a visual journal and start compiling things that inspire you. Rip up magazines, collect images (not just photographs), and start to learn what colors go together, how lines work to direct your eye, what to include in a shot, and what to leave out. Learn to *see* photographs. Analyze your favorite music and books to see if there is a certain tone or genre that resonates with you. Research master photographers from ages past and find your favorites. What about their work ties them together? You will start to see many different themes arise and can start looking for those elements of color, tone, and subject in your daily life. Soon you will start seeing them everywhere, and before you know it, you will be developing your style. As you come across images that speak to you on the Web, collect them as eye candy on boards you create with Pinterest (www.pinterest.com). Not only does Pinterest let you save all the wonderful things you find, it allows you to discover so much more by following the boards others create.

Of course, you must keep working on getting to know your camera, the controls, and the technical details of making a photograph. The more these become second nature, the more you will be able to concentrate on composition and creating great images. It is surprising how many people expect to get great shots the first time they pick up a camera. When this does not happen, they feel disappointed and frustrated. But anything worth doing well takes practice. Think of photography as an evolving practice, a new habit to foster and grow.

If you get stuck for what to shoot, go for a walk with your camera and take photographs of the world around you—shadows, details, and light. Try shooting the same subject with different lenses. If you only have the one lens, try renting others for a reasonable fee. This is a great way to start seeing things around you in a new way.

Don't spend too much time dwelling on photography blogs or trying to re-create other photographers' work. You want to develop your own style, not find a style to copy. Never worry about competing with other photographers or comparing your images. It doesn't matter what anyone else is doing as long as you keep on making images for yourself. Confidence is key, but you are only as good as your last image, so keep taking photographs.

R — Kids are full of unconstrained energy. Encourage them to be themselves, then step back and capture their enthusiastic antics. I chose a neutral location and clothing beforehand to make sure this image would not be visually busy, so the viewer could really see the personality of the boy. To me, this is real life, and recording real life is what I think of as my style.

▼ Nikon D200 with Tamron 17–50mm F2.8 lens at 32mm | ISO 400 | f/4.0 for 1/200 sec.

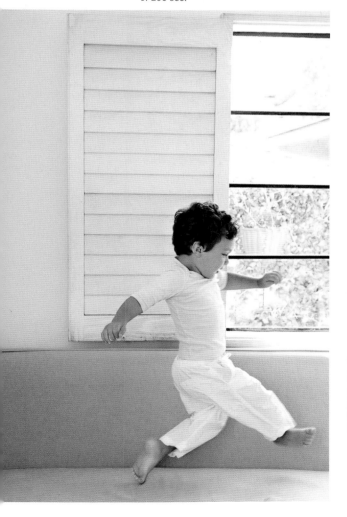

AN INSPIRATION JAR

A great thing to do is to start an idea collection. Fill a bowl with words that are cut or ripped from magazines and other publications. Since the words are from different sources, they almost always have colors in the background. When you feel stuck on what to shoot, put your hand into that bowl and pull out a word. Then create photos or a photographic story around that word and the colors that came with it.

R — This jar of word cutouts sits on a table ready to inspire. New selections are added regularly as old magazines get recycled.

▲ Nikon D3 with Nikkor 50mm F1.4 lens | ISO 250 | f/1.8 for 1/500 sec.

FOCUS

What to focus on, how to get it in focus, and where to place it in the frame sound like simple concepts, but they are your main tools as a visual storyteller. As you develop your style, you will find ways of using these tools to reflect your own photographic sensibilities. For now, we'll just cover the basics of focus and composition.

By choosing your point of focus, you draw the viewer's attention to the most important aspect of an image. Focal points are like pins in a road map, telling people where to stop and look. If you look in your viewfinder, you will see a grid of rectangular brackets. The rectangles are the focal points of your lens. You will use those to tell your camera where to focus.

You may remember how it was to focus a film camera—using the ring around the lens to zero in until the image was clear. Though that is still an option, these days most people using digital cameras rely on autofocus, one of the few automatic settings we heartily endorse. We're going to walk you through the three main ways of using autofocus: single point, continuous tracking, and closest subject. There is usually a lever or switch on the front of the camera near the lens with M (manual), S (single), and C (continuous) options, so you can easily choose your focus method. Different camera manufacturers use slightly different names, but the concepts are the same.

P This photograph shows a young friend waiting for her father to return home from a military assignment in Iraq. I focused on the girl's pensive face, while the windblown flag partly obscured the scene and added layers to the shot.

▲ Canon 5D with Canon 24–70 F2.8 L lens at 24mm | ISO 100 | f/4.0 for 1/1250 sec.

Single-point focus let's you tell the camera what exact spot you want it to focus on—on a flower, perhaps, or the face of a friend. To use single point, look through your viewfinder and place the rectangle over whatever area of the subject you want in focus, then press the shutter. You can use your menu settings to change which rectangle is the focus point—center, side, top, or bottom.

What if you want your focal point to be in a different spot than where the rectangle is? Some people use a method called *focus and recompose,* where they place the rectangle over the point they want in focus, press the shutter release button *halfway* down to lock the focus, move the camera until the subject is where they want, and press the shutter button the rest of the way to take the photo. While this is an easy habit to fall into, we recommend manually changing your focal point using the menu options instead. With focus and recompose, the focus tends to be less accurate. It takes some getting used to, but learning how to switch focal points is a good skill to have. Most cameras have a button that allows you to do this easily.

P This illustration shows an overlay of the Canon 5D and its focal points over the resulting image. I wanted the baby's face in focus, so I started by choosing the closest focal point (highlighted in red). It wasn't exactly on the baby's face, however, so I moved my camera until it *was* on her face and pushed the shutter halfway to lock the focus. Then I recomposed to frame the photo as I wanted, and pushed the button the rest of the way to take the shot.

▲ **Canon 5D with Canon 24–70mm F2.8 L lens at 59mm | ISO 1250 | f/3.5 for 1/200 sec.**

Continuous focus is a practical choice for sports shooting as it allows you to follow a moving subject with the focus locked on. If you forget and leave it on all the time, you may miss a shot when the camera accidentally "tracks" an object as you focus elsewhere.

Closest subject focus is what we like to call point-and-shoot mode. Instead of you picking your point of focus, the camera will focus on the subject closest to the lens. We don't recommend this option, for the same reason we don't recommend you shoot on auto. You might get a result you like, but it's luck of the draw. It's so much better to be in charge of your outcome. This can be set with an external lever on some cameras or in the menu options.

P I used the continuous focus setting while photographing this dad pushing his daughter around on the bicycle, which helped me capture shots as they quickly moved through different focal planes.

▲ (left) Canon 5D with Canon 24–70mm F2.8 L lens at 30mm | ISO 200 | f/4 for 1/250 sec.; (right) Canon 5D with Canon 24–70mm F2.8 L lens at 43mm | ISO 200 | f/4 for 1/250 sec.

R Shooting through objects in the foreground is one of the most common times that you will need to switch to manual focus. This shot of my daughter on a trampoline was impossible to achieve without manual focus as the camera kept getting confused by the netting. I focused on my daughter, throwing the foreground out of focus.

▶ Nikon D3 with Nikon 50mm F1.4G lens | ISO 320 | f/5.6 for 1/320 sec.

R These shots of siblings are a good example of single-point focus. In the first shot, I focused on the little boy's eye. As his sister pulled away, I was able to quickly focus on his smile, since the focus point was still set to that area of the frame. This series was then processed into black and white to keep it simple, so the expressions took center stage.

◀ Nikon D3 with Nikon 50mm F1.4G lens | ISO 800 | f/2.2 for 1/250 sec.

COMPOSE

Now that you know how to focus, you need to think about composition. There is more to composition than just centering the shot and pressing the button, and yet composition is regularly overlooked. Most people use the camera to record what they see, but composition is where you can play and be creative, knowing that the choices you make will impact the emotional content of the image. Where you place a subject in the frame can impart power or instill a sense of vulnerability. This is where you get to make artistic choices, to craft a shot to your liking. Here are some easy ways you can play with composition.

Place your subject off center. Imagine there is a tic-tac-toe board over your viewfinder; the most compelling images are made when the subject is placed where those lines intersect. This is called the *rule of thirds*. For years painters and other artists have known that placing your subject in one of these four intersections will create a composition that is balanced and pleasing to the eye.

Center your subject when it works. While the rule of thirds is generally the most reliable way to create an interesting composition, there are times when a centered composition works better. Often this is true with images shot from a distance, where you can center a faraway subject to help it dominate the scene and create a sense of balance, or with extreme macro (very close-up) shots. Don't let the rule of thirds scare you away from centering your shot if the image is more powerful that way. Ultimately it's your eye and style that should be your guide.

Use leading lines. A great way to draw attention to the subject of your shot is to place the subject at the end of lines that already exist in the scene. The lines of the background or foreground will lead the viewer's eye right to your subject. Make sure you scan your shot with a critical eye, because you do not want the lines to look like they are growing out of your subject's head. The key to this technique is careful placement of the subject in relation to the lines.

R This unusual butterfly stayed absolutely still as I came in close with my macro lens. To separate it from the busy background, I framed it just under a line of blooms at the top and between flowers on either side. Putting it right in the middle of the frame gave the tiny creature stature.
◀ **Nikon D100 with Nikkor 60mm F2.8 lens at 60mm | ISO 200 | f/9.0 for 1/320 sec.**

P This photo of Rachel's son was taken at the home of her stylish best friends. I anchored Kieran on an intersecting point on the grid to draw the eye to him in such a busy scene.

◀ Canon 5D with Canon 24–70mm F2.8 L lens at 24mm | ISO 1000 | f/2.8 for 1/200 sec.

Make the most of natural frames. Like leading lines, natural frames are elements that exist in the scene already and can be used to highlight your subject. While leading lines draw your eye directly to a subject, a natural frame will fall around your subject to, well, frame it.

Leave something to the imagination. You do not need to include everything in an image to tell your story. Even portraits can be elevated from mundane to iconic when they are created without actually showing someone's face. Give enough information to set a scene for a story, and then leave enough out to let viewers imagine their own ending.

Let your subject breathe. While beautiful close-ups definitely have a place in your photo collection, don't forget to step back sometimes and let your subject breathe. White space and negative space are terms used in design and photography for the space around the main subject in a composition. If you are using the rule of thirds, try placing white space in front of your subject, in the direction they are facing, for the most pleasing composition.

P This shot of my sister being goofy with a flotation ring shows how using a frame within the composition can help draw the eye to the subject.
▲ Canon 5D with Canon 24–70mm F2.8 L lens at 60mm | ISO 100 | f/4 for 1/1250 sec.

R Not every portrait needs to show a face for impact. This shot of a busy toddler's legs and feet rounding the stairs suggests a universal moment most parents can relate to.

▼ Nikon D3 with Sigma 24mm F1.8 macro lens | ISO 1250 | f/1.8 for 1/160 sec.

R Horizontal fence posts draw the viewer's eyes right into the frame, leading directly to the little girl.

▲ Nikon D100 with Nikkor 60mm F2.8 micro lens | ISO 320 | f/3.2 for 1/1000 sec.

P The evening I shot this was so peaceful and still, and the sky such a lovely pastel hue, that I wanted to capture that feeling of calmness in a photo. The red of the little girl's dress and balloons, along with her strong pose, helped anchor her in the huge space. I took this from halfway down a small hill, with the subject standing above me at the top.

▲ Canon 5D with Canon 24–70mm F2.8 L lens at 50mm | ISO 400 | f/4.0 for 1/250 sec.

The shallow depth of field combined with a reflection on the table transform this tiny glass sculpture into a strong subject.

▲ Nikon D3 with Nikon 50mm F1.4G lens | ISO 500 | f/1.8 for 1/200 sec.

Here is another example of how giving the subject space in the frame can help make a photo interesting. As with the example above, the elements in the photo need to be simple to pull off a faraway shot. This photo is mostly just two colors. Placing the subject around one of the intersecting points on the rule of thirds grid helps draw the eye to her.

▲ Canon 5D with Canon 24–70mm F2.8 L lens at 60mm | ISO 100 | f/4 for 1/1250 sec.

Look for reflections. Look for reflections and patterns in your shots. If you are using a reflection purposefully, it is best to include the entire reflection in your image. Cropping off before the reflection is complete takes away from its power as a compositional element.

Use odd-numbered subjects. According to the rule of odds, it is more interesting to use an odd number of subjects in an image than an even number. This is because using an odd number creates a dynamic composition and keeps the eye moving around the image. Humans are naturally and subconsciously drawn toward pairing objects. Once all elements within an image have been paired, the image becomes static.

Think outside the rectangle. While your DSLR camera will capture every scene in a standard rectangle, there is no reason you need to stick to that format as you take the image into your editing software. Square crops are a wonderful alternative to the norm. Rachel's favorite film camera is a medium-format camera called a Hasselblad, and all of the images it produces are square. You can add a retro quality to your image by simply cropping it to reflect the old-style medium-format or Polaroid film.

P The bold colors of these clementines went so nicely with the pale aqua of the bowl and tablecloth. A simple composition of just three pieces of fruit was enough to make a striking, graphic photo.
▲ **Canon 5D with Canon 24–70mm F2.8 L lens at 62mm | ISO 200 | f/2.8 for 1/250 sec.**

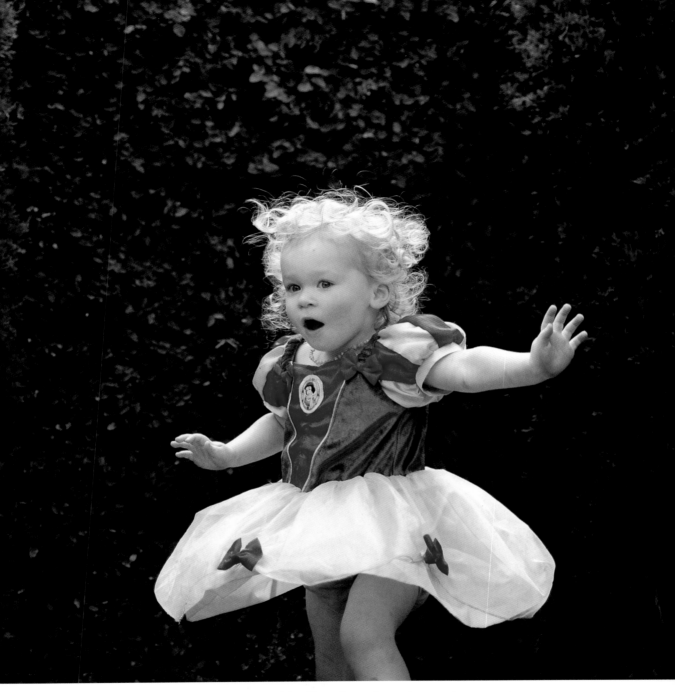

R This image was taken while my daughter, Clover, jumped on an in-ground trampoline. I cropped out the bottom and top of the shot so the trampoline and edge of the bushes were no longer visible, creating the effect of a little fairy tale princess floating mid-air.

▲ Nikon D3 with Sigma 24–70mm lens at 56mm | ISO 800 | f/4.2 for 1/1250 sec.

WHAT *NOT* TO DO

Sometimes we need to see the bad to recognize the good. To help illustrate this we have compiled our very own list of composition "don'ts," or, as we like to call them, "Mistakes People Don't Know They Are Making."

Tilt the horizon. Quite often we come across shots that actually make us queasy—photographs where the horizon line is slanted diagonally across the image. This is so disorienting that we have to look away to get our bearings. This cockeyed horizon is called a *Dutch angle*, and it is used to impart anxiety in an image. It can be a useful tool in the right

circumstances, but to photograph your friend or a peaceful family scene and use Dutch angles introduces a subtle note of chaos into the image. If there are trees or light posts in the background, they should not be pointing off in awkward directions. If something is straight in nature, it most often should be straight in your shot. Merely tilting your camera with no other purpose than "trying to be different" does not make an interesting photograph. A slight tilt will not make your subject look like it's going to slide off the planet, but reserve Dutch angles for images that warrant it.

Use train tracks and other dangerous settings. We get it—train tracks are leading lines, but think twice about using them to frame your portraits. Even when they are rundown and not in use, viewers feel uncomfortable when a subject is put in a dangerous situation for a simple portrait (for example, on a road, in front of the tires of a tractor, on the hood of an old rusty truck with a cracked windshield). It does not work, especially for small children. Now if it is a story about tough times or a war-torn country, then there is merit in the setting.

R This is a perfect example of an inappropriately tilted horizon. The scene is a peaceful one where my daughter is just strolling along. The angled horizon line adds a feeling of disequilibrium and tension, not interest. ◀ **Nikon D200 with Tamron 17–50mm F2.8 lens at 17mm | ISO 250 | f/16 for 1/250 sec.**

Follow the 5-foot-5-inch phenomenon. If all of your photos are taken at the eye level of the photographer, they will all look the same. This could be the four-foot-eleven or six-foot-three phenomenon, depending on the photographer's height—the point is, they are all the same and this gets dull. Get down low, stand on something, change your perspective, and immediately the image becomes more interesting.

Stand far away. All too often the photographer stands at the edge of the scene and takes every single one of his shots from there. As a result, images are busy and boring. Don't just stand on the sidelines—get in close and really capture the shot. A photographer has to engage with the subject. This is not a spectator sport.

Use too many props. Old suitcases, balloons, antique bikes, rain boots, flowers, a sofa in a field—it can all add up to too much. Over-reliance on trendy props can quickly make your images look dated. Then again, one single prop can be the absolute perfect accessory for your visual story. If you are going for a look, keep it simple. Can you take something out of the photograph and still make an interesting image? Some of the most arresting photographs have no props at all.

A great photographer is also a great observer. If you learn to look at images, you will begin to see the pictures while you are shooting.

P The first natural approach to photographing a scene is to hold the camera in a landscape position and shoot straight on, as in the first photo. But notice how much more interesting things become when I turn the camera to a portrait orientation, get in close, and bend down to the dog's eye level.

▲ (both images) **Canon 20D with Tamron 17–50mm F2.8 lens at 50mm | ISO 200 | f/2.8 for 1/640 sec.**

COLOR THEORY

Colors set a mood to your shot, and knowing how to use color to create the feeling you want is a good trick to have up your sleeve. The best way to learn the different color schemes and how they function is through studying a color wheel (shown below). Each color has its opposite (also called *complementary*), which lies on the other side of the color wheel. Below, for example, the "opposite" of red is green, the opposite of orange is blue. Next to each color is its closest relative. Now, let's look at how we can use these colors to impact mood and emotion.

There are three main color schemes:
Monochromatic. This calm, soothing color scheme is made up of different tones and tints of one color.

Complementary. Contrasting and vivid thanks to the use of colors at opposite sides of the color wheel, this color scheme creates an intense aesthetic even at low saturation. Advertisements often use complementary colors as they are eye-catching and energetic.

Analogous. The colors in analogous color schemes happily sit next to each other on the color wheel and can give a natural, harmonious look to your photos.

A color wheel is a great tool for learning about color schemes.

P Monochromatic color schemes may be less punchy than those using multiple colors, but the simplicity of a single color can be beautiful and soothing when used well.
▲ **Canon 5D with Canon 24–70mm F2.8 L lens at 70mm | ISO 320 | f/4.5 for 1/250 sec.**

R If a monochromatic color scheme is calm and soothing, a complementary color scheme is its crazy cousin.
▲ **Nikon D200 with Tamron 17–50mm F2.8 lens at 50mm | ISO 320 | f/2.8 for 1/250 sec.**

There are other color schemes as well:

Square. Square color schemes have four colors evenly spaced throughout the color wheel (like a square). This is another punchy, vibrant color scheme.

Split complementary. This is a variation of the complementary scheme. Rather than selecting the first color's opposite, you use the two neighbors of the opposite, to complement the first color. The effect is similar to the complementary color scheme, but a bit less intense.

Warm and cool. Warm color schemes use any or all of the colors from the "warm" half of the color wheel, which ranges from pink to yellow and are vibrant and energetic. Cool color schemes use the colors that range from violet to green and are calm and soothing. This is why restaurants are often painted with warm colors while institutions were traditionally painted a calming muted green.

R Analogous color schemes like this one happen often in nature.
▲ Nikon D200 with Tamron 17–50mm F2.8 lens at 17mm | ISO 250 | f/13 for 1/250 sec.

P The square color scheme is best executed when one color is dominant, as the red is here. Otherwise, it can lack focus when the colors are more evenly spread out.
▲ Canon 5D with Canon 24–70mm F2.8 L lens at 70mm | ISO 200 | f/2.8 for 1/1600 sec.

R Split complementary color schemes are often more successful than straight complementary schemes.
▲ Nikon D200 with Tamron 17–50mm F2.8 lens at 36mm | ISO 200 | f/4.0 for 1/250 sec.

REVIEW YOUR SHOTS

So you've taken the shot. Now what? Do you find yourself constantly checking the back of your camera to see if your image worked? Reviewing your shots on the LCD screen is called *chimping*. Why chimping? Someone once heard the oohs and aahs of a photographer admiring her own work and thought it sounded like a monkey—or so the legend goes. While chimping is fine to make sure you are on the right track, we do not recommend it after every press of the shutter button. It will not only break the flow of your shoot, but the LCD screen is not a foolproof way to check color and exposure. It's better to rely on other, more technical measures than a quick glance at your shot. The more useful tools on the viewfinder are the *histogram* and the *blinkies*.

The histogram is a graph of the tones in your image. It looks like a mountain range. You can analyze the graph to make sure your image is properly exposed. When the histogram appears in black and white, it represents the entire image. When it is shown in red, blue, and green, it identifies specific problem areas in the individual colors (see page 40 for more about the RGB color space). You can toggle back and forth between the black-and-white and color versions using buttons in your camera's menu display.

If the lines of the graph are all piled on the right side, it means the image lacks information in the highlight areas and is overexposed (a spike on the right in a certain color means the image is overexposed in that color). If the lines are all jammed up to the left edge, you have lost detail in the shadows and the image is underexposed. One giant hill in the middle with the lines not reaching either end means a muddy image. What you want is a nice even mountain range, with peaks throughout. It is beyond the scope of this book to discuss histograms in detail, but you may want to learn more about them, as they can be useful aids.

Many cameras have a second, even simpler, tool at your disposal, often referred to as the "blinkies." You can set your camera so that any overexposed areas of the image will flash red. When you look at your screen with the blinkie option (often called the "highlight warning" option) turned on, you can easily see the warning without having to study the histogram, and you will know you need to reduce the light in the image (by either lowering the ISO, slowing the shutter speed, or decreasing the aperture). Look for the option to turn on the highlight notification system. If your camera has one, it will be in the playback menu.

The histogram for this image shows that the exposure over each of the colors is even; no colors are jutting out away from the gray area. Because the image is made up of almost entirely light content, most of the information is on the right (light) area of the graph. Since there are no spikes on the right wall, however, nothing is overexposed. For images with more tonal variation you would expect the "mountain range" to span across more of the graph, but you still wouldn't want spikes on either extreme end.

In this shot, the over-exposed areas appear red, mimicking the way the "blinkies" look in your camera.

▲ **Canon 5D with Canon 24–70mm F2.8 L lens at 25mm | ISO 400 | f/4.5 for 1/3200 sec.**

KNOW WHEN TO STOP

While you never want to interrupt the flow of a shoot by stopping to chimp after each click, you also do not want to just shoot and shoot with no end. Some people are blessed with the innate ability to just know when they have *the* shot of the day. It is the image that, when you see it through the viewfinder, makes your heart skip a beat. The light is perfect, the emotion is clear, and the timing is just right. There are times when we all have that feeling. Other times, it is too easy to keep on shooting, just in case there are more moments. You need to know when to stop.

In the days of film, we were limited by money and supplies. Overshooting was expensive, so you had to really concentrate on getting the elements of the image right. Because of this, shots were wasted less often. These days, with the near limitlessness of digital, there is a tendency to shoot and shoot and hope for the best. Setting the camera to Sports mode, where the shutter releases continuously, is overkill—unless one is shooting a running toddler, a racing car, or an actual sporting event. Overshooting just creates more work for

KEEP A SHOT RECORD

To avoid overshooting, try keeping a shot record to make notes of lighting and camera settings that worked—as well as those that didn't. Eventually these will become second nature. Going back over the elements of your image at a later date is part of the learning process.

When you have a record to look back at, you can also see what inspires you. Write down the music you were playing at the time, world events that may have been unfolding, or the books you were reading. Think about the emotions you were feeling and put those on paper, too. When you look back at all the information next to the images you created, you will be able to see the major influences and how your style changes according to your situation.

Shot Record

Subject Time of Day

Season Lighting Situation

Settings that worked

Things that didn't work

Mood I was in

Music I have been listening to

Books I've read lately

Recent world events

Other things that have been inspiring me

Let this shot record inspire you to create your own version tailored to your needs.

you afterward, on the computer. It also keeps you from learning what works. Instead, you rely on luck and volume.

Our tip is to stick to the "two rolls rule." Professional 35mm film comes in rolls of thirty-six frames. If you were to shoot two rolls, you would have seventy-two shots before you had to stop. While seventy-two sounds like a lot, you would be surprised how easy it is to end up with three hundred or more images on digital in a matter of minutes. Constraining yourself to those two rolls of virtual film requires you to think about your shots, and it will teach you how to shoot.

R I had imagined the perfect birth announcement shot for our twins. I'd pictured our older daughter peacefully holding her sweetly sleeping new siblings—only the children had different ideas. After trying to get Clover to sleep, or at least not scream, I just had to laugh. Life was chaotic with newborn twins, but we were happy and embracing the crazy. This one image represented our life better than anything else I could create. I had my shot, even if it was not the one I had envisioned.

▲ **Nikon D3 with Sigma 24–70mm F2.8 lens at 46mm | ISO 500 | f/5.0 for 1/250 sec.**

SETTING UP A HOME STUDIO

Are you ready to take it even further? Setting up a home studio does not have to be expensive or difficult. All you really need is a camera and some window light.

If you are just going to be photographing still objects, or maybe even pets, you could create an improvised tabletop studio. Simply set up a table near a window. You can either use a white table, as Rachel does, or purchase white foam-core boards from your local office supply store. (One benefit of the white boards is that they can do double duty as reflectors.) You're going to set up so the subject is facing the window—or is lit from the side, if you prefer. (Backlighting won't work well in this situation.) In other words, you'll be standing with your back to the window, as in the image opposite.

If the table is far enough from the opposite wall, you can blur the wall by using a wide aperture (shallow depth of field) and may not need a backdrop. If you do want to use a backdrop, hanging a sheet between two chairs placed on the table should suffice for a smaller workspace. It's best if you iron the sheet first, as a bit of quick ironing is easier than hours of cloning out wrinkled fabric in Photoshop.

For photographing people, especially the wriggly toddler variety, it is good to have something a bit sturdier than a sheet. There are many lightweight backdrop stands that break down easily to pack away in their own bags. With the addition of a handful of heavy-duty clips and some fabric or paper, you can set up anytime. You can even take the equipment with you to other locations.

There is a huge array of backdrops commercially available in colors to suit every taste and style. You can also purchase seamless paper that comes on rolls to fit the backdrop stand—simply rip off the worn or dirty paper after a shoot and pull down more. It is a good idea to start with a neutral white, black, or gray backdrop, though it can be fun to incorporate color backdrops into your photography to give a modern aesthetic.

As wonderful as commercial backdrops are, you can also pop down to your local craft store and buy fabric to make your own. This allows you to get something unique that really reflects your style. Fleece is a great fabric to start with, as it doesn't show creases like cotton does. Keep your eye out for cheerful stripes and patterns. Retro sheets and wallpaper are also a lot of fun to incorporate into your shoots, especially when the subject is dressed simply in solid colors with some interesting vintage accessories. This is an opportunity to get creative and express your style.

Ideally, your backdrop should be about six to ten feet away from the window, positioned to take advantage of the light. If your house is too dark or cluttered to set up a backdrop, a garage with an open door is often a fantastic place to find great light.

P This is Rachel's simple home studio, set up in her family playroom. The windows provide fantastic afternoon light.

▲ Canon 5D with Canon 24–70mm F2.8 L lens at 25mm | ISO 500 | f/4.0 for 1/200 sec.

P I created a very simple tabletop studio by placing a table in front of a large window, setting two chairs on top, and draping a blanket over the backs of the chairs. The height of the table also kept Annie the pug from running away. (If you do the same, just make sure you have a helper, in case the dog decides to jump!)

▲ Canon 5D with Canon 24–70mm F2.8 L lens at 70mm | ISO 400 | f/3.2 for 1/200 sec.

chapter four

YOU ARE NOT
DONE YET

We find that even the shots that are close to perfect SOOC (straight out of camera) need a bit of work on the computer. We usually fix any color cast, add some light or deepen the darks, perhaps add a twinkle to the eyes, and finish up with sharpening. Other times, we may play with a set of shots for an hour, making the tiniest adjustments. We could write a book on processing alone, so this is just an overview. As your skills develop, you may want to educate yourself further. You can find resources in the back of the book.

WHERE TO START:
SOFTWARE PROGRAMS

Yes, you need an editing program. You really do. Because most digital cameras and computers come with complimentary photo-editing software, many people wonder why they need to buy anything more, but there really is no comparison. Developers have spent years devising programs to manipulate your digital images. If you want to produce the best photographs possible, purchasing a professional program will be worth every penny.

If you are on a PC, it is also a good idea to get some calibration software. Computer screens differ in the way they display colors and brightness; having your screen calibrated means your prints will come out more like you see them on your computer. Mac screens are generally very reliable, though it helps to turn the screen brightness down a bit when editing to combat the fact that prints are never lit as strongly as computer screens are. If your prints are not looking the same as your screen, calibration issues are a good place to start looking for a fix.

In terms of editing programs, what is out there? Here is a list of the main ones, with the pros and cons of each.

NOTE *In this book we will refer to Adobe Photoshop techniques, as that is the industry standard. Most of the adjustments mentioned can also be done in Elements and Lightroom, with some modifications.*

R Editing your images should not be about rescuing them from mistakes, but about enhancing proper exposure. This shot only needed a little saturation bump to bring out the colors of the menu on the ice cream truck.
◀ **Nikon D3 with Sigma 24–70mm F2.8 lens at 24mm | ISO 800 | f/3.5 for 1/640 sec.**

PROGRAM	Pros	Cons
ADOBE PHOTOSHOP *The* program to invest in if you are serious about photography.	› Includes everything you need to edit your photographs › Can run actions	› Expensive › Complex to learn on your own
ADOBE PHOTOSHOP ELEMENTS The best program for beginners.	› Low price › One-click editing for beginners › Full editing features for intermediate users	› Clunky interface › No curves adjustment
ADOBE LIGHTROOM The do-it-all program and favorite of most professionals	› Simple one-page editing layout › Full featured editing for raw and JPEG files › Easy to build web galleries from your files	› Confusing organization of files › Does not allow you to edit in layers › No adjustment masks
PICNIK Straightforward and free; great for beginners	› Free › Pulls images from your existing online accounts › Allows you to edit directly from Flickr, Facebook, Picasa, Myspace, etc. › Easy to use › Includes lots of effects, from text to textures, which are frequently updated › Low-cost option for premium features › Printing options	› Limited functionality › Easy to overdo the effects
GOOGLE'S PICASA Another great, free program for beginners with the added benefit of online image storage.	› Free › Great organization tools › Runs in the background › Easily allows for uploading to a Google account › Make easy photo projects › One-click controls for printing and blogging › Shows the histogram of image › Simple tools for simple edits	› Heavy-handed effects › Basic editing tools are too basic
iPHOTO This free program comes with every Mac computer.	› Allows you to sort, edit, share, and order prints › User-friendly and simple › Offers rotating, cropping, automatic enhancements, red eye reduction, retouching, effects, and adjustment panel › Adjustment panel is a great simple tool (definitely use this over "enhance") › Allows you to adjust brightness, contrast, saturation, temperature, tint, sharpness, straightening, exposure, and levels (all quite effectively if "eyeballed" and not technically measured) › Can edit in full-screen mode › Zooming in and out is easy	› Comparatively low in features and control › Enhance, red-eye, and retouch tools aren't great › Doesn't appear to have a "save as" option, so original files are overwritten with edited ones

ORGANIZE YOUR WORKFLOW

Before you start thinking about processing, or editing, your photos, it's good to consider how you want to organize your workflow. The more you shoot—and we hope that you shoot a lot—the more important it becomes to have a system to keep your images organized and backed up in case of hard drive failure. You also want to be able to find certain images in the future, when you have thousands to choose from.

We average about forty-five personal photos a day. Some days we shoot two hundred, other days we don't shoot at all, but in the end it is still a lot of photos. For every photograph we blog or share on social network outlets, there are three more that are processed and saved. While we would love to load the images and sort and process our picks all at once, our busy lives mean nothing gets done without interruption. Because of this, we have a system that allows for the pauses we all must take throughout the day. Here's how we organize our workflow.

1. Download the images. At the end of each day, we load the images from our memory cards onto the computer using a card reader (see page 39).

2. Organize the images. We then organize the images in a filing system. We use Adobe Lightroom to keep our files organized, but Adobe Bridge offers similar features and is also good. We put the files in folders named with the date and/or a short description of the shoot or day. Those are our individual project folders. If we are shooting both raw and JPEG, two subfolders go inside each individual project folder—one for raw, one for JPEG.

3. Back up the folder. Before we reformat our cards (which we do each time we put them back into our cameras), we copy the new individual project folder onto an external hard drive for backup, to make sure we have two reliable copies of whatever we are about to erase.

4. Select which images to edit. We then use the starring feature these programs offer to select which photos to edit. We give five stars to the photos we want to work on; the others stay at zero. To star a photo, you select the photo you want and hit the "5" key on the keyboard. When we're done, we choose a filter to show only the starred photos, select them all, and move them to another subfolder called "Photos to Edit." When we start to edit, we work on a copy of the original file, just so we have an extra.

5. Edit the photos. We'll talk about this step separately on pages 92–99.

6. Back up again. When we're done editing for the day, we replace the original folder on the external hard drive with one containing all the unedited and edited photos and then delete it from the laptop. We also upload the final full-resolution JPEGs to a private site online for additional backup. In case of emergency, we will at least have the edited JPEGs.

One of the things I remember most about Venice is the laundry hanging over the canals. By using Adobe Bridge's star system, I was able to quickly and easily pick my favorite shots from the trip, including this one, to process and share.

◀ Nikon D3 with Nikon 24–85mm lens at 72mm | ISO 200 | f/4.5 for 1/500 sec.

EDIT YOUR IMAGES

Photo editing is a huge topic, worthy of a couple of books at least, and you may well be learning about it for the rest of your photographic life (we sure are). Here we are only scratching the surface, giving you a working knowledge that will help you tighten your shots.

There are some drawbacks to easy at-home editing, however. Many photographers go overboard. We encourage you to keep your processing natural and avoid what we call the "overs": oversharpening, oversaturating, overediting, and oversmoothing. Good editing takes advantage of the tools at our disposal but doesn't abuse them. We'll show you how. Here is a sample of our normal editing workflow.

1. Eyeball the image. Open the image in your editing program and examine it. Make a mental list of all the faults that need to be adjusted. Look for problems with exposure and color cast, crooked horizon lines, background distractions, blemishes, and spots from dust on the sensor.

It is important to get comfortable looking at your images critically. A good way to experiment is to look at some well-edited images alongside your unedited ones. Compare the contrast, lightness, color, and tones. Sometimes it's hard to pinpoint exactly what it is you love about the processing of an image until you pick it apart and look at the individual components.

R I underexposed this image of North Carolina beach houses on purpose to retain the rich detail and color in the storm clouds. Later, on my computer, I brightened the houses by adding a Curves layer (see page 94) and slightly upping the saturation. I then masked the saturation (see page 94) from the sand and sandbags in the foreground to keep them a more natural color. While the goal is to get a perfectly exposed image in camera, sometimes a decision must be made that requires postprocessing work.
▲ Nikon D200 with Tamron 17–50mm F2.8 lens at 17mm | ISO 250 | f/13 for 1/250 sec.

GET FRIENDLY WITH ADJUSTMENT LAYERS

When editing, we always use Adjustment Layers, a feature in Photoshop that allows you to add a "layer" on top of your image and adjust that rather than your original image. This means that if you do something that doesn't work, you can just delete that layer without having to go all the way back to the beginning.

Adjustment Layers is found at the bottom of the Layers window. First, open the Layers window. Then look for an icon on the bottom that looks like a little black-and-white cookie. If you click on the cookie, a pull-down menu will appear with several options. These are what you'll be using to do most of your edits.

Adjustment Layers are your friends. The icon even looks like a yummy cookie, so what's not to love? Click on the little black-and-white circle, and you will be presented with all the different Adjustment Layer options.

2. **Adjust the exposure.** Is the image too dark? Is it a touch too bright? We use a combination of Curves and Levels to adjust exposure, rather than Brightness and Contrast. Both of these adjustment methods are a lot less harsh than the Brightness/Contrast option.

While Curves and Levels both add brightness to a photo, they do so in different ways. Levels adds brightness but no contrast, so the final result tends to be softer. Curves brightens and also adds contrast, which has a stronger impact on the image. We use both options, depending on the situation. Experiment to find what works best for you.

To use Curves, create a Curves adjustment layer by clicking on the Adjustment Layers icon in your Layers window (see sidebar above) and

selecting "Curves." When the Curves window appears, pull the middle of the curve line up until the desired lightness is reached. The opposite can be done to darken the photo.

To use Levels, create a Levels adjustment layer by clicking on the Adjustment Layers icon and selecting "Levels." When the Levels window appears, pull the middle triangle of the first slider to the left until the desired lightness is achieved, or to the right to make the photo darker.

Even if you are not using Photoshop or editing software, we encourage you to read through this so you have an idea of just what is done to an image after it is put on the computer.

This illustration shows how to brighten midtones using Levels in Photoshop. To make your image lighter, move the middle gray triangle to the left until desired brightness is achieved. To darken midtones, move the same triangle to the right.

3. Adjust the contrast. Almost all digital photos need a little bit of added contrast. To increase the contrast in Curves, open a new Curves adjustment layer, then make the line into a slight *S* by lifting the curve up a touch right of center and down a touch left of center as shown opposite. If you'd rather use Levels, open a new Levels adjustment layer, then pull the far-left triangle slightly toward the right, and the far-right slider a little toward the left.

4. Adjust the color. How is the color? Too cool? Too warm? Most of the problems people have with their images have to do with color. Slight color issues are easy to fix if you are able to identify the color that is off. One way to do this is to create a new Hue/Saturation adjustment layer and drag the saturation slider for the Master level all the way to the most saturated. The image will be shown to you in bright color, and you can clearly see what the problem colors are.

From there you have a lot of options. The easiest is adjusting the color balance. As shown on pages 96–97, use the Adjustment Layers menu to select Color Balance. If the color is too cool (blue), pull the sliders toward red and yellow until it looks right. If the color is too warm (red), pull the sliders toward cyan (blue-green) and blue.

Hue and Saturation can also be helpful tools, as you can adjust the tone and saturation of different colors or the image as a whole (see pages 104–105). There are more advanced methods of color correction, including Selective Color and the color adjustment options within Curves and Levels, but we find that they can be confusing for beginners.

5. Straighten the horizon. How's the horizon line looking? We all tend to lean a little to one side or the other, so straightening this up makes a big difference.

The easiest way to do this is by using the Cropping tool, which looks like a dashed square in your toolbar. Click on this icon, then select the image and rotate the cropping tool until it is aligned with your horizon line. You will then need to pull in the outside corners until none of the cropping zone extends outside the frame of the image. You will lose a little of the outside of the image in most cases, but usually it is worth the sacrifice.

6. Clean up the image. Clean up any background distractions around the subject using the Clone tool, which is found in your toolbar and looks like a little rubber stamp. To get rid of facial blemishes and dust spots, use the Healing Brush, which is also in your toolbar and looks like a Band-Aid. To use both tools, select the tool, then hold down the Option key as you click on whatever part of the image you'd like to copy onto the "dirty" area. For example,

to clean up a bit of food on someone's face, "clone" the closest clean area of the face to cover the messy spot. Release the Option key and click on whatever you'd like to clean up.

7. Save your file. If you have the storage space, it is good to save the Photoshop format files at this point. When saving as PSDs (Photoshop Document format files), the layers stay intact. If you want to go back and do something differently, you won't have to start the edit all over again. Once the image is saved, "flatten" the layers (Layer > Flatten Image) to combine them into one single background image.

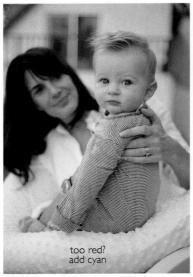

too red?
add cyan

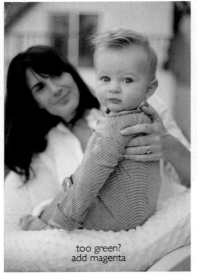

too green?
add magenta

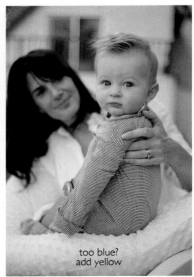

too blue?
add yellow

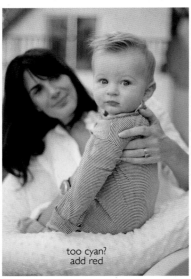

too cyan?
add red

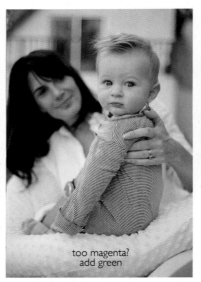

too magenta?
add green

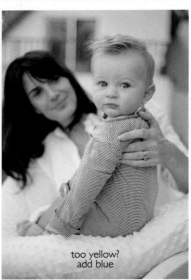

too yellow?
add blue

R This image shows exaggerated versions of each of the possible color casts and what their opposite color is. To fix a color cast, add more of the *opposite* color using sliders in a Color Balance adjustment layer.

R The version here was too yellow, so we corrected it by adding the opposite color (blue) by pulling the Yellow/Blue slider to the right.

R A peaceful scene such as this shot of a secluded resort pier in Belize needs a perfectly straight horizon line.

P In both rows above, the original image on the left is unsharpened. The middle is sharpened just a small amount. The right image is oversharpened, making it look "crunchy" and harsh.

▲ **Canon 5D with Canon 24–70mm F2.8 L lens at 42mm | ISO 160 | f/3.5 for 1/250 sec.**

8. Sharpen the image. We hate to break it to you, but nothing will make an out-of-focus image magically appear in sharp focus. Photo editing has come a long way, but there is still no magic button for that one. What does exist, though, are procedures that enhance the *perception* of sharpness—our favorite is the Unsharp Mask. (As with many things in photography, it has a confusing name: "Unsharp" Mask is a funny way to refer to something that makes an image sharper.) Unsharp Mask is the most common method used, and most editing programs have it as an option. The Unsharp Mask makes an image appear sharper by increasing the contrast at the edges of certain pixels. The increased contrast makes the image appear more defined, and therefore "sharper."

You can find this function by selecting Filter > Sharpen > Unsharp Mask. A dialog box will appear, and you will have the option to change the settings. A good starting point is to set the Amount to 40–50 percent, the Radius from 2 to 3.5 pixels, and the Threshold to 0–10 levels. You can preview your shot in the dialog box; move the image around to check important areas like faces. To avoid oversharpening, make sure the features don't begin to look "crunchy" or take on a jagged appearance. Less is always more, and a good shot should be nearly sharp enough straight out of the camera.

Finally, use File > Save As to save your JPEG with a new name so you don't save over the original image. You can either add "edit" after the image name, or create a new folder for edited JPEGs. If you want to add a special look to a shot, you can do extra Curves, Levels, and Color Balance adjustment layers (see also page 93).

Creating your unique editing style
Everyone is different—that is what makes photography an art form. You get to show the world how you see life through your photographs. The specifics of how you choose to process your images are up to you—this is how you share your vision. How do you see the world? Is it full of hope? Is it exciting? Is it peaceful? Do you want to set a romantic mood with vintage toning, or transform sentimental photos into black-and-white shots with blurred and vignetted edges? There are many possibilities to experiment with.

Think of three words that describe your view of life and see if they match how you present your images. They do not have to define you, just guide you. Another idea we have suggested already is to collect images that speak to you. You can begin to examine these to plan your own shoots, from setup through to processing.

OUR TOP FOUR PHOTO FIXES

The list of issues that can go wrong in a photo is very long, as is the list of fixes. Here are the four we get asked about the most. Working in Layers with Layer masks is an advantage for any photo fix, as you can deal with problems locally. This means you can isolate the problem and work only on that area without impacting the rest of the image.

Enhancing Skin Tones

The best way to ensure correct skin tones is to start by photographing them carefully. First, be sure to select the proper white balance. You can buy gray cards or custom white balance tools to do a custom white balance on a DSLR. Careful exposure is also important. Underexpose and you will get muddy skin tones; overexpose and you will lose details. You want to keep the contrast low. High-contrast images are harsh for skin tones. Lower contrast images keep more detail in the midtones, which is where the majority of skin tones fall. And lastly, always shoot on the lowest ISO possible to reduce noise.

Even with all this, however, you may find that skin tones need adjusting afterward. Here are some basic fixes.

To brighten or darken skin tones, create a Curves adjustment layer (see page 93) and adjust until the skin tones are as desired. Then add a black layer mask (see sidebar, "Working with Layer Masks," opposite) and use a white

paintbrush to paint over the face, hands—anywhere there is skin—to reveal the adjusted layer. Just make sure to watch the contrast.

R Skin tones come in such a range, from the lightest blue-tinged pale pink to the deepest red-toned browns. Good filtered light and correct exposure ensure that this little boy's toasted honey skin is beautifully reproduced.

▲ Nikon D200 with Tamron 17–50mm F2.8 lens at 50mm | ISO 250 | f/5.0 for 1/100 sec.

WORKING WITH LAYER MASKS

Layer masks are essential tools for fine-tuning any adjustment layers created in Photoshop. They allow you to "paint" through a layer, to either hide or reveal whatever is beneath. This means that you can apply Levels, Curves, Color Balance, or any other adjustment to only *part* of an image. Any layer can have a layer mask applied to it.

At the bottom of the Layers window is an icon that looks like a square with a circle in the middle. Clicking on that will add a mask to whatever adjustment layer you have selected. The mask will appear next to the layer thumbnail in the Layers window. Click on the mask and a border will appear around the mask thumbnail. If the mask thumbnail is white, the layer will become opaque, covering all layers below it in the list. If the mask is black, the layer will become transparent and you'll see the layer underneath instead. To switch the color of your mask from white to black, or vice versa, hit Command + I on an Apple computer, or Control + I on a PC.

To work on a mask, use the Paintbrush tool in the Tools palette on the left of your screen. If you'd like to *erase* part of your layer to show the layer underneath, use a black paintbrush on a white layer mask. If you'd like to *reveal* parts of your layer, use a white paintbrush on a black layer mask. It may sound confusing at first, but the ability to "paint" the effects of the layer either on or off an image is the benefit of using layer masks.

To change the style of the paintbrush, use the pull-down menus at the top of the screen. You can set the size and the softness of the edges to suit the area you are going to paint. We like to work with soft brushes so the adjustment is seamless. To choose a white or black paintbrush, note the square of black over white, or vice versa, at the bottom of your Tools palette. To switch between the two, click on the small curved double-sided arrow.

If your contrast is too high, you will get supersaturated, bright areas in the highlights and midtones, while your shadows will lose detail. If you'd like to reduce the intensity of your adjustment layer, simply move the Opacity slider in the Layers window to the left. The Opacity slider appears in the top right corner of any adjustment layer box and determines how strong the effect of the selected layer is. At 10 percent the effect will only be slight, while at 100 percent it will be in full force.

Oversaturation is another common problem. Reds and yellows can get pushed too far, especially when you are trying to "pop" the color of an entire shot. If the skin is too saturated, take the saturation down on just the skin by adding a white layer mask to the adjusted layer and using a black paintbrush to "hide" the skin areas, revealing the original layer beneath.

Lastly, if the noise in your image is high, there are ways to smooth out the skin without

making it look plastic. Try duplicating your background layer (Layer > Duplicate Layer) and applying a light blur to your duplicate layer (Filter > Blur > Gaussian Blur). Add a black layer mask to your adjusted layer and use a white paintbrush to paint over only the skin areas to reveal the blurred layer, leaving things like eyes and hair sharp. There is also software you can buy that will analyze your image and do the noise reduction for you. Examples of this are Portraiture and Neat Image, which can be installed on your computer and accessed through Photoshop. Just be aware not to overdo noise reduction, as it can make your subject look artificial and doll-like. Too much noise reduction on a landscape photo will blend the edges of the details, resulting in a loss of sharpness.

Getting Sparkly Eyes

Sparkly eyes are one of the most common things people ask us about when they want photography and editing tips. Getting sparkly, light-filled eyes is a huge part of making your portraits lively and energetic. *Catchlights* are the highlights you see in the eyes of your subject, reflections of a light source of some kind. Without good catchlights, a portrait can look dull and lifeless.

The best way to achieve great catchlights while shooting is to look for them. As you position yourself in relation to the subject, or the subject in relation to the environment, always be aware of whether there is light in their eyes. If there isn't, adjust their position

R This portrait was taken with the boy standing in an open front door, protected by a covered porch—the perfect place to get a flattering portrait with big sparkling catchlights in the eyes. I used a medium aperture of f/5.6 so the freckles and hair would be in focus as well as the eyes. Even though the eyes are not the only thing in focus, they still pop out because of the light captured in them.

▲ Nikon D200 with Tamron 17–50mm F2.8 lens at 50mm | ISO 400 | f/5.6 for 1/250 sec.

so they are looking more in the direction of a light source or reflector and their eyes are lit and sparkly. Soon this will become second nature. One of the best places to get catchlights is open shade. This is where the subject is in the shade (say, of a building, a doorway, even a baby stroller) but they are looking out onto something that is lit. As long as there's not too much glare, it should work every time.

The other part of getting eyes to look sparkly and alive comes in postprocessing, though for this to work, the eyes need to be well lit to start with. To give them something extra, use layers and layer masks. Bump up the lightness and contrast using a Curves and/or Layers adjustment layer. Then add a black mask to your adjustment layer and use a white paintbrush to paint over only the whites of the eyes and the catchlight, revealing the brighter layer. Be careful not to go too far; a light hand is always the best approach.

Blending two images

What if you edit an image, then later decide you went slightly overboard? You can use Photoshop to blend the original image with the edited image for a more subdued version. To do this, open the original image in Photoshop and create a new layer. Then open the edited image, select it (Select > All), and copy and paste it onto the new layer. Finally, use the Opacity pull-down menu to adjust the layer so the lower image shows through as much as you want.

When editing eyes, be careful of the whites. The whites naturally have a tiny amount of cyan (blue-green) in them and some of the editing adjustments can make this cyan more enhanced and unnatural looking. The best solution, if you are using Photoshop, is to make a Hue and Saturation adjustment layer and select cyan, found in the drop-down menu at the top of the window. Reduce the saturation of the cyan to suit the image (usually around −20, then add about +5 in lightness, and leave the hue value at 0). Then, add a black layer mask to the adjustment layer and use a small white paintbrush to paint over the whites of the eyes. You want to leave the iris alone, lest you change the color of the subject's eyes.

Converting to Black and White

All editing programs allow you to change your images to black and white. Keep in mind that you need to adjust the exposure first, as improperly exposed images can look even worse in black and white, especially those that are underexposed. The images that look best in black and white are simple, uncluttered ones. The more there is going on in an image, the more lost the subject will be without color to guide the eye.

There are different ways to convert an image to black and white. The *worst* way is by completely desaturating the image or swapping it to grayscale. Those two options produce the least-rich conversions. Our favorite base for a black and white is a simple Gradient Map conversion, which is an option in Photoshop and Elements. To do this, click on the Adjustment

Layers menu (see page 93) and choose Gradient Map, then set the colored bar to black and white. It creates a nice balance between dark and light.

If the black-and-white image has a background that's a deeper tone than the subject, try darkening the background further, to help the subject stand out by enhancing the contrast between the two. There are many ways to darken the background, but a simple approach is to use the Burn tool at a low opacity. First, create a copy of your background layer (Layer > Duplicate Layer). Then select the Burn tool, which looks like a hand making an *o* shape with the thumb and index finger, from the Tools palette on the left and "paint" over the section you wish to darken. To reduce the intensity, simply reduce the opacity (shown in the Layers window).

Making Colors Pop

Bright, colorful images are always eye-catching. While you are shooting, keep an eye out for color. Photos that are mostly beige or gray (for example, a beige background, gray carpet, and a subject dressed in brown) will never "pop," no matter how much postprocessing is done to them. You need to begin with an image that has a lot of bright, saturated color—fall leaves, or a colorful summer beach boardwalk. It is all about enhancing the color that is already there.

For postprocessing, we recommend doing all of your brightness adjustments (Levels, Curves, Exposure) and color correction before

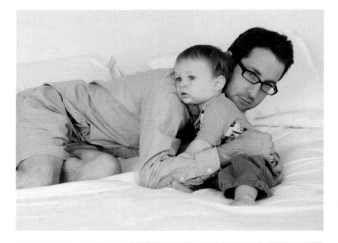

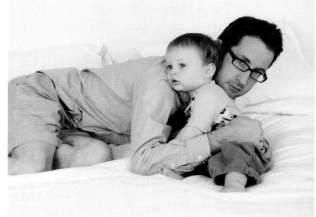

R The first example above is just a grayscale conversion. As you can see, the image falls flat as the white areas of the bed and background all take on a gray tone. The second version has a black-to-white Gradient Map applied to it, giving it more contrast, and the subjects stand out against the pure white surroundings.

▲ **Nikon D3 with Nikkor 50mm F1.4 lens | ISO 250 | f/4.0 for 1/250 sec.**

you start thinking about adding saturation. Colors will naturally become more vivid through these adjustments, and you may find the photo needs little or no additional saturation.

If you decide the photo still needs an extra lift after these adjustments, click on the Adjustment Layers menu and select Hue/Saturation. Slightly increase the saturation by moving the sliders to the right. We recommend going no more than +10 in saturation, and sometimes it's best to adjust each hue separately. If you bump all colors by +10 for example, you may find one or two of them get too saturated, so then you can adjust these colors separately and lessen them until it looks right.

There is a fine line between bright color and overdone color. Our suggestion is to keep things in the realm of reality, even when enhanced. If the grass looks like it's radioactive, the cyans in the eyes are overtaking the whites, or colors are turning into big blobs without details (shadows, tonal variation), it is time to back off the saturation adjustment a little bit. Ideally, you want colors only a little bit brighter than they appear in person.

P Most of the time, a little "pop" is enough. The version on the top is unedited. The middle version shows the image after a slight Curves bump and saturation boost, enough to give it more energy. The version on the bottom, however, has been taken to the point where the skin is orange, the grass is radioactive green, and there are blocks of color that have lost all detail and shading.
▶ **Canon 20D with Tamron 17–50mm F2.8 lens at 17mm | ISO 100 | f/3.2 for 1/400 sec.**

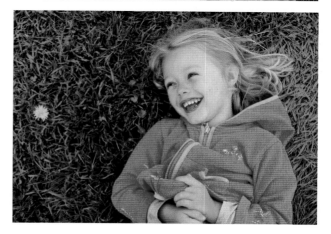

USING ACTIONS AND PRESETS

While we feel strongly that you shouldn't put your camera on auto, there's nothing wrong with using a little automation in your editing, especially once you have a grasp of the basics. That's where actions and presets become useful. Actions can't save a poorly exposed image, so they need to be used to enhance, not rescue, your work.

An *action* is a prerecorded series of processing steps that can be applied to an image at the click of a button in Photoshop (a few actions are also designed for Elements). Actions can create a special effect that changes the look of an image, or make simple routine exposure adjustments. We use actions to speed up and automate processing steps we do on a regular basis—like black-and-white conversions or sharpening an image for print.

Using actions can speed up your processing workflow, as they run through the steps for you. Actions are also a wonderful way to learn about Photoshop, because you can go into the history of the photo and see what the action has done. Actions are also adjustable. You can play with the different steps to fine-tune the look of your image.

You can purchase actions from established photographers who have had a lot of editing experience and have put together actions that harness their skills. These are available online. There are also some available for free, but often these aren't as complete. We suggest you purchase actions only from a photographer who has a style you like, and who lets you see at least a few samples of what the actions do. Only a few people make actions that work on any program other than Photoshop. Be aware of this before you buy.

Presets are settings applied to an image in Lightroom and ACR (Adobe Camera Raw). Like actions, they can range from the most basic settings to stylized effects. The main difference is that actions are applied in layers—which means you can go back, step by step, to see what has been done. You can also reduce the opacity of any layer, if you don't like a certain effect. Presets are applied in one go to an image, so there is no way to track or change certain details.

If you do the same things over and over to your images, such as sharpening them or bumping up the contrast, you can record your own actions or presets and save them to your computer. This will help cut your processing time. If you have a lot of images to do at one time, you can set Photoshop to run a certain action on all of them as a batch and walk away. The files will be worked on and you do not even have to be there.

To record your own actions or presets, open the image you want to work on and make sure the Actions palette is open (find it in the Windows menu). At the top right is a pull-down menu, which will allow you to select a new set

and give it a name. Next, choose "New Action" and give that a name. This will automatically cause Photoshop to record everything you do on that image. When you are finished, press the stop button at the bottom of the Actions palette. You can now use this set of actions on any photo you want.

If you are using Lightroom, apply the adjustments you want to save, then click on the plus (+) button next to the preset menu header. Give your preset a name and make sure to save it.

We both have action sets that can get you started if you are using Photoshop. They are available on our websites (see Where to Look: A Reference Guide, on page 238).

The Actions palette should be displayed at the right of your screen; if it is not there, go to Window > Actions in your top menu. To run an action, click on the little arrow next to the folder name, select the name of the action you want to run, and click on the play button at the bottom of the Actions palette.

PRINT

We are both terrible at printing. We forget to have things printed. Most of our personal stuff will live in digital format forever and never see the light of day. That doesn't mean you should follow our lead. Displaying work you are proud of is a wonderful thing.

When we do print, we love printing on canvas. Images look like art when they are printed large and hung without a frame. You can even combine two shots on one canvas for a beautiful diptych. Just make sure you love the shot, because canvas prints are an investment you will be looking at for a long time.

Another option is having a book printed. We have printed tiny photo books through Flickr's connection with QOOP and found them perfect for handing out as thank-you gifts after the holidays, or as mini portfolios of professional work. We have also used Blurb for our more substantial books. They do a very nice job.

Make certain that whatever you are printing has been sized properly. After you have done your editing, flatten all your adjustment layers (Layer > Flatten Image), and save as a JPEG. When you save, you will be given a dialog box where you can select the quality level—make sure to set it to 10.

For printing, you need to worry about resolution, which is expressed by a term you may have heard: dpi. It means "dots per inch." Obviously, a higher dpi means better image quality. For online use, what you need is a dpi of 72, but for printing you want 300. Anything less will print poorly.

If you are shooting for print, set your camera to shoot at the highest quality image (you can do this in the display menu). There is no way to increase or add dpi to a photograph if it's not there to begin with. You can make an image smaller or decrease the dpi, but not the other way around. If you want to check the dpi on a certain photograph, this information can be found and set in the Image menu (Image > Image Size > Resolution).

R Any large wall in your home is the perfect place to showcase a canvas print. They are lightweight and, when printed as a gallery wrap (canvas wrapped around wooden stretcher bars), are easy to hang as there is no need for a frame.

SHARE

Now that you have images you're happy with, you need to show off your work. Sharing online is the easiest option. Our favorite ways to do this are through the online photo community site Flickr (www.flickr.com) and through blogging, both of which have free options.

The benefit of Flickr is that you can use it as a one-stop shop to store and show off your photos. You can even blog your images from there (by linking your Flickr account to your blog after you have set them both up). You can also print your photographs directly from Flickr, so make sure you upload the full resolution image (Flickr will resize it for you).

We suggest you upgrade to the paid version of Flickr, as you will be able to upload an unlimited number of images and download your full-resolution files. Rachel uploads almost every file she has to that site as an emergency backup option. Since it is online, you will always be able to reach your files, from any computer. You can set the privacy levels to control who can see what, and there is a huge community of people on Flickr who are passionate about photography.

Blogging is another good option. You can add multiple images under one post, add thoughts and words, and share with the world or whomever you choose. As with Flickr, those who see your posts can leave comments about your images and even spark a discussion. You can set up your blog so it is public to the world, or private and viewable only by invited guests.

There are several different blogging platforms out there. Here are a few of our favorites.

Blogger/Blogspot (www.blogspot.com). A great option if you want to create a blog easily and quickly. The basic setup is free and you can customize the appearance and layout.

Typepad (www.typepad.com). A good option if you want to get started quickly but still want bells and whistles. Customization is possible but complicated, so it's a good option for those who just want a blog that works without fussing too much over how it looks. The small monthly fee covers some basic tech support.

Wordpress.com (http://wordpress.com). A free service that comes with three gigabytes of storage, a user-friendly system, and a multitude of free themes.

Wordpress.org (http://wordpress.org). This is Wordpress on your own server, which we both use. This takes more technical knowledge to set up. If it is something you are interested in but you don't know a lot about servers and html, you may want to enlist the help of someone who does. It has a lot of great benefits. Having everything on your own server leaves you in complete control. There are no ads (unless you want them), and the look and layout is completely customizable.

However you choose to share your images, we encourage you to do so. Part of the joy of photography is bringing your vision to life.

PART TWO

LIFE IS A PHOTO OP

Once you have a sense of how your camera works, the real fun begins. We know in the beginning the technical information may seem overwhelming, but with practice you'll be surprised at how quickly it becomes second nature. Soon you won't even think about it, you'll be too busy capturing the world around you. Life is indeed a photo opportunity.

WHAT LOVE
LOOKS LIKE

For us, photography is a work of love. That might sound like a bold statement, but it's true. Whether we are capturing children at play, our friends, our family, or our pets, the images we want to preserve are those that remind us of the people we care about, of the love we have in our lives. For us, photography is a way of celebrating what matters to us, the things that move us the most. In the end, every time we pick up our camera, it's about love. But how does one capture something as amorphous as love? What does love look like?

COUPLES

When people think about capturing love, couple shots are the first things that come to mind. From the romance of young love to relationships that have stood the test of time, everyone deserves portraits that celebrate and capture the essence of their particular relationships.

Often, couples don't have many pictures of the two of them together, as one person is usually behind the camera. Offer to take a few shots of a friend and his partner, or catch a quiet moment between a pair when they are unaware. It might just mean the world to them.

If you are planning a portrait ahead of time, pick a location that is meaningful to your subjects. Perhaps it is where they went for their first date, where they got engaged, or even just the café they visit every Sunday.

It is natural for adults to be self-conscious when their photo is being taken, so give them some direction and encourage interaction. Ask them to tell you a story—perhaps of how they met. You want to do all you can to bring the spirit of their relationship and connection to life. Photos of couples standing side by side and not knowing what to do are always awkward. On the flip side, it can be equally uncomfortable if a couple has their hands all over each other. Couples photography is about finding a happy medium. You want to capture the sweetness, flirtation, and love without it looking like the cover of a cheap romance novel.

Make sure you don't have anyone the couple knows observing your shoot, so they can open up and be comfortable. Get them to cuddle close, but step back and get some full-length shots as well. The distance will highlight their intimacy by giving them literal space in the image. Suggest a kiss by excluding their faces altogether, having them hide behind a big umbrella, or just cropping with that in mind. Sometimes romance is just an idea.

Couple photos don't have to be all about romance. It is also great to capture the laughter, fun, and friendship that is the foundation of love.

R Relaxed occasions can produce candid moments of true love, like this one of my best friend and her husband. This image was converted to black and white to remove the distraction of colors and highlight the connection between the couple.
◀ Nikon D200 with Tamron 17–50mm F2.8 lens at 50mm | ISO 250 | f/4.5 for 1/160 sec.

P This sweet couple was so relaxed, it didn't take much direction to get them to interact in a way that made for some lovely photos.

▼ Canon 5D with Canon 50mm F1.8 lens | ISO 160 | f/2.2 for 1/250 sec.

Get creative with Lensbaby

The Lensbaby system is a series of lenses that let you focus on a small segment of the image, leaving the surrounding area in blur. When used well, they can give a sweet moment some extra magic. This look is especially popular with those who appreciate the more arty side of photography.

R The selective focus created by Lensbaby adds to the intimacy of this portrait by adding a veil of blur over the husband and drawing the viewer's attention to the wife's direct gaze. Little did I know that this couple had a secret at the time of the shoot: They were expecting their first baby.

▲ Nikon D3 with Lensbaby Composer | ISO 500 | f/0.0 for 1/60 sec.

SINGLE SUBJECTS

A single-subject portrait of a friend or family member has the power to illustrate love. With portraits, the end result relies on the relationship between photographer and subject. There are certain expressions saved only for people who are loved and trusted. To shoot a portrait that shows the subject at her most comfortable and open is a coup. It is amazing to look at a photograph someone has taken of a person they love, and to feel the connection—it makes you feel like you are being let in on a secret.

Most adults prefer not to be in front of a camera. The best way to capture real expressions is to make them feel at ease. Be spontaneous and take photos when they are not expecting it. Those shots are often the most telling. If you want a nice portrait of them looking into the camera, try to avoid holding the camera to your face the entire time. Talk to your subject and let him or her see your face. Then, when the energy is right and the moment presents itself, bring the camera up to snap the shot.

There is strength in this direct portrait of the fireman, but the connection he has with the photographer adds gentleness to his face. This is not just a picture of a fireman, but a proud portrait of my brother.
▲ **Nikon D200 with Tamron 17–50mm F2.8 lens at 50mm | ISO 320 | f/2.8 for 1/250 sec.**

AGING: PORTRAITS TO MARK TIME

Creating portraits to mark time can be bittersweet. As hard as it may be to confront the aging of our parents and loved ones, those who desire to document their lives should not let fear stop them. Use that anxiety to create new ways of seeing them, or let the way you frame the shot expose your feelings. Remember to use soft light, which is always more flattering, and look for details. Sometimes a simple shot of timeworn hands says everything.

R Since the loss of my father to prostate cancer in 1999, I have been hyperaware of my mother's aging. It has made me want to create images to hold on to. As I was walking down the hall of my mother's new condo, I caught a glimpse of Mom reflected in a frame on the wall. She looked so small and alone. It was hard to pick up the camera, but I wanted to record all sides of the aging process, including those moments that are not easy to look at. The image suggests a memory, and the framing removes us (the photographer and viewer) from the subject while still creating a moving image.

▶ Nikon D200 with Tamron 17–50mm F2.8 lens at 26mm | ISO 800 | f/3.2 for 1/13 sec.

CHILDREN

The beauty of photographing children is that they are not nearly as self-conscious as adults. There is something so honest and real about little kids. The most real thing is that they don't want to sit still for a moment, let alone long enough for you to get "the shot." There are ways around this, and it's good to have a few tricks up your sleeve. The biggest one is to engage them. Play with them, have fun—make it a game. The more fun they are having, the more likely they are to play along. Sing, tickle, talk about their obsessions, let them do something usually forbidden, like jumping on the bed.

Kids have attention spans as short as their pinkie fingers. Make things easy on yourself and pick the right moment. If they are snotty, grumpy, or overtired, save your camera for another day; nobody wants a photo session that ends in tears. And when it seems as though the end is near, stop while you are ahead to make sure their photo experience is a positive one. If you need to squeeze in more shots, showing the photos on the viewfinder sometimes keeps them engaged a bit longer.

Once they enter school, kids start to become more self-aware. This age can be a real delight to photograph, as they often enjoy the one-on-one attention. Sometimes they can pull "photo faces" though, and getting them to loosen up and be natural is key to producing good photographs. Give them some direction, so they don't feel like you expect them to know what to do. Talk to them about school, movies, books, friends, anything that will make them less focused on the camera.

P I couldn't resist photographing this sweet boy in front of a blue wall—it brought out his eyes so beautifully! I also like the way his fun candy necklace contrasts with his serene, nearly serious expression.

▲ Canon 5D with Canon 24–70mm F2.8 L lens at 70mm | ISO 250 | f/2.8 for 1/320 sec.

R My son found watching himself on the Flip camera almost more fun than running around. Sometimes the reward of seeing themselves is all the little ones need to keep going.

▼ Nikon D3 with Nikon 50mm F1.4G lens | ISO 320 | f/2.5 for 1/3200 sec.

P Shy children can come out of their shells if you get them involved in something other than the photos at hand.

▲ Canon 5D with Canon 24–70mm F2.8 L lens at 35mm | ISO 125 | f/3.5 for 1/400 sec.

P Such a cheeky grin! This age is so much fun to photograph—they love the attention and interacting with you behind the camera. They also tend to laugh at ridiculous things.

▶ Canon 5D with Canon 24–70mm F2.8 L lens at 70mm | ISO 200 | f/3.5 for 1/400 sec.

R I made a deal with this little client that I would take one shot with the face he wanted and then one shot with a smile. He had so much fun making faces for the camera that he would laugh his head off each time, and I did not even need to ask for a smile.

▲ Nikon D3 with Nikon 50mm F1.4G lens | ISO 200 | f/2 for 1/125 sec.

R Tweens can be an elusive bunch, but joking around with my nephew made him more relaxed, and in between goofy faces I caught this moment of calm. Making the shot black and white added to the portrait's timeless feel.

◀ Nikon D200 with 50mm F1.8 lens | ISO 640 | f/4.5 for 1/250 sec.

P This photograph of my cousin was taken in the glowy evening light. I asked him to lean against this rustic fence, as it went well with his vintage T-shirt and haircut. Unlike little kids, preteens need a bit of direction so they don't feel like they have to figure out what you want from them.

◀ Canon 5D with Canon 24–70mm F2.8 L lens at 70mm | ISO 320 | f/5 for 1/200 sec.

P Photographs of smiling subjects are always joyful and fun, but there is something nice about more subdued expressions, too.

▼ Canon 20D with Tamron 17–50 F2.8 lens at 50mm | ISO 100 | f/2.0 for 1/800 sec.

TIPS FOR GREAT PORTRAITS

When we say "nice portrait," we mean something simple and straight that is free from distractions. This allows your subject to be the focus, the center of visual importance. Here's how to go about creating this sort of a setup.

- Place your subject in front of an uncluttered background. Even though the background will be thrown out of focus, crazy colors and mismatched areas of light and dark can still be distracting. Look at your subject through your lens and move yourself to the left or right to see how the background changes.

- Even the clothes your subject is wearing can become a visual distraction. Bright colors and busy patterns should be avoided. If you have time to plan ahead, give them a little guidance on what works best.

- Think about your lighting. You ideally want soft, even light in open shade.

- Shoot portraits with a longer lens, one with a focal length of 85mm or greater. This will flatten the features and reduce distortion. It also allows you to step back from the subject.

- Shoot your subject from slightly above to slim (and get rid of any double chins). If you can't get on something higher than your subject, have her sit. Getting the subject to slightly tilt her head away from the tilt of her hips will create a lovely S shape. Any posing should be natural, however, as the goal is to have a relaxed subject looking her best. Have your subject relax her hands by putting her thumbs in her pockets, and then relax her stance by shifting her weight onto one hip.

- They say eyes are windows to the soul for a reason—focus on them. When the eyes of your subject are in focus, the viewer is drawn right into the image. Use the largest aperture (smallest f-stop) that your lens allows to create smooth "bokeh" in the background (the fuzzy, out-of-focus stuff). For more dramatic, intimate shots, fill the frame with your subject's face.

R I placed this young girl by a window covered in sheer white curtains, which threw soft, even light on her face and bright white catchlights on either side of her pupil. I sat close and used a long focal-length lens to frame the portrait with her gorgeous curls.

▲ Nikon D200 with Nikkor 60mm micro F2 lens | ISO 320 | f/4.0 for 1/200 sec.

P Rachel getting the shot at right. You can see how she and her camera were in the bright sun while the subject stayed just inside the shade of the open doorway.

▼ **Canon 5D with Canon 24–70mm F2.8 L lens at 40mm | ISO 200 | f/4.0 for 1/1000 sec.**

R I took this portrait of a friend while we were out for a photo walk in Melbourne. A greenhouse made the perfect background when thrown out of focus with a long lens and wide aperture.

▲ **Nikon D3 with Tamron 75–300mm F4-5.6 lens at 190mm | ISO 400 | f/4.8 for 1/200 sec.**

FAMILY

The most treasured family photographs are the ones where everyone is relaxed and having fun. Keep the mood upbeat and encourage joking, tickles, laughter, and cuddles. While it is fantastic to have a great shot of everyone looking toward the camera, it is also just as nice to get shots of families interacting with one another.

Get in close and capture expressions and faces, but also step back and take shots that show the family in space. Use environmental elements like architecture and landscaping to guide your composition, and place the family in the frame in a dynamic way. This sort of shot has a timeless graphic aesthetic and is nice printed large, rather than close-ups that can be confronting and easy to tire of when enlarged.

When it comes to siblings, there are generally two kinds—the ones who can't get enough of each other, and the ones who won't touch each other with a ten-foot pole. Sometimes one set of siblings can represent both ends of the spectrum over the course of a single day. If the siblings you are photographing are the cuddly type, get them cheek-to-cheek, arms wrapped around each other. Not only does every parent cherish a shot of their kids being loving with each other, but the intertwined arms creates an interesting composition that leads the eye around each of the siblings. If the siblings are less affectionate, place them back to back to create a strong image of two independent spirits who have each other to lean on.

And don't forget, if you are the family photographer, you need to get into the frame sometimes, too. Set up a tripod and make impromptu sessions a fun activity for the family, or enlist a photo enthusiast friend or extended family member to snap some photos for you.

R While these siblings share quite a close bond, we decided to go with a serious pose to accompany their formal outfits. Posing siblings back to back works well for kids who are not as keen to touch each other. It is a way to keep them connected without forcing affection.
◀ **Nikon D200 with Tamron 17–50mm F2.8 lens at 45mm | ISO 320 | f/3.5 for 1/250 sec.**

P This is a favorite family shot of mine, and a great example of how sometimes the best moments can't be planned, especially when kids are involved! While mom and dad snuck a kiss, the twins stole the show with their antics and cute expressions.

▲ Canon 5D with Canon 50mm F1.8 lens | ISO 160 | f/2.2 for 1/800 sec.

[P] Spacing this architect's family around a graphic space created a dynamic portrait. To pull off a distance portrait like this, give the subjects some direction about placement. To combat the potential for disconnection, I encouraged the family members to interact and focus on the baby.

▼ Canon 5D with Canon 24–70mm F2.8 L lens at 70mm | ISO 100 | f/3.5 for 1/400 sec.

[P] These three siblings had the sweetest bond. They were perfect candidates for an entwined, cuddly portrait. The off-center composition with white space around them highlights the shape they create, and black and white was chosen to add a touch of timelessness.

▲ Canon 20D with Tamron 17–50mm F2.8 lens at 43mm | ISO 400 | f/4.5 for 1/640 sec.

PETS

We can't forget our furry family members—the ones who don't care if we haven't showered for three days and forgive us for missing a walk on a hectic day. They keep our laps warm, and their antics put smiles on our faces. They are often the most willing to sit and pose for us as well. Puppies and kittens are high-energy little balls of fur. Their speed can make it hard to get photographs, but use a high shutter speed and persevere—they have to wear out some time. Animals are never cuter than at that age, and it's nice to have the shots to look back on.

Dogs are suckers for treats; just mention the word and they will work the camera. Make sure you follow through on your promises; they may grow to be your best models. Cats are a bit harder to bribe into performing, but it can be done. Rachel's cat Kiki is particularly fond of lunch meat and will give her a few minutes of camera time when it is thrown into the mix. Be sure to go beyond the straight portrait, too—photograph your pets with their favorite toys and doing their favorite things. Those are the shots that will spark the best memories.

It doesn't end with dogs and cats. All pets—big and small, furry and scaly—are fantastic subjects. If your pet is particularly little, a macro lens is a good bet. Neither of us has come across mice in our travels (except as intruders in Peta's bathroom walls), but we have seen many surprisingly sweet pictures of tiny rodent pets taken with macro lenses.

R One of my last memories of Ozzy and Macgyver, our beloved dogs who we left behind when we moved to Australia, is their exploration of the barn on the farm where they were to live. This shot of them together, standing confidently in their new place, is even more precious because they both passed away less than two years later.
◀ **Nikon D3 with Sigma 24–70mm F2.8 lens at 28mm | ISO 640 | f/3.5 for 1/320 sec.**

R This cat was the kindest stray, and quickly went from being a skittish nuisance to one of the family. She never wanted to come inside, so her feeding was always a front porch affair, often done in pajamas and slippers.
▼ Nikon D100 with Tamron 17–50mm F2.8 lens at 24mm | ISO 100 | f/3.5 for 1/250 sec.

P Just as with humans, different approaches illustrate different aspects of your pet's personality. In the photo of my dog Ruby in the shower, a wide-angle lens and sense of scale shows how tiny and comical she can be. When shooting with a 50mm lens from below, on the other hand, she appears more like the regal creature she is in her own mind.
▲ Canon 20D with Canon 50mm F1.8 lens | ISO 100 | f/2.8 for 1/500 sec.

◄ Canon 20D with Tamron 17–50mm F2.8 lens at 17mm | ISO 800 | f/3.2 for 1/100 sec.

P The relaxed puppy and the hint of a smile from the boy show trust and affection, and the direct gazes into the camera by both subjects make the shot.

▼ Canon 20D with Tamron 17–50mm F2.8 lens at 50mm | ISO 400 | f/4.5 for 1/250 sec.

P Don't forget to get photos of pets and their owners to capture the love and trust animals share with their human counterparts. The expression on my sister's face in this shot shows the affection she has for her horse.

▲ Canon 5D with Canon 24–70mm F2.8 L lens at 50mm | ISO 400 | f/2.8 for 1/1250 sec.

chapter six

MILESTONES
AND FIRSTS

The big milestones in life are when most of us naturally reach for our cameras. In fact, many people buy new cameras in anticipation of the birth of their first child or the upcoming wedding of a friend. Major events remind us that we want to create memories. When beautifully recorded, these memories transform into something special to look back upon.

But why not also record the milestones they *don't* make greeting cards for? Learn to be an observer, recording the moments that define life. A child's first haircut will be in any scrapbook, but the first time your daughter goes to see a movie is another one of the experiences that make your life yours.

WEDDINGS

One of the biggest milestones of all is the wedding of a friend or family member. This sort of event can cause different reactions in budding photographers. Some people go out and buy new and better cameras to help them record the day. Others want to leave their good camera behind—it's big and bulky, and there will be an official photographer on duty anyway. A few people may be asked by their friends to photograph the day, either as the main photographer or as backup. The more your skills develop, the more likely it is that you'll be asked to help with photos.

For those tempted to leave the DSLR on the shelf, we hope you don't. Having a nice camera bag that doubles as a purse can help deal with gear issues, and there is so much beauty to capture at a wedding—from emotional moments between people to exquisitely planned decorations. Since you don't have any official photography duties, you can focus on things the hired photographer might miss and the bride and groom will be too busy to see. The flowers, the cake, even the bride's shoes make iconic subjects for wedding photos. Contributing to their photo memories of the day can be a priceless gift to the couple.

Our advice is to simply remember that you are a guest and not the pro. Leave the formal group shots to the photographers and stay out of their way. (The last thing the wedding photographer needs is a bunch of guests shooting over his shoulder.) Wait until the pro has finished the job and moved on before you rush in for your shot.

This doesn't mean you can't get beautiful and meaningful shots of the day. Photograph the guests socializing during the waiting period while the formal portraits are being taken—something the couple wouldn't otherwise see. Take shots of young children playing (there are few things cuter than little kids dressed up for special occasions). Make a point to capture the details of the day: the flowers, the dessert display, even a pretty hospitality tray or basket in the bathroom. Your friends likely spent months planning the small touches of this celebration; they will love having a lasting record of their efforts.

▲ Nikon D200 with Tamron 17–50mm F2.8 lens at 50mm | ISO 200 | f/4.0 for 1/250 sec.

Rebecca and Michael were getting married in Mexico and wanted a save-the-date portrait that evoked old-time Mexican wedding shots. Since I was going to be shooting their wedding, I took this save-the-date portrait as well (far left). A square format and black-and-white conversion were just the right effects to bring to mind old film shots. The idea for the mustaches came from the couple. After they were pronounced husband and wife, Michael and Rebecca had their first kiss while all the guests donned the fake mustaches they had secretly been given on arrival. When the couple looked out, they were greeted with a hilarious scene that was meaningful to them (left).

▲ Nikon D200 with Tamron 17–50mm F2.8 lens at 29mm | ISO 360 | f/6.3 for 1/250 sec.

P The emotion on this grandmother's face while congratulating her granddaughter tugged on my heartstrings. When capturing special interactions between guests, quietly shoot over their shoulder or stand off to the side.

▲ Canon 20D with Tamron 17–50mm F2.8 lens at 50mm | ISO 200 | f/2.8 for 1/500 sec.

As for wedding shooting, we recommend a fast 50mm lens. The large aperture will allow you to shoot in lower light situations, so you won't disturb things with an annoying flash. You could use a zoom, but 50mm is small enough that your camera will remain as inconspicuous as possible. The main reason for taking the 50mm with you is the shallow depth of field you can achieve with the f/1.8 or bigger aperture. This will allow you to highlight the details and send the distractions around them into a lovely blur.

For those of you asked to serve as official photographer for a friend's wedding, that's a whole other kettle of fish (and something you want to think about seriously). Wedding photography is a specialty, and there is a reason wedding photographers charge what they do. There are also entire books written on the subject.

Sit down with the couple and put together a "shot list" of images and portraits they want

to make sure you capture. Talk about when and where these pictures are going to be taken (for example, family photos after the ceremony, couple shots before). This game plan should be shared with all members of the wedding party and family, so everyone knows when they are expected to show up. You don't want to lose valuable time looking for a missing grandparent to complete the family portrait.

Ideally, you would walk the site with the couple before the wedding day to get a sense of background and lighting and where to take specific images. Try to be there at the same time of day the event is planned, so you can get a sense of light and shadow. You have to expect some level of weather and light unpredictability, but do your best to plan. If it's an outdoor wedding, think about what you might do in case of rain. For example, matching colorful umbrellas can actually make a fun prop.

By using a shallow depth of field, the vows printed on this paper fade to create a lovely and fitting backdrop to the rings.

▼ Nikon D200 with Tamron 17–50mm F2.8 lens at 50mm | ISO 800 | f/2.8 for 1/200 sec.

This photo of champagne being poured captured the beginning of a great night of celebration.

▲ Canon 20D with Tamron 17–50mm F2.8 lens at 50mm | ISO 200 | f/2.8 for 1/1000 sec.

This simple shot of the bride unscrewing the top of her bottle of Rescue Remedy, a homeopathic stress reliever, tells a universal story about nerves leading up to a wedding ceremony.

▶ Canon 20D with Tamron 17–50mm F2.8 lens at 50mm | ISO 800 | f/2.8 for 1/160 sec.

EXPECTING

For any mother, a child's photo story really begins the moment she gets a positive pregnancy test. A quick snap of that plus sign or second pink line is the perfect opening shot for a baby book. When the pregnancy is ready to be shared with the world, there are many clever ways to announce the news with a photograph.

Pregnancy is a time to celebrate and marvel at the human body. It is amazing to think of a tiny life (or multiple lives) growing inside a beautifully round belly. While some new moms may be shy to have photos taken at this time, none will regret doing so down the track. If you are expecting, muster up the courage to either take some pregnancy self-portraits, or enlist a photographer to capture this time for you. Or if it is a friend or partner who is pregnant, give her a gentle push in the direction of your lens.

Maternity photos are often synonymous with bare bellies. When done tastefully, this makes for beautiful photos, but for the more modest expectant mom there are other ways to capture a striking maternity shot. Choose clothing that hugs the bump—solid colors are a nice choice, or stripes can work well to accentuate the contours of the belly. Photograph partners and siblings with mom and bump, too, to make them feel involved and capture their anticipation. Everything feels magical in the days just before a new baby is born.

When it comes time for the birth, prepare your husband, partner, or a friend, set the camera up for the proper exposure, and trust that he or she will get the best shots possible.

The harsh light in hospitals can be softened a bit by changing your original color files into black and white later (sometimes life can be a bit *too* colorful). This also removes distractions and puts the focus on the emotion of the moment. The color images are saved, but the black and whites are what get shown.

R The first shot involving my twins was a faint line on a pregnancy test early one morning (top). When the time was right to announce my pregnancy, I used a shot of my older daughter holding novelty pacifiers (bottom).
▼ Nikon D3 with Nikkor 60mm micro F2.8 lens | ISO 200 | f/4.0 for 1/400 sec.

▲ Nikon D200 with Tamron 17–50mm F2.8 lens at 17mm | ISO 200 | f/5.6 for 1/60 sec.

P After seeing this mom and daughter's cute matching T-shirts, I chose a simple background that matched the little girl's outfit. The soon-to-be big sister was full of anticipation and very excited to be involved in the photo shoot. This sweet peck on mom's tummy took little encouragement, and the hands touching further show the connection.

▲ **Canon 5D with Canon 24–70mm F2.8 L lens at 54mm | ISO 400 | f/3.5 for 1/250 sec.**

BEAUTIFUL BABIES

Babyhood—it really does go by faster than you can ever imagine. If you have a new baby in the house, make sure your camera is always in reach and make time to grab it. You'll want to capture all you can.

Babies are right up there in our list of favorite subjects. They are cute, they don't move (much or fast), and they think torn paper and tummy raspberries are the funniest thing in the world, so they're pretty easy to impress. Everybody loves a sweet photo of a happy baby. And while a prop to show scale may be nice in some shots, often the best baby photos are the simplest. Strip away the distractions and let the little one be the star of the show.

Because babies change and grow faster than at any other stage of life, there are different things to keep in mind when photographing them at different stages. All of these simple moments are actually milestones in such a tiny new life.

Newborns: 0–3 months

Sweet and oh-so-impossibly tiny, newborns are irresistible. They can be curled into all sorts of adorable positions, their itty-bitty features make for amazing macro shots, and they don't even notice they are starring in their own photo session. If you are a new mom or dad, it seems like this stage will go on forever, and amid all the diaper changes and feeds, it can be a chore to bring out the camera and interrupt precious rest time. Do try to make time for pictures, though—you will thank yourself later. If you are a friend of a new parent, give the gift of some sweet photos. It doesn't have to be in the form of a properly staged photo shoot. Real, natural photos often turn out to be the most cherished.

Capture macros of little features: tiny toes and fingers, rosebud lips, and sleeping eyelashes. Don't forget to show how tiny they are in the arms of their parents and in their world—back up and shoot some frames that show how little they are. Sleeping photos are absolutely precious, and let's face it, getting a cute photo of an awake newborn is difficult with their wandering eyes and lack of focus, but try to get a few. They will be wonderful to look back on over the years.

If you want to get some bare skin newborn photos (neither of us do these often), turn up the heat and make sure the baby is well fed and sleepy. It's best to do the simplest versions of these shots, where the baby is sweetly curled on a blanket on a beanbag. Avoid any precarious situations. Those pictures you see of newborns hanging from scales or balanced on objects are done by professionals, and often there is someone supporting the baby who is then erased in postprocessing. If you really want these sorts of photos, it's the perfect time to invest in a pro.

R I captured this scene of my friend holding her newborn son the week she and her husband brought him home from the hospital. While she held him on the edge of her bed, I knew I had captured some of the first images of my friend as a mother.

▼ **Nikon D3 with Nikon 50mm F1.4G lens | ISO 400 | f/2.5 for 1/400 sec.**

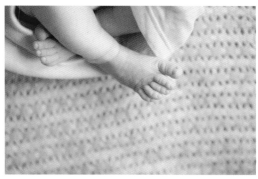

P I took this shot of Rachel's twins when they were just one day old. They were actually in one of those plastic hospital cribs—I just wheeled it over to a window.

▲ **Canon 5D with Canon 24–70mm F2.8 L lens at 62mm | ISO 800 | f/4 for 1/250 sec.**

P Newborn feet are impossibly tiny. Composing the frame so the subject was mostly in the top quarter added a bit of quirk.

▲ **Canon 5D with Canon 24–70mm F2.8 L lens at 70mm | ISO 100 | f/3.2 for 1/320 sec.**

R The moment a baby first rolls over marks the beginning of her life on the go. Often, there is motivation for the action—in this case, a pacifier just out of reach. Including the pacifier in the foreground keeps that detail from being forgotten.
◀ Nikon D3 with Nikkor 105mm F2.0 lens | ISO 800 | f/2.5 for 1/500 sec.

Little babies: 3–6 months

This is such a lovely stage, when babies are beginning to turn into their own little people. This is when you start to see the faces and character they will have for the rest of their lives. They start having longer awake stretches and are generally happier to be part of the outside world. All this makes for wonderful subjects. Laying a baby down on a soft blanket and photographing from above can give you a chance to capture a wide variety of adorable faces. If they are strong enough, you can also lay them on their tummy and get down on their level. If they are not rolling over yet, a bed is a great spot to do this (you can just kneel at the edge of the bed). Most babies have strong feelings about "tummy time," and you can get some funny faces from them in this position.

Some people find this stage a bit harder to photograph than newborns or sitting babies because they are still quite floppy and difficult to prop up. We see this an excuse to get photos with parents in the frame. Capture some moments between your partner and baby, or simply with the baby propped up in their arms.

P Little Monty had a sweet routine for getting freed from his naptime swaddle. The "1-2-3," they called it. It's easy to forget about taking these types of shots in favor of the pretty portraits, but step back and show how little they are in their environment.
▶ Canon 5D with Canon 24–70mm F2.8 L lens at 24mm | ISO 1600 | f/2.8 for 1/250 sec.

Growing babies: 6–12 months

This is the age when baby personalities explode to the surface. They are full of giggles and smiles and start to gain a bit of independence. If you are lucky, they will be sitting up but not yet crawling away. This opens the door to a new world of photographic opportunities. They can be sat in all sorts of great light and settings, and if they are fed and rested they will usually be happy wherever you put them. Most babies of this age lap up the attention and have a huge fascination with the camera. It helps not to be embarrassed to make silly noises and jump around like a primate to get their attention, especially if you are in a busy place with lots of other things going on.

P This photo of a cute baby boy with his doting mom shows how little babies are often most at home in the arms of a loved one. Propping them up on mom's or dad's lap means you can get some cute shots of their adorable faces.
◄ **Canon 5D with Canon 50mm F1.8 lens | ISO 200 | f/2 for 1/320 sec.**

P Sitting babies can be plopped down in all sorts of spots. The light shining through this fence one evening was so pretty. I carried six-month-old Clover across and put her on the sidewalk; we even found a cute flower that matched her outfit on the way. I love the curiosity this age has for the camera. Once they get a little older, most babies find other things much more interesting, so get as many shots as you can while they are captivated!
◀ Canon 5D with Canon 24–70mm F2.8 L lens at 60mm | ISO 100 | f/3.2 for 1/640 sec.

R While walking to the next location for our portrait shoot, this baby watched me with much interest from the safety of her father's arms. I asked them to stop for a moment and grabbed this quick shot of her adorable face peeking over his shoulder.
▶ Nikon D200 with Nikon 60mm macro F2.8 lens | ISO 400 | f/5.6 for 1/200 sec.

It's easy to remember to get in close and show baby faces, but even when babies are sitting, they are still so small in their environments. I pulled back to get a shot of this cutie in front of a piece of art her great-uncle painted.

◀ **Canon 5D with Canon 24–70mm F2.8 L lens at 57mm | ISO 1600 | f/3.5 for 1/250 sec.**

P This little guy was full of laughs and grins. I wanted to capture that stage in a simple portrait, so I sat him in some nice open shade on the deck and got in close. All it took were a couple of tickles on the tummy to get him smiling up a storm.

▼ **Canon 5D with Canon 24–70mm F2.8 L lens at 70mm | ISO 250 | f/3.5 for 1/320 sec.**

R This baby boy had a lot of portraits taken sitting down or being held during the session. His parents wanted to get a shot of his latest inclination to stand even though he could not quite do it on his own yet. Having mom and dad hold one hand each is a great way to represent this milestone.

▲ **Nikon D3 with Nikon 50mm F1.4G lens | ISO 500 | f/4 for 1/100 sec.**

P I took this shot of Rachel's son Kieran after he had woken from a nap. Babies are often at their chirpiest after a sleep, plus their cheeks are rosy and their baby bed-heads are so charming. A wide angle added a comical look that went well with his expression, and the discarded pacifier is just visible through the crib railing.

▲ **Canon 5D with Canon 24–70mm F2.8 L lens at 30mm | ISO 800 | f/2.8 for 1/320 sec.**

Toddlers: 12 months and up

There's no denying it, photographing toddlers is hard work. Getting shots of toddlers exploring their world is not a problem, they do plenty of that, but we want a few nice shots of their sweet faces now and then. The biggest obstacle with photographing these tiny explorers is that they are *fast* and have the attention spans of gnats. There is so much to see and do, and smiling into a black box is pretty low on their list. With that in mind, our three best tips are work fast, contain, and (*shock, horror*) bribe.

You want to have everything set up before you engage a toddler in a shoot. Decide where you want to shoot and set your exposure. Then when you are ready, be interesting. Be silly, excited, and high energy; make it a game. Even when you make it fun, little ones will tire quickly, so shoot a lot, but don't keep your face hidden behind the camera the whole time. Peek around and over so as not to lose your connection with your subject.

Bath time, cribs, even cardboard boxes—anything that can constrain your toddler—are your friends. There is more chance of your subject giving you his attention when he has nowhere else to go.

Finally, bribes! They are always our last resort, and we try not to do it too often, but a small treat or a little sticker can go a long way with the under-three set.

P Captive audiences are great; captive subjects are even better! The kitchen sink made a great container for this cute toddler. I loved how it looks as though she is singing into a microphone.

▲ **Canon 5D with Canon 24–70mm F2.8 L lens at 55mm | ISO 3200 | f/2.8 for 1/250 sec.**

R Children this age are just starting to show an interest in drawing. Capture the creation of their first masterpieces. I shot this while lying on the floor, putting me on the same level as my friend's two-year-old daughter. A wide aperture threw the background and foreground out of focus enough to keep attention on the child, but not so much that the papers and setting were unidentifiable.

◀ **Nikon D3 with Nikon 50mm F1.4G lens | ISO 800 | f/1.8 for 1/80 sec.**

R This simple, direct portrait of my godson was created in the midst of a lot of playing. He had grown into a fun, active one-year-old and was proud to show me he could climb onto the chair all by himself. This portrait was taken just after I clapped for his achievement. The shallow depth of field adds softness to his face and makes his gorgeous eyes stand out, as they are the only elements in sharp focus.

◀ **Nikon D3 with Nikon 50mm F1.4G lens | ISO 500 | f/1.8 for 1/160 sec.**

YOUR LIFE IN A BOOK

After you have photographed a year full of life stories and personal milestones, big and small, have them printed in a book. Arrange the book in monthly chapters and include a short synopsis of names, dates, and locations, so you won't forget these times. Collections printed by year make it easy to stroll back through history. (For suggestions on where to print your book, see page 108.)

Another way to use your images from the year is to design a time-capsule photo calendar. You can select one or even a few images from each month and upload them to one of the many online photo labs (Snapfish and Shutterfly are two) to insert into their calendar template. Print the calendar for yourself, and as you flip through the pages next year you can reflect on the difference a year makes.

R A book of photographs documenting the first year of our life with twins.

▲ **Nikon D3 with Nikkor 60mm micro F2.8 lens | ISO 640 | f/3.2 for 1/80 sec.**

MILESTONES ARE MANY

Milestones are not just for babies, and weddings are not the only moments to celebrate adulthood. How about a portrait session on the steps of a newly purchased first home? What about first teeth, first haircuts, first ice cream cones? Capture the details of that first walk to a new job or school, and there are always promotions to celebrate and new friends to celebrate with. Bring your camera along for the ride.

The trick to making shots like these interesting is to think about your composition. For example, get low down on the floor the first time your baby rolls over, and embrace the blur of motion with their first steps.

Milestones can also mean events that take place on a national or worldwide scale. From politics to human drama, from shock to tears of happiness, these moments weave deep emotions into our shared history and bring us together as a people. Make sure you get your camera out and record where you were. Far in the future, you will be able to relive those days through your photographs and they will become part of your historical record. If one day your grandchildren ask what that moment was like, you will be able to show them.

R To set the extra-special moments apart, try using a different focal length. Using a wide-angle lens up close for this documentation of the first lost tooth added a bit of silliness, which perfectly matches the emotion of the moment.

▲ Nikon D3 with Sigma 24–70mm F2.8 lens at 24mm | ISO 800 | f/1.8 for 1/80 sec.

P Moving into a first home is perhaps the biggest step into the world of independence. This photo of a young couple holding packing boxes is a universal shot of moving day that most of us can relate to, with a bit of added quirk.

▶ **Canon 5D with Canon 24–70mm F2.8 L lens at 70mm | ISO 200 | f/3.2 for 1/1000 sec.**

R My family and I were living in Australia during the 2008 election, and it was important to me to share the historic inauguration speech with my daughter Gemma. Processing the shot into black and white gave it a timeless feel.

◀ **Nikon D3 with Nikkor 50mm F1.4 lens | ISO 800 | f/2.8 for 1/250 sec.**

P The emotion shown by these families welcoming home their deployed partners, parents, and siblings had to be captured quickly! They were in a hurry to reunite, and the long stretch of tarmac was covered in a few short seconds. The joy and anticipation were palpable.

▲ **Canon 5D with Canon 24–70mm F2.8 L lens at 24mm | ISO 100 | f/4.0 for 1/1250 sec.**

Beyond Snapshots

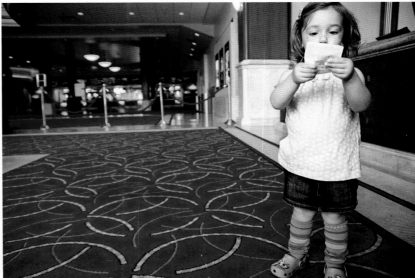

Taking just one group shot of the kids outside the theater would be fine to mark this occasion of a first trip to the movies, but by capturing the little girl's pride in holding her very own ticket and her delight in getting to sample grown-up treats, the ordinary memory becomes an interesting tale anyone can relate to.

▲ Nikon D200 with Tamron 17–50mm F2.8 lens at 17mm | ISO 400 | f/2.8 for 1/40 sec.

◀ Nikon D200 with Tamron 17–50mm F2.8 lens at 17mm | ISO 250 | f/4.0 for 1/100 sec.

chapter seven
DOCUMENTING FAMILY LIFE

Don't wait for professional photography sessions to capture your family moments. You don't want to look back on your photo legacy and only be able to say, "Remember that time we all got together at a studio at the mall wearing khaki pants and navy shirts?" We believe strongly that every day is memorable and the ordinary is extraordinary. You can always find something to celebrate with a photograph.

 The story of your own family is one that unfolds daily, and all too often whole chapters are lost to time. By documenting your family's life, you will make memories with the people you love, and record history for future generations to enjoy.

LIFE AS IT IS

When you prepare to take a portrait, you plan ahead and set up the location. There is time to decide on outfits and props; people even have time to brush their hair. When you document family life, on the other hand, you work with the environment and let the portraits unfold as you shoot. With this photojournalistic approach, let the family bed, the spaghetti sauce, and the bubble bath all become elements of your visual story. You want the people you love in their most comfortable daily moments: brushing their teeth, playing with the dog. This is about as far from those posed formal portraits as you can get.

Restrain the urge to direct the shots too much. That's not to say that you don't have *any* control over the scene, however, so try to keep things simple. Push that laundry basket out of the frame, put dirty dishes in the dishwasher. Close doors, open curtains, shove things under the bed. If something does not add an important narrative element to the photograph, remove it. Make sure your camera battery is charged and you have a few large-capacity memory cards freshly formatted, then put the camera right by your bed. When you get up in the morning, you can reach for the camera before you even have your feet in your slippers. That is the way to get true portraits.

Family life does not have to be shot all in one day, but you can find something to shoot every day.

Keep it real with natural light

While you are shooting, try not to intrude on the moments with a flash. Instead, use your camera's higher ISO settings and maximum aperture on your lens to take advantage of the existing light.

P A morning pileup is a great way to get a few more minutes in bed before the day begins. Shooting from above on a bed often means the ISO has to be pushed high, but the grain is worth it for moments like these.
◀ **Canon 5D with Canon 24–70mm F2.8 L lens at 24mm** | **ISO 1250** | **f/3.2 for 1/250 sec.**

PHOTOGRAPHIC INSPIRATION

If documentary photography begins to feel overwhelming, turn to others for inspiration. We have long lists of photographers whose work gets us excited and thinking about capturing images in a new way. Here are some of our favorites. Spend time with these amazing artists, and you'll come back to your camera with renewed enthusiasm. We always do.

Sally Mann (http://sallymann.com) is the preeminent photographer in the art of documenting family life. Her series featured in the collection *Immediate Family* is a raw and often controversial recording of her three children growing up in rural Virginia. After her children became more aware of the camera and less willing to be photographed, her work moved on and grew to include ghostly scenes of civil war battlefields and an exploration of what remains after death. The images are mesmerizing for something that sounds so grim in words.

Mary Ellen Mark (www.maryellenmark.com) is a documentary portrait artist. Her photo essays on subjects ranging from film sets to rock-and-roll bands, homeless families, Indian circus troops, and disabled children in special schools in Iceland are some of the most iconic of the last century. She treats each and every person in front of her lens with the same skill and respect. Her images are haunting and strong in their simplicity. She is a true master of photography.

Stephanie Rausser (www.stephanierausser. com) is an editorial and commercial photographer who has a special place in both of our inspiration pools. Her images are full of quirk and charm and tell such wonderful stories. We also love the natural way she injects color into her photographs. It is always just the perfect touch, nothing very processed, relying on the content to make the image great.

Julie Blackmon (www.julieblackmon.com) is a fine art photographer who has two very distinct sets of work. *Domestic Vacations* is series of color photographic collages that depict suburban life in a beautiful and quirky way, with dark undertones running though many of the images. *Mind Games* is a beautifully executed series of black-and-white images that chronicle children at play. All of her work harnesses talents for beautiful compositions and storytelling.

The photographs of **Tara Whitney** (http:// tarawhitney.com) are real, fun, quirky, full of love and passion, and a huge inspiration to us. Tara is a family photographer who "gets it." She has an amazing eye for capturing what could be seen as ordinary moments in the most captivating ways. She makes imperfections perfect and turns conventions on their head, which may just be the perfect place for them.

Spend a day in the life of your family and capture the story.

You will never get those moments back, but with your images, they will never be fully gone. We photographed a typical weekend day in the life of our friends, from morning cuddles to bedtime stories.

7:42 am

7:45 am

8:35 am

8:42 am

10:15 am

11:02 am

11:17 am

1:45 pm

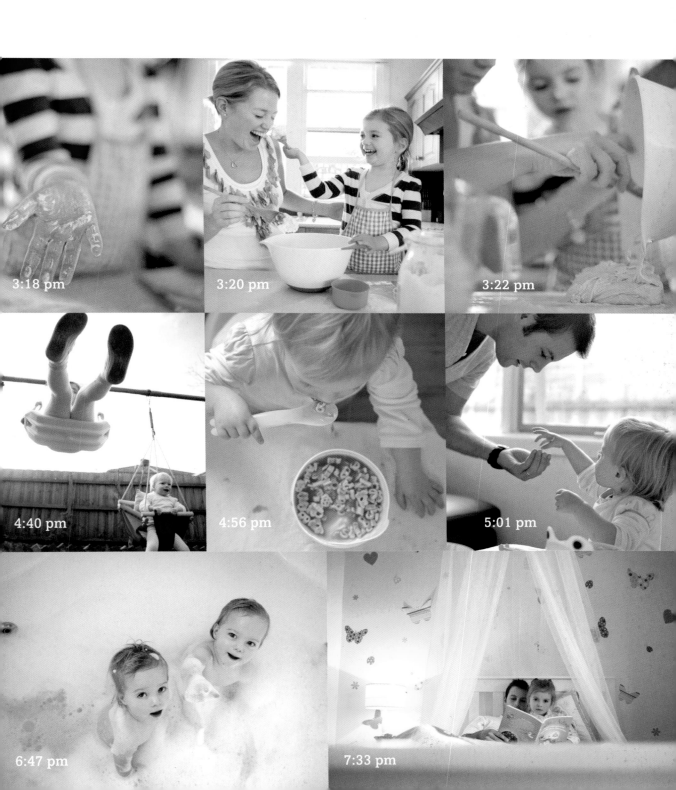

3:18 pm

3:20 pm

3:22 pm

4:40 pm

4:56 pm

5:01 pm

6:47 pm

7:33 pm

BATH TIME

Bath time is a great example of a daily moment, those everyday rituals we take for granted but that, when captured well, reveal so much about the people who fill our lives. Kids are generally happy in the bath—and captive subjects.
Use the size of the tub for scale to show just how little children are in the big adult world. Conversely let the baby fill up the kitchen sink. Make sure you are prepared ahead of time and take care. You never want to leave a child alone in or near water to get your camera. Also make sure your camera is safely out of range of spontaneous splashing.

Getting in the shot

Don't forget about having your life recorded, too. You may be the photographer of the family, but you don't want to only appear in the posed family portraits. This means handing over the camera to your partner or friends and getting them to photograph some of the daily moments you share with your loved ones. If they don't share your talent for photography, give them some pointers. Teach them a bit about focus and composition and put the camera on Aperture Priority mode with an ISO that is right for the situation. Better still, get them excited about photography and encourage them to read this book! If they are really not interested, just remember that imperfect photos are better than no photos at all.

P This black bath was so unusual, and I loved the light coming from behind and the contrast between the white wall and the tub. The little girl's flash of bright red hair and curious peek over the tub made the shot.

▲ Canon 5D with Canon 24–70mm F2.8 L lens at 70mm | ISO 1600 | f/3.2 for 1/500 sec.

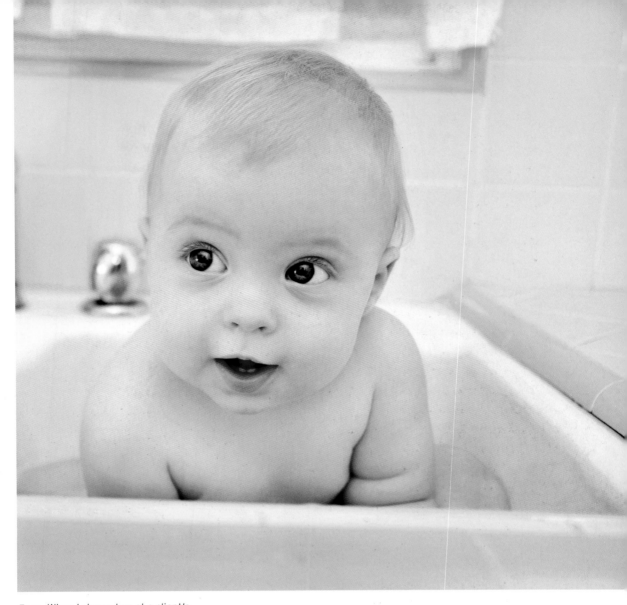

R When I showed up at a client's home and noticed the gorgeous colors in their lovingly restored vintage kitchen, I knew there would have to be at least one sink-bath photo. The kitchen sink is a great spot for photos of small kids—it keeps them contained and often gets much better natural light than in the bathroom.

▲ **Nikon D200 with Tamron 17–50mm F2.8 lens at 26mm | ISO 320 | f/3.2 for 1/250 sec.**

OUTFITS

While you may want to style your family for their portraits, the outfits you'll remember are the ones your kids put together themselves. You don't want to forget the months when he was so obsessed with cowboys he wouldn't take off his hat. Nor do you want the memory of your toddler's fascination with dress-up to fade with time. These are moments that should be captured. Years from now the tutus and tiaras will be long gone, but you will have the images to remind you.

R There was no getting the dragon costume off this boy. Going with a toddler's choice of apparel will not only make the photo session go more smoothly but will be an honest record of that time in their life.
▲ Nikon D3 with Nikkor 50mm F1.4 lens | ISO 1250 | f/2.2 for 1/125 sec.

P Bigger kids are often very proud of the things they love. This boy is a big fan of Michael Jackson and wanted at least one portrait taken in his hat and glove. It was easy to get him to do all the other portraits by promising that the one he really wanted would be saved for last.
◀ Canon 5D with Canon 24–70mm F2.8 L lens at 30mm | ISO 160 | f/3.2 for 1/200 sec.

SECURITY OBJECTS

Sometimes the defining objects of daily life are fuzzy—our children's most loved toys and animals. These bunnies, bears, and blankets can become part of the family. Capture the relationships your children have with their cherished toys. The kids take these treasures everywhere they go, so you will have plenty of material to cover. Pay homage to the stuffed friend with a proper portrait that you can frame and hang in your child's room. Maybe you even have your old "lovey" in a box somewhere. Perhaps a photo of your old friend is a good idea as well; you know it will bring back the best of memories.

R The simple background created by photographing my daughter's "nunny" on our guest bed with a white sheet elevates this from just a snapshot of a toy to a portrait of a beloved friend. (When photographing on a sheet, pull it as tightly as possible to get rid of wrinkles.) The bunny has since been loved a lot more, and it is nice to look back on this image and see how clean it once was. Printed small and framed, it looks sweet on Clover's bedside table.

▲ **Nikon D3 with Nikkor 50mm F1.4 lens | ISO 500 | f/1.8 for 1/200 sec.**

THE 365 PROJECT

These days many people undertake a "365 project," shooting a photo each day for a year to document their life as well as practice their photography skills. Many post their photos on Flickr or a dedicated photo blog, where they serve as a visual journal of the year. The idea is not new, but it is a good one. Refine the concept with a theme that is meaningful to your family. Document what a child's hair looks like after a full day away from home. Photograph the daily return from school—lunch box and backpack in tow—through the seasons. Use these images to spark imagination instead of telling a literal story.

R These two shots of my daughter Gemma, taken from behind, turned into a series during her first year of Australian preschool. Gemma would go to school with her hair perfectly brushed and arrive home a few hours later a mess. The crazier her hair was, the more fun she'd had. Taking these photos in the same spot each day with a neutral background allowed the series to visually flow in a cohesive manner.
▲ **(left) Nikon D3 with Nikkor 105mm F2 lens | ISO 1600 | f/4.5 for 1/60 sec.;** (right) **Nikon D3 with Nikkor 105mm F2 lens | ISO 320 | f/2.8 for 1/60 sec.**

CHANGING YOUR PERSPECTIVE

A simple change in perspective can take a shot from boring to beautiful. If you are shooting what seems to be a great moment but not feeling inspired by the photos in your viewfinder, think about how you can change the angle for a more dynamic perspective. The more you practice, the more it will become second nature. Next time you shoot, allow yourself only a few shots from one position, then get moving. What does the same scene look like from behind? How about lying on the ground, focusing on something unexpected? What about a bird's-eye view?

A zoom lens allows you to be really fluid about changing things up. You can go from a close-up portrait to a full body shot with a flick of the wrist. If your budget allows, a 24–70mm F2.8 lens is perfect because it gives you amazing range, and its quality rivals that of prime lenses.

Different angles suggest very different things. Viewing a scene from above or through the frame of a doorway removes the photographer from the action and gives a fly-on-the-wall perspective, especially when subjects are caught up in their own world. This can be especially effective for intimate family moments, like bedtime stories or Sunday morning pileups in bed.

Getting down low gives the viewer more involvement, as the lower angle really puts them in the scene. This type of angle is best for activity and play, like family bike rides and fun playground trips. It can also lend well to quieter moments, like time coloring or playing with toys. From a low vantage point, focus on a toddler's cute hands exploring her world, or a kindergartener's perfectly imperfect writing.

Getting in close has a more direct quality, helping the viewer feel like he is interacting with the subject. This is best for portraits, when you are recording a person's quirks and expressions, rather than telling a story.

P I walked into my friend's room to find her twins fast asleep on her bed. I wanted to show how sweet and small they looked, so I climbed up on the bed and shot from as wide an angle as my lens would allow.
▲ **Canon 5D with Canon 24–70mm F2.8 L lens at 24mm | ISO 3200 | f/2.8 for 1/125 sec.**

chapter eight
SHARING
YOURSELF

Most photographers spend more time behind the camera than in front of it. It is important for your family to see the photographer as much as the photographs, especially as time goes by. These photographs do not have to be art, they just have to be. Grab your child on your lap, throw an arm around your best friend, hold the camera out at arm's length, and press the shutter. Don't worry about your smile or your hair. Hold the camera a bit higher than your faces (shooting from above is always slimming), and enjoy a moment with a person you love.

EASE INTO IT

It's perhaps no surprise that photographers who find such beauty in others are often critical of their own image. So to start, remember that no one *needs* to see these shots. You can delete them "in camera" if you want. The point is to push your comfort zone. This process takes courage, and it will take time to build that strength. Start when no one is around. Put on your favorite music and have fun. Or don't, if this makes you feel weird; silence is okay, too. Allowing yourself to be silly and feel unattractive will build your confidence and help you work out what you feel your best angles are.

If you have a hard time facing the camera, start by looking out of the frame. You may find it easier to view those images. Another idea is to bring an object that is relevant to your story into the image with you and look at that. You can even choose to exclude your face completely. Detail shots of your hands or other body parts can say a lot.

We know people who have committed to taking a self-portrait every week for a year—or, for the truly committed, every *day* for a year (there are groups for each project on Flickr). While this may sound like hell for anyone who doesn't like seeing her own self-portrait, people who have participated say that seeing shot after shot actually takes away the stigma. Some days we look good, some days we don't—it's part of life.

Another good time to come face to face with the reality of your image is during big changes and transitions. These may seem unlikely times to pick up a camera and step in front of it, but big life events offer a unique opportunity to capture yourself. We encourage you to chronicle transitions, such as a move, your body going through pregnancy, or the changes you see as you make an effort to get healthy. The stress or strength of the moment will come through in the image, and in years to come you will look back and remember those exhausting and exhilarating days of change and uncertainty.

R Looking out of the frame can set up a story in an image, like this one, which implies that I am actually talking on the phone to someone (I'm not). Giving the self-portrait a narrative element makes it more interesting.
▲ **Nikon D200 with Tamron 17–50mm F2.8 lens at 22mm | ISO 100 | f/4.5 for 1/125 sec.**

R Mothers can never quite believe how huge they were while pregnant. Taking a weekly belly shot in the mirror is the best way to record the growth. By using a long lens, I was able to frame my belly tightly, removing any distractions in the background.
▼ **Nikon D3 with Nikkor 105mm F2 lens | ISO 400 | f/4.5 for 1/250 sec.**

R When the twins were small, the only way to keep them content was to wear them in separate slings at the same time. When people ask how I did anything with newborn twins, I show them this shot.
▲ **Nikon D3 with Nikkor 50mm F1.4 lens | ISO 800 | f/4.0 for 1/80 sec.**

Yet another way to ease into self-portraits is to incorporate them into your everyday life. We rarely stop to think about all that we do in a day, but there is a story that flows through the seemingly mundane details, and it's your story. In the future, you may love to have images of the house you were living in, the coffee shop you went to each day, the way the sun filtered through the trees on your walk to work or school. There is even a project on Flickr where participants document their daily activities on the summer and winter solstice (longest and shortest days of the year) and submit the images to a communal "Day in the Life" pool (the main one can be found at http://www.flickr.com/groups/adayinthelife/). It's fun to see photographs of daily life from all over the world.

Regardless of what sort of self-portrait you're shooting, we encourage you to keep them real. This is an opportunity to see the beauty in the details of your story. It may be tempting to smooth out wrinkles in postprocessing, but you've earned those lines—they are all part of your story; don't whitewash them. Think of images you take of your friends. Don't you prefer those that look like the real person—twinkle in the eye, laugh lines, and all? Your friends and family would rather have a real version of you than a gussied-up fake. If you really need to tidy yourself up, use postprocessing to take out a pimple or two (skin blemishes are transitory anyway). Make yourself comfortable, but we think it's much more powerful to use the self-portrait

experience to come to terms with yourself. Perhaps you can begin to see the beauty in you.

If the idea of a self-portrait still scares you, step back and get more abstract. Photograph things that are not actually you, but carry your stamp and personality. How about laying the contents of your purse on the floor and showing what is in your bag? It may sound odd but it's incredibly personal and revealing. There is even a Flickr group set up to share those images (http://www.flickr.com/groups/whats_in_your_bag).

Self-portraits may seem as though they're just about me-me-me, but there is an entire history and theory behind them. Looking at some of the artists who have expressed themselves over the years through self-portraits can give you insight into the genre. Cindy Sherman is a world-famous photographer who has built her career around self-portraits. She becomes characters in her images and elevates the self-portrait to art. There is a power to self-portraits; you control what you describe and what you want to tell the world about yourself. You get to tell your own story.

R I wore these necklaces throughout my entire pregnancy, even though they became hopelessly tangled. One was from my father, the other from my best friend, and they took on the role of accidental talisman. I didn't take them off until the day I delivered the twins.

◀ **Nikon D3 with Nikkor 60mm micro F2.8 lens | ISO 400 | f/3.2 for 1/250 sec.**

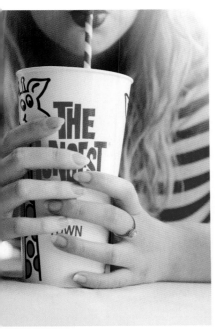

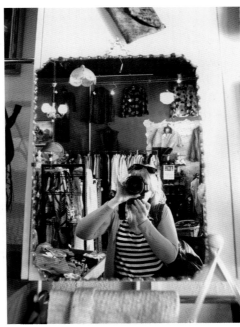

 Consider spending a day recording your life. In this series of shots, I kept my camera on hand and took advantage of moments as they presented themselves.

◀ (top left) Canon 5D with Canon 24–70mm F2.8 L lens at 57mm | ISO 500 | f/3.5 for 1/320 sec.

◀ (top right) Canon 5D with Canon 24–70mm F2.8 L lens at 28mm | ISO 1000 | f/4.0 for 1/30 sec.

◀ (bottom left) Canon 5D with Canon 24–70mm F2.8 L lens at 25mm | ISO 250 | f/3.2 for 1/1000 sec.

◀ (bottom right) Canon 5D with Canon 24–70mm F2.8 L lens at 70mm | ISO 500 | f/3.2 for 1/500 sec.

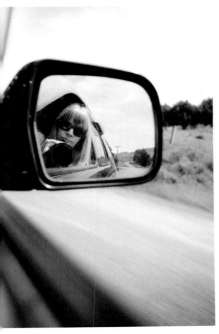

TAKE THE SHOT

One of the practical stumbling blocks to self-portrait photography is focusing when you cannot actually look through the viewfinder. In most cases, you can rely on auto focus (AF) to do the work for you. Your DSLR will have a few different methods of autofocusing. When you look through the viewfinder, you can see little illuminated brackets called "focal points." You can set the camera to use only one of those focal points (Single-point AF) or to pick whichever one falls on the subject closest to the lens.

Setting the camera to focus on the closest subject is an option, but keep in mind that the closest object to the lens will often be your nose or eyebrow—so that's what the camera would focus on. This is not ideal, as your eye should be the sharpest point. We prefer Single-point AF, because you are not stuck with the one in the center of the viewfinder. You can select any of them, depending on where you will be in the frame, and lock your selection in. You may have to experiment a little to get it just the way you want, but that's part of the fun of self-portrait—you are the only person to please.

Whatever method you choose, you must also consider the *mode* of autofocus. The mode determines whether the camera locks focus on a still object (AF-S) or tracks a moving object and continuously adjusts focus in pace with the subject (AF-C). For self-portrait photography, AF-S is a better bet as you do not want to have your focal point lock on one spot and then move to keep that area in focus if you move your camera. The way to set up these options varies by camera model (either an external switch on the back of the camera or a menu option). Refer to the manual for your camera to find out how to set yours.

Regardless of focusing method, most self-portraits are the result of multiple shots. Be prepared to use the "shoot, look, and shoot again" method. Embrace those that are not in focus as well, for they can be beautiful. In the end it is a combination of practice and skill.

In terms of how to hold the camera, the best option is a tripod. If you don't have a tripod, rest your camera on a flat surface like the floor (which will make for interesting angles), a table, or a bench. (Just make sure your camera is in a safe location before you leave it to step into the frame. Untended cameras, especially with heavy lenses on them, have a tendency to topple.) You can also purchase a cool little monopod arm that attaches to the camera base and allows you to hold it out much farther in front of you.

And finally, how do you press the shutter release? The best way is to get a remote trigger, which allows you to both focus the frame and release the shutter remotely. There are super-cheap ones sold on eBay, as well as expensive ones available from the manufacturer of your camera brand—either will do the job. You can also use the self-timer, but unless you have a stand-in to focus the frame, the process becomes a little improvisational, as mentioned above.

R This self-portrait was a challenge from a friend, who asked for a shot of me, my daughter, and all of our pets. I started by placing a chair in the yard by our fishpond, so the fish would be in the shot, and putting the camera on a tripod. I focused on the chair and went and got the other animals. From there it all went a bit crazy. Since these were self-timer shots, I had to keep setting the timer and then running back to the chair, which scared the cat out of frame, enticed the Maltese to play, and annoyed the Schipperke.

▼ **Nikon D100 with Tamron 17–50mm F2.8 lens at 60mm | ISO 100 | f/8.0 for 1/125 sec.**

R This is one of those lucky shots. I had set the camera to closest focus and held it in front of me and my son. (You can see my arms and the camera in the reflection in his eye.) I closed my eyes and gave him a kiss. I had no idea that he was even looking at the camera, let alone that it would focus on his eye.

▲ **Nikon D3 with Sigma 24–70mm F2.8 lens at 70mm | ISO 1600 | f/4.5 for 1/50 sec.**

GET CREATIVE

You can have a lot of fun with self-portraits. They can be as quirky or as serious as you want to make them. Set a scene, tell a story, create something whimsical. You can dress yourself up in the fancy clothes you don't get enough chance to wear, or capture yourself on a Monday morning in pajamas and messy hair while drinking coffee. Remember, you don't need to share these images with anyone else if you don't want to. Here are a few fun techniques to try.

Reflections

There are mirrors everywhere in your house, your car, and public bathrooms. When playing with reflected self-portraits, you can hide behind the camera or reveal your face by holding your camera to the side. Even though there are plenty of them around, you do not need a mirror for a reflection. Look for opportunities to photograph yourself in anything shiny, from puddles to windows. These shots can be wonderfully atmospheric.

P While walking around Melbourne one Saturday, I noticed the different-color reflective stickers on the window of a rundown building. The colors and lines made for a great spot to catch a reflected self-portrait.
▶ **Canon 5D with Canon 24–70mm F2.8 L lens at 59mm | ISO 160 | f/4.5 for 1/100 sec.**

Shadows

Self-portraits can be a less literal thing as well. The mere shape of you can tell an entire story without ever revealing your identity. Depending on where the sun is in the sky, your shadow can range from a small spot to a long, majestic suggestion of a giant. Use this unique view if you are having a hard time facing the camera.

Multiplicity

One interesting way to tell a story with your self-portrait is to use a little postprocessing magic to combine multiple images into one seamless frame. When done well, this form of photography, called *multiplicity*, elevates the simple self-portrait to art.

R Including the footprints in the sand with this shadow self-portrait adds a bit of texture to the story and leads the viewer's eye through the shot.

▼ **Nikon D3 with Sigma 24–70mm F2.8 lens at 32mm | ISO 320 | f/8.0 for 1/500 sec.**

R By combining two self-portraits with Photoshop, I am able to fully explore the dichotomy I feel between being both a mother and photographer. There are many days when I would love a clean house and a chance to wear makeup, but am lucky just to find a clean sweatshirt and pair of jeans before quickly brushing my teeth. The professional self I imagine in the mirror can be literally represented with this self-portrait technique. To try multiplicity, take two shots using a tripod (so as not to move the camera). Layer them in Photoshop, then paint in one half of the shot with a white brush on a black mask linked to the top layer.

▲ **Both images: Nikon D3 with Nikon 50mm f/1.4G lens | ISO 400 | f/5 at 1/25 sec.**

LIFE IS IN
THE DETAILS

They say life is in the details, and they're right. The downy fluff of a newborn's hair, the grass underfoot on a summer evening, a cozy cup of tea as the snow falls—this is the fabric of our lives, the stuff of our memories.

Once you start paying attention to the little things, you will find yourself becoming even more grateful for them. You may find that your detail shots quickly become your favorites. They are a record of how you live your life, the small moments and items that fill your days. Years later, you will be glad you took the time to capture the richness of your own life, the beauty you've created.

WHAT'S IN A DETAIL?

It's easy to think that when we talk of details we are talking about *things*, but it's really the people and stories behind those objects that make them worth recording. A rock is just a rock, unless it's the rock your child collected on the beach and gave you as a gift. Then it becomes a treasured memory and reminder of a day well spent.

The one thing all of these items and memories have in common is *you*. Photograph the things you love, the things that give you a sense of pride. Take pictures of the corners of your home that make you smile, the meals you have cooked with love, the projects you have spent hours perfecting. We all bring beauty into our lives in different ways. Record the moments and images that give you joy. You will end up with a series that is intensely personal and revealing: the texture and colors of your life.

P My memories of time spent with my dressmaker grandmother as a child revolve so much around the sewing room, watching beautiful garments being whipped up out of yards of fabric, lace, and beads. This photo is one in a series of shots taken detailing my nana at work on the craft she has spent years perfecting. The fine needle, intricate beading, and time-weathered hands tell a story without showing more than the hands at work.

▶ **Canon 5D with Canon 24–70mm F2.8 L lens at 60mm | ISO 800 | f/2.8 for 1/500 sec.**

USING DEPTH OF FIELD

Knowing how to control depth of field can take your detail pictures from shots of things to simply beautiful photos. By throwing the background and foreground into blur, the viewer's eye is naturally drawn to the focused part of your image. To do this, you need a *shallow depth of field*. This means that only a narrow line of the composition is in focus. The larger the aperture, the smaller the area of focus and the blurrier the background. This is where having a lens with a large maximum aperture comes in really handy.

Great lenses for this are the "nifty fifties"— also known as 50mm lenses, especially if you are just starting out and do not have a big budget. Almost every photographic brand has an inexpensive version of the 50mm F1.8 lens. If you have money to burn, there are also 50mm F1.4, and even F1.2 versions. They are more expensive but offer a higher quality lens.

Lenses don't perform their best at the maximum aperture, especially not the cheap ones. One or 2 stops above the largest aperture is an ideal place to land when capturing details. That will be the best combination of sharpness and shallow depth of field.

> **P** When you use a shallow depth of field, whatever you focus on is rendered in sharp detail while the foreground and background are thrown into a soft blur.
> ▶ **Canon 5D with Canon 24–70mm F2.8 L lens at 60mm | ISO 250 | f/2.8 for 1/125 sec.**

A step beyond using maximum aperture to create shallow depth of field is using a macro lens. Macro lenses let you get much closer to the subject than normal lenses. This means you can get in extremely tight and blow those details up to larger-than-life proportions. Macro lenses are perfect for capturing tiny newborn details, flowers, bugs, or whatever other tiny things take your fancy.

AROUND THE HOUSE

When things catch your eye around the house, make sure to photograph them. It's funny sometimes what can make for a cool image: discarded pacifiers, big papa shoes next to little baby shoes, funny or sweet notes left in random places, even something as mundane as a tray of eggs.

Dress up your details

While our lives and houses don't (and shouldn't) look like they were lifted out of a magazine, a little bit of styling can make a huge difference in your photos. This is especially true when it comes to details. Find a good spot with even or filtered light. If you are taking photos of a certain corner, wait for the pretty light to arrive in that area before shooting. Clear clutter and simplify, moving aside distracting background elements. If you want to set up a scene to give the subject some context, look for things that tie in with the feel of the subject and be careful not to take the focus away from the main event.

R Finding a happy-face sticker smiling out at you from the washing machine is just one of those things that makes you laugh. Why not remember it with a photo?
▲ **Nikon D3 with Nikkor 60mm micro F2.8 lens | ISO 1000 | f/4.0 for 1/125 sec.**

These eggs were given to us by friends with free-range hens. It is hard not to notice the odd one out (poor Henrietta!).

▲ **Canon 20D with Tamron 17–50mm F2.8 lens at 50mm | ISO 100 | f/2.8 for 1/125 sec.**

After the birth of a child, life changes in many ways. This shot illustrates the shift from young and single to motherhood with the reutilization of a drink shaker to warm a bottle of milk.

◀ **Nikon D3 with Nikkor 105mm F2 lens | ISO 1250 | f/2.0 for 1/125 sec.**

PEOPLE

Portraits are usually used to record faces and expressions, but sometimes it's the little things that make the ones you love unique and deserve to be front and center in a photograph. How about pudgy baby fingers, the curl of a friend's ponytail, or the way your father clasps his hands just so? You'll never regret capturing the small details of the people in your life.

P This is one of Clover's first ponytails. By isolating the composition to just the top of her head, I forced the focus to the cute spout, rather than her equally adorable face (had it been in the frame).
▲ **Canon 5D with Canon 24–70mm F2.8 L lens at 40mm | ISO 1000 | f/2.8 for 1/200 sec.**

P This sweet grin certainly warranted a moment in the spotlight. The way the hair peeks into the shot, and the cute striped top, helped frame the face and draw the eye in.
▲ **Canon 20D with Tamron 17–50mm F2.8 lens at 50mm | ISO 200 | f/3.2 for 1/2000 sec.**

P The details of this four-year-old's particular outfit deserved recording close-up. It's not only a cute shot, but a reminder to be grateful to the kids in our lives for showing us that life is fun, and to do what we love with confidence.
◀ **Canon 5D with Canon 24–70mm F2.8 L lens at 70mm | ISO 160 | f/3.5 for 1/200 sec.**

P Okay, so this isn't a person, but who wouldn't be grateful for the presence of a tail as cute as this? Not photographing it would be a crime.
◀ **Canon 5D with Canon 24–70mm F2.8 L lens at 70mm | ISO 400 | f/3.2 for 1/200 sec.**

NATURE

Nature is such an intriguing subject that some photographers make it their entire career. You may be amazed at the patterns and details to be found in a leaf, a shell, a caterpillar. Photographing this sort of detail makes you slow down and truly appreciate how beautiful the world can be.

R Things that frighten us can be wonderful subjects. As we work through our fears, they become the details of our lives that mark our journey. Spiders are now a daily part of my life in Australia, and I am slowly (very slowly) learning to appreciate their beauty.
◀ **Nikon D3 with Nikkor 105mm F2 lens | ISO500 | f/5.0 for 1/250 sec.**

FOOD

Recipes for gooey brownies, buttery cookies, and a home-cooked breakfast all sound great, but when it comes to recipe books, it's the photos that have us rushing to the pantry. If you are an avid baker or cook, take the time to photograph your creations. When holiday season rolls around, combine your recipes and pictures to create a special cookbook for family and friends. Or create a food blog to share your recipes with friends around the world.

P Keep the styling clean and simple to let the food be the hero. Here, I used monochromatic tones and a blurred background (shallow depth of field) to keep the focus on the yummy tower of cookies.
◀ Canon 5D with Canon 24–70mm F2.8 L lens at 70mm | ISO 320 | f/3.5 for 1/80 sec.

POSSESSIONS

One of the best things about photographing details is that it can also help you part with "stuff" if you are trying to downsize or streamline. Once photographed, your things are there forever, and you may find that letting go is not quite as hard. You now have a beautifully photographed memory, one that won't clutter up your shelves and counters.

R If your home has a gallery for your children's artwork, document the evolution of their style as you recycle their old masterpieces.
▲ **Nikon D3 with Nikkor 50mm F1.4 lens | ISO 500 | f/1.8 for 1/160 sec.**

R Sometimes things that inspire us can end up in the most unlikely places. These two pieces, an abstract painting of Malibu and an old map of Iceland, hold special significance for me and ended up hanging in the downstairs bathroom in our home.
▲ **Nikon D3 with Sigma 24–70mm F2.8 lens at 24mm | ISO 1000 | f/4.0 for 1/60 sec.**

PRESERVE YOUR PICASSO-IN-TRAINING

Kids' artwork seems to breed when your back is turned. Instead of storing it all, take a picture as it enters the house—fill the whole frame with the artwork and use natural, even, filtered light. Pop the original on the fridge until the novelty wears off, then recycle it or turn it into thank-you cards for family. At the end of the year, you can collate all the images into a book or album. Ask your children to tell you about the images and create captions with their crazy words (www.blurb.com is an easy and affordable way to make a book). These books are fun to flip through, for both you and your kids. They are much more enjoyable and accessible than a box of drawings stuffed in a closet.

P To photograph a child's artwork, lay the art flat on a smooth surface in natural, indirect light and shoot from directly above. ◀ **Canon 5D with Canon 24–70mm F2.8 L lens at 70mm | ISO 400 | f/5.0 for 1/125 sec.**

CRAFT PROJECTS

Everyone appreciates a homemade gift, and while the making and giving of these special presents is reward enough, it is nice to have a record of them as they leave for a new home. If you are a prolific crafter, create a photo album or book with all of your projects. You can even photograph the project step by step as you work through it. Blog the images with instructions as a free tutorial.

P This quilt was made for a friend's newborn baby girl. The grayed wood and rustic chair made a great backdrop for its style and tones, and a little bit of breeze added a touch of movement.
▶ Canon 5D with Canon 24–70mm F2.8 L lens at 43mm | ISO 250 | f/2.8 for 1/640 sec.

DIPTYCHS

Diptychs are images that are paired together. Like color schemes, they can be used to complement or contrast one another. Unexpected pairings can make you think about and weave together a story in your mind. Alternatively, images that are similar can pair together to tell a bigger story than just one image alone. If you want to pair otherwise unrelated images, try choosing images with similar color schemes. You can choose to frame the images together as separate prints or you can create the diptych as one image in Photoshop.

To make a diptych with two images that are exactly the same size, first open both images in Photoshop and decide which one will be on the left. Select that image and go to Image > Canvas Size. In the dialog box that pops up, change the units for the new size to percent and set the width to 200, leaving the "Relative" box unchecked. Next, click the middle left square in the Anchor (position) diagram. (Leave the "Canvas extension color" whatever is listed as it will be covered by the other image and not matter.) Click "OK"—your image will suddenly have blank space on the right. Click your second image and select Edit > Copy to copy it. Go back to your newly enlarged first image and select Edit > Paste to place your second image into the first image. All you need to do now is slide that image to the right using the right arrow button on your keyboard until it is lined up correctly. Flatten the new diptych (Layer > Flatten Image) and save it as a new JPEG.

When choosing which image will go on which side of a diptych, think about how they will flow together. The eye normally looks at things from left to right, so if your images tell a story, you should place them in that order.

Taking two photographs with seemingly nothing in common, like this diptych of an antique camera and a flower, can spark conversations. Diptychs work best when they are united by some element of design, such as similar colors and tones.
◀ (left) Nikon D3 with Nikkor 60mm micro F2.8 lens | ISO 1000 | f/4.0 for 1/100 sec.
◀ (right) Nikon D3 with Nikkor 60mm micro F2.8 lens | ISO 1000 | f/4.2 for 1/200 sec.

chapter ten

SEEING THE WORLD (OR JUST YOUR OWN HOMETOWN)

So often we wander through this amazing world and don't take much notice of it. Whether you are on a luxury holiday with your family, backpacking with friends, or just stepping out your front door for a walk by yourself, we encourage you to really *see* the world. This chapter isn't about getting great landscape shots; it is about learning how to look at the world and share it with others through your images. It is about connecting to life as it surrounds you—whether that is your neighborhood café or famous monuments in a far-off land.

TRAVEL DOS AND DON'TS

Daunted by the weight and complexity of your DSLR, you may be tempted instead to take a small point-and-shoot when traveling. But please don't leave that fancy camera at home. It is not going to take any nice photographs sitting on the shelf. Here are some simple tips that can make it easier and less worrisome to bring your camera on a trip.

Get to know your camera settings. If you are fussing with your settings, or have to check each shot on the LCD screen, you will miss things. You will also draw attention to yourself by standing there concentrating on your camera.

Bring a dust blower and lens cleaner. A dirty camera is a dirty camera—it's also avoidable.

Let go of the prime lenses. This is the time to invest in a full- or medium-range zoom lens. The convenience of being able to change focal lengths without changing lenses is essential to making photography on the go a pleasure.

Buy a comfy strap. The camera strap that came with your camera is usually just an advertisement for the brand. There are many other options out there that pad your neck or add a bit of buoyancy to the camera with elasticized sides. Some even extend so you can keep the camera close to your body until you need to pull it out for a shot. When selecting a camera strap, comfort is key.

Buy a filter and leave your lens cap in your bag. If your lens cap is on, you are not ready to take a photograph.

Get a great bag. There are many bags on the market. Peta carries her camera with lens attached and extra memory cards in a small Lowepro bag that conforms to the shape of

P We recommend taking your DSLR in carry-on luggage—take it out before you stow the bag overhead and keep it within reach over the course of the flight. You will be given plenty of opportunities for fantastic shots with a bird's-eye view, especially if you have reserved a window seat.
▶ Canon 5D with Canon 24–70mm F2.8 L lens at 57mm | ISO 400 | f/3.5 for 1/100 sec.

her gear. It can be carried on its own or tossed inside a larger bag, all the while keeping the camera and lens protected. It's easy to access the camera, so shots are not missed. Rachel carries more things with her, so she uses a camera bag that also serves as her handbag. Epiphanie and Emera are just two of numerous handbag-style camera bags now on the market. Carrying a bag that blends in as a purse also keeps you from sticking out too much as a tourist.

So take your point-and-shoot, take your camera phone, but take your DSLR, too. The images you bring back will make you glad you did.

R These sparkle shoes have traveled many miles. By showing only the shoes and the train window, I left viewers to weave stories in their imagination. The unexpected composition also represents how comfortable my well-traveled daughter Gemma is with being on the go. ▼ Nikon D3 with Sigma 24–70mm F2.8 lens at 28mm | ISO 1600 | f/3.5 for 1/100 sec.

SHOOTING FROM THE HIP

R On a trip to Venice, I saw this woman sitting on a bench. Her hair and outfit matched so well with the surroundings, it all looked like a beautiful painting. I zoomed my lens and held the camera at hip level pointing in her direction. With the proper exposure already set and the focus set to closest subject, I was able to capture the scene without her noticing.

▲ **Nikon D3 with Nikon 24–85mm F3.5–4.5 lens at 78mm | ISO 640 | f/6.3 for 1/1000 sec.**

Whether you are on the other side of the globe, or two towns away, it can feel awkward to pull out your camera and start shooting. Every situation is different, but taking photos in a respectful manner can actually open up connections and conversations with locals. The trick is to be polite—ask for permission where it seems appropriate, and be considerate if people say no. Children especially love posing, and may want to see their image on your LCD screen (always ask the parents' permission if they are present).

There will be many moments when you want to capture a scene without making it obvious that you are taking a photo. To capture something without drawing attention to yourself, try shooting from the hip. To do this, simply shoot with your camera down by your side. This means what is captured will be somewhat of a surprise. Use the widest focal length available on your lens to get as much in the shot as possible—you can always crop later. Make sure you have a high-capacity memory card and shoot *lots* of photos. This approach is particularly useful for capturing market and street scenes, when you want to catch daily life and not draw attention to your camera.

Shooting from the hip means you'll get some strangely angled and out-of-focus shots, but you can also get some real keepers. Try to keep the bottom (or edge, if shooting portrait orientation) of the camera parallel to avoid Dutch angles (see page 76).

LANDMARKS

While we encourage you to look beyond traditional landmark snapshots as much as possible, what is a trip to London without Big Ben? Or Paris without the Eiffel Tower? These things have been photographed millions of times, but it may be the first time they are in front of *your* lens.

Get a few of the standard postcard shots, then try some new angles. Get close to something tall and shoot straight up; the mammoth structure will seem even more overwhelming at that vantage point. Put the element in context with your travel partners by using a wide-angle lens and a small aperture, placing people close to the camera and the landmark in the background. You can also try a wider aperture, focusing on the people and throwing the landmark in the background into a bit of a blur. Iconic structures like the Golden Gate Bridge are identifiable even when not in focus.

Finally, don't forget the small landmarks that make a trip your own—the funky hotel room that did not look as advertised, or the tall glasses of Guinness in that Irish pub.

R Waiting just a moment before clicking the shutter button made all the difference in this shot of Big Ben. The airplane trail not only suggests travel, but it also guides the viewer around the image, starting from the clock tower leading into the frame, up to the clouds, and then back down with the jet as it crosses the sky.

▲ **Nikon D200 with Tamron 17–50mm F2.8 lens at 17mm | ISO 200 | f/8.0 for 1/250 sec.**

SCENERY

The world is beautifully designed. Even the most boring fields become fascinating when you start looking at colors, patterns, and textures.

One thing to think about with scenery shots are leading lines, those lines within an image that lead the eye in a certain direction. These are important elements of visual design, and nature is full of them. A leading line can be a curving country path that takes the viewer on a journey through your image, or rolling hills that add depth to a scene. Straight lines of trees become a vertical pattern across the frame that is a beautiful stand-alone shot. Lines of trees, when shot from the side, can guide the eye into the frame. Think about lines and angles and how you want to compose your shot.

The horizon line will be the most common line in your images. Keep in mind the rule of thirds (see page 68) and set the horizon in either the upper or lower third of the image, so as not to divide the shot directly in the middle. Also, remember to keep it natural. A mountain may have a steep slope, but don't slant the sea so that it looks as if it will rush out the corner of your shot. Look for symmetry; pay attention to reflections on water and groups of repeating patterns. These can make for striking images.

Color is an integral factor of any shot, but it is especially important in scenery. Colors create an overall feel at first glance. Cool blues suit a calm image, while the earthy oranges of the desert will accentuate the heat. Take notice of the colors that dominate the area around you: the lush greens that can only be found in wet climates, or the incredible shades of gray in cold climates.

Use weather and light to your advantage. Instead of bemoaning the rain, take cover and photograph the downpour. Experiment with a fast shutter speed to catch the drops midair. Use fog to add mystery and texture to your scene. It's best to avoid taking portraits outside at noon, but the midday sun casts interesting shadows from trees and adds contrast to your images.

Landscape photography is the time to stop down your lens to a small aperture, such as f/22, to ensure the image stays in focus over varied distances. Use your widest focal length to include the most sweeping scenes and then your macro lens to follow up with photos of delicate details. Flaking bark or a dried-up riverbed is amazingly complicated when you stop to look closely. These details contain the essence of a place. Capture them while you can, and you'll always remember them.

R Traveling through the desert outside Los Angeles at sunset makes for incredible skies as the light travels through and bounces off the smog. This row of windmills provides an industrial contrast to the natural scene. Looking back on this makes me miss my time in California.
▲ Nikon D200 with Tamron 17–50mm F2.8 lens at 50mm | ISO 250 | f/6.3 for 1/160 sec.

P A rising sun lit the Castle Point lighthouse in New Zealand with a beautiful golden glow. Notice how the lighthouse is off center, with the curving wooden pathway leading the eye through the image.

◀ Canon 5D with Canon 24–70mm F2.8 L lens at 24mm | ISO 400 | f/4.5 for 1/1600 sec.

P I shot this photo with the sun setting behind the camera, illuminating the field and barn in a soft light and bringing the colors to life.

▼ Canon 5D with Canon 24–70mm F2.8 L lens at 25mm | ISO 100 | f/5.0 for 1/800 sec.`

The glassy, reflective water on the sand of the beaches along Great Ocean Road in Australia provided a surreal, sweeping backdrop for my friend's family to stretch their legs after a long drive. The little girl almost looks as though she is skipping in the clouds. The sun was hiding behind the clouds creating a filtered light—a real treat with beach photography, where there is little shade to be found.

▶ Canon 5D with Canon 24–70mm F2.8 L lens at 24mm | ISO 100 | f/3.5 for 1/1000 sec.

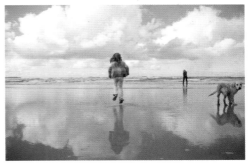

SHOOTING AT NIGHT

There is something magical about a well-photographed night scene, whether it is city lights in a bustling metropolis or the glow of a cabin in the woods. The main secret behind getting a great nighttime shot is using a long exposure (a slow shutter speed). This means the twinkle of lights and the ambience of the scene can be captured.

Because you will be using a very slow shutter speed, your camera will need to be absolutely still. The best way to do this is to set your camera up on a tripod, but not everyone wants to schlep a tripod on their travels. There are also some portable options that are great for travelers, like the GorillaPod, which fits into a camera bag or backpack. If you don't want to invest in a tripod, keep your eye out for surfaces that are solid and safe to set your camera on (the railing of a bridge may not be the best idea).

Try to keep your ISO low (around 100 is best). Put your camera on Evaluative/Matrix metering mode (see page 24), and start with an aperture of around f/5.6. Ideally, your shutter speed should be between 3 and 30 seconds. It may take a bit of trial and error to get the exposure exactly right, but just go for it. Then review the shot and adjust accordingly if you think the scene needs to be lighter or darker. With such a long shutter speed, even the press of the shutter may move the camera enough to mess up the shot. If you find this happening, either use the self-timer or a remote if you have one. This technique is also the best way to capture fireworks.

If you need to capture action at night and want to avoid the black background and bright subject people tend to get when using a flash, try a little technique called "dragging the shutter." Select a slow shutter speed, such as 1/30th of a second, and set your pop-up flash to TTL. (This is an automatic metering mode that tells the flash to let the camera meter the scene through the lens.) This will allow you to record the ambient light in the background as well as freezing your subject. You may also create some interesting trails of light as bright things (like cars) move through the frame.

R There is something so exciting about Christmas in New York City. To capture the hustle and bustle, I photographed Fifth Avenue as the evening began. The lights were coming on, and the street was busy with people going home from work. The regular building and traffic lights took on appropriate tones of green and red, while the star stole the shot in all its gleaming glory.
▶ Nikon D100 with Tamron 17–50mm F2.8 lens at 50mm | ISO 800 | f/3.5 for 1/30 sec.

GET INSPIRED

If you are feeling uninspired about your travel photography, or overwhelmed by the options, here are some ideas to help you. The most important thing, of course, is to have fun.

Scavenger hunt. Traveling itself is sort of like a scavenger hunt, so why not make it official? Make a list of things you want to see and track them down. This is particularly fun if you have school-age children or older. Get them involved in making the list and finding the items.

Doorways and windows. When you travel you are an outsider, wondering what life might be like if you lived in this different place. Doorways and windows are poignant symbols of this—from the brightly painted front doors of Dublin to Japanese wooden-and-paper sliders. These portals into a different life make for an evocative photo essay.

Colors. Have you ever walked through a city and looked for only one color? Search for blue in Paris, or neon in New York. Alternately, look for colors that are not familiar to you—the celadon green pottery in Thailand, for example, or the orange robes of monks in Laos.

Food. A huge part of experiencing another culture is trying new foods, so why not record them? Start on the airplane with your prepackaged meal. Record your breakfasts (pastries in Europe, soup and rice in Asia), snacks you have never seen before, and other meals. Don't miss local food markets, grocery stores, and street vendors. The varied ways people feed themselves around the world is a fascinating theme.

Transit. How did you travel on your trip: Was it a road trip or a plane ride? Did you take the subway, and was it clean? How people move around is another intriguing theme, one that says a lot about the place you are in. Are there high-speed trains, or rattling old buses with livestock in the back?

R The markets in Japan were so beautifully appointed that even the melons looked like gifts. It was a stark contrast to the piles of produce I'm used to seeing in our local grocery store!

▲ Nikon D100 with Tamron 17–50mm F2.8 lens at 50mm | ISO 800 | f/3.2 for 1/200 sec.

Flora and fauna. Depending on where you go, the foliage may be dramatically different from what you are used to. Think cactus in the arid desert, lush jungle on tropical islands, or redwood forests that tower high above you and catch the coastal fog. Make sure to record the unfamiliar and beautiful things you see.

Clothing. Document what you are wearing on your travels (sandals? a parka?), and don't forget about what people are wearing around you. From the handwoven textiles of Guatemala to the high fashion of Milan and Paris, local clothing is fascinating. People express the spirit of the place when they dress, as well as their own innate style. To get inspired for taking street fashion shots, the best site to look at is the Sartorialist (http://thesartorialist.blogspot.com).

Look up and look down. Sometimes the best shots come while looking at things from a different angle. How does the sky look in this new place? Is it a big sky exposed over wide-open plains, or the truncated sky of a big city cut off by tall buildings? What does the ground look like? Is it the moist green fields of Ireland, or arid desert and shifting sands?

R This shot of our baby's foot emerging from the airplane bassinet is a humorous way to mark an infant's first major journey. It becomes a universal image of the fears parents have of traveling with children, who never sit still for an entire flight.

▲ Nikon D100 with Tamron 17–50mm F2.8 lens at 30mm | ISO 800 | f/3.2 for 1/150 sec.

R Look for interesting juxtapositions, like the colorful coat of my daughter Gemma parting the sea of dark-suited businesspeople as she walked her dad back to the office after lunch. Keeping part of the stroller and baby toys in the frame adds another layer of interest to the story and makes it personal.

▲ Nikon D3 with Sigma 24–70mm F2.8 lens at 28mm | ISO 640 | f/11 for 1/800 sec.

R There is a hotel in Melbourne, Australia, where the swimming pool overhangs the street below. At the moment I was passing underneath, a hotel guest was enjoying the view from his spot in the water.

▲ Nikon D200 with Tamron 17–50mm F2.8 lens at 50mm | ISO 250 | f/18 for 1/160 sec.

IN YOUR OWN BACKYARD

If you're feeling jealous or deflated by all this travel talk, be assured that you don't need to travel to take great photos. There's an endless well of images to explore in your own hometown. Just bring your camera and a sense of adventure.

You may be surprised by how much fun you can have in your own backyard when you take a photo walk. Often you will find beautiful things without leaving your own block. Here are a couple suggestions, if you're not feeling inspired.

Tripod 365

Set up a tripod and place your camera on it every day at the same time for a year to watch that corner of your world unfold. Do the same people pass on the sidewalk outside your window? Or watch how the light falls and how the flowers bloom on the tree in the backyard. There is beauty to be found right in front of us, if only we take the time to notice.

R This is a special tree, as the first image was taken as I contemplated the news that one of my friends had lost his wife in an accident. I saw the beauty in the tree's blooms against the chilly winter clouds. I think of my friend every time I see this tree; watching it change and grow over the different seasons makes me stop and honor the passing of time. The other image was taken in spring some two years later.

▲ (left) Nikon D3 with Nikkor 60mm micro F2.8 lens | ISO 200 | f/5.0 for 1/300 sec.; (right) Nikon D3 with Nikkor 60mm micro F2.8 lens | ISO 250 | f/5.0 for 1/500 sec.

A Photo Walk

Anyone who has ever taken a walk with a child knows they can easily turn a five-minute trip to the corner into a half-hour adventure. Normally we try to hurry them along, but this time we urge you to slow down. Take your child for a walk (or borrow a friend's child; they'll be grateful for the break) and learn about the world through a child's eyes. (Make sure you put him in a cute outfit—this is *all* about the photographs!) Stop when the child stops, and ask him to show you what he has found. Being a child means the commonplace is filled with wonder. Photograph their treasures—you may pick up a sense of wonder, too.

If no child is easily at hand, set aside an hour or so and go wander by yourself, or with friends who also like to take pictures. Explore your neighborhood, or visit another neighborhood or park you've always admired. Perhaps there is a cozy café you've always wanted to photograph. Summon up your courage and give it a try. Many towns have groups that get together just to take photo walks. Research and see if there is one near you. They are a great way to meet other amateurs and often are led by a pro.

Go slow and look all around you—up, down, under trees and bushes. You'll be surprised by the beauty of water droplets caught on a leaf, a handful of petals blown on the wind, a gathering of friends laughing over coffee. One photographer we know takes a twenty-minute photo walk each morning, starting her day with beauty and wonder.

If you have a macro lens, this is the perfect time to put it on your camera. A macro lens will let you get in close and capture the details. Kneel down to photograph from a lower perspective. Try venturing out during the "golden hour"; the day's last hour of light is so rich and warm and will add a bit of magic to the scene.

The world is a stunning and beautiful place—whether it is the wide and foreign world far away or the daily world we live in. Take your camera along for the trip and let it wake up your sense of curiosity and awe.

P These four photos were taken in the space of a few hundred meters on an evening walk. The last few weeks of summer in New Zealand are rife with brown grasses in gentle winds, and I was doing an exercise in changing perspectives and freeing myself from perfectionism. I got down low to look at details, played with not focusing so as to capture a simple curve in the road in a dreamlike way, and looked up to see birds chirping from their wire.

▶ (top left) **Canon 20D with Tamron 17–50mm F2.8 lens at 50mm** | ISO 100 | f/3.2 for 1/800 sec.

▶ (top right) **Canon 20D with Tamron 17–50mm F2.8 lens at 50mm** | ISO 100 | f/3.2 for 1/400 sec.

▶ (bottom left) **Canon 20D with Tamron 17–50mm F2.8 lens at 28mm** | ISO 100 | f/3.2 for 1/400 sec.

▶ (bottom right) **Canon 20D with Tamron 17–50mm F2.8 lens at 50mm** | ISO 100 | f/3.2 for 1/400 sec.

chapter eleven

SEASONS OF CHANGE

Like photographs, our memories are firmly planted in the seasons. No doubt your childhood memories revolve around seasons past. Peta has memories of running around barefoot while camping with her family in the summer. Rachel remembers summers spent on the family sailboat, her dad at the helm. Rachel's North American Christmases always had a blanket of snow, sledding, and pumpkin pie, while Peta's New Zealand holidays were about long, warm nights, barbecues, and Pohutukawa trees in bloom. Let's look at how to best capture the atmosphere of our favorites seasons and holidays, whatever they mean to you.

WINTER

Winter's short days, long nights, and cold weather provide their own challenges, but these can also be factors in making lovely images. With a little bit of skill, winter wonderlands can be captured in all their white glory without losing details in the scene. The key is to trick your camera's light meter.

There are a few ways to do this, all of which are easy when you control the camera settings with manual exposure. Camera meters try to render the best exposure for a neutral gray—that's how they are programmed. White, however, is not gray, so if you let the camera do what it thinks is correct, the scene will be underexposed and you'll end up with gray, dingy-looking snow. This is one of those times when the fancy technology in your camera fails the task at hand. Point-and-shoot cameras and some consumer DSLRs have snow scene modes to compensate, but you can do the same on your own.

The simple solution is to set the camera to Spot meter (see page 25), then take an exposure reading of your hand outstretched in front of the lens, palm side up. The camera will give you a shutter speed and aperture combination to expose for the tone of your hand (which is closer to that middle gray than the snow). Make a note of these settings—they will be your starting point. (If you plan on being in a lot of situations that are tricky for your camera, you can buy a photographic gray card to carry with you that will produce better results than your hand. There are some made small enough to go in your camera bag.)

Switch your camera to manual and enter the settings you wrote down. You may want to slightly underexpose from there (maybe 1/2 stop) to make sure there is detail captured in the white snow. To do that, select a faster shutter speed or smaller aperture than recommended to reduce the amount of light recorded. Check your LCD screen and histogram for overexposure warnings. (As we mentioned on page 80, if all the lines in the histogram are on the extreme right side, your image is overexposed.) You can also check the "blinkies," which we talked about on page 80, to avoid overexposing the scene and losing detail in the highlights.

The best part of winter in the Northern Hemisphere, of course, is holiday meals, celebrations, and decorations. This is the season of lights—and the photographic challenge of how best to capture them. See page 222 for more on photographing the holidays.

> *Don't stop with sweeping landscapes during winter. While the grand scenes covered in snow may be breathtaking, ice formations are a perfect subject for your macro lens and can reveal extraordinary beauty and geometry.*

P I took this shot from the deck on a foggy winter morning. The scene had an eerie quality that lent itself well to a strong contrasting black-and-white conversion. The lone horse framed by the dark trees made the shot for me.

▲ Canon 20D with Tamron 17–50mm F2.8 lens at 50mm | ISO 200 | f/4.0 for 1/100 sec.

R When the camera tries to read a scene like this, with such contrasting areas of dark and light, it gets confused and calculates the exposure incorrectly. If the camera meters off the trees, the image will likely be overexposed (too bright); if it meters off the snow, the image will be underexposed (too dark). Shooting in manual allows you to take control and get the exact exposure you want.

▼ Nikon D100 with Tamron 17–50mm F2.8 lens at 28mm | ISO 200 | f/5.6 for 1/750 sec.

R Action on the ice at New York City's Rockefeller Center is rendered with an almost painterly quality by using a very slow shutter speed. I rested the camera on the railing to prevent camera shake, used a small aperture to bring as much of the scene into focus as possible, and allowed the flash from a camera across the way to be recorded as a starburst.

▲ Nikon D100 with Tamron 17–50mm F2.8 lens at 60mm | ISO 800 | f/13 for 1/4 sec.

SPRING

Spring is a great time to think about fresh starts. Get out in the garden and look for blooms or spiderwebs catching the morning rays. Take your cue from the season and start something new in your own life—begin a 365 Project (see page 164), or upgrade your photo equipment (look on eBay for deals; other people may be spring cleaning, too).

Spring also brings a certain sort of weather—namely, rain—which can be both fun and challenging to photograph. While no one wants to get their camera wet, warm spring rains are a wonderful time to get playful shots of your kids or friends. Encourage bright colors for clothing and umbrellas. Those pops of color against the gray will look lovely. Take your flash for filling in the gray, overcast light. Be mindful of the splashes, but let yourself and your subjects have fun.

After the rain shower has passed, have your camera ready for rainbows. You're going to want to use a small to medium aperture to get the whole scene in focus (f/8 to f/5.6 is a good place to start), and maybe even underexpose the image slightly to capture the distinct bands of color.

Spring is a great time to take out (or purchase) a macro lens. This is what you're going to want to use to capture all the beautiful flowers that are blooming. A macro lens will help you get in close enough to capture the smallest details and patterns.

Spring is also the time when baby animals are born—take a trip to the zoo or nearby farm, or even a local duck pond, to capture this annual event. As with flowers, a macro lens is a great tool to get detail shots of new baby birds, or the gorgeous blue of a robin's egg in a nest.

R I love to get up early. At dawn, the drops of dew in the garden look like little diamonds, a secret reward for those who get up early enough to see them. Dawn is a beautiful time of day for photos with the crisp blue hues cast as the sun begins to rise. Using a long focal length, I was able to get this close-up shot from our back deck without having to get down into the muddy yard.
▶ **Nikon D3 with Nikon 105mm f/2 lens | ISO 800 | f/4.5 for 1/125 sec.**

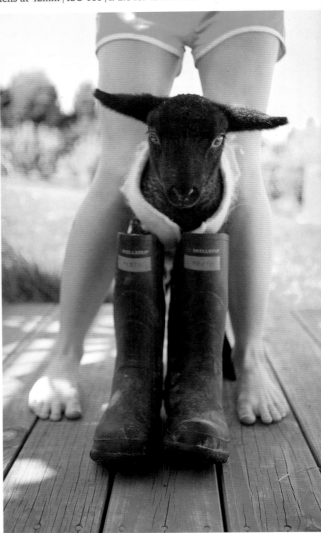

P Spring is the season of baby animals, and baby animals don't get much cuter than pet lambs. In this shot, my sister couldn't resist getting her little shadow, Billy the lamb, to try on her rain boots.

▼ **Canon 5D with Canon 24–70mm F2.8 L lens at 42mm | ISO 160 | f/2.8 for 1/250 sec.**

P Moments like this can't be planned. I noticed this amazing rainbow and coaxed Gemma outside to dance under it in the misty rain. Not only was the rainbow wonderful, but the light was just setting behind me, casting a warm glow over the whole shot.

▲ **Canon 5D with Canon 24–70mm F2.8 L lens at 24mm | ISO 250 | f/3.5 for 1/200 sec.**

R Melbourne gets glorious rainstorms, and on one particular day, my daughter and I decided to turn it into a fun photo session. I used a Lensbaby Composer lens to enhance the feeling of excitement with its signature zoom-like blur. I also used my external flash to fill in the flat overcast lighting, which illuminated individual raindrops like little jewels.

◀ **Nikon D3 with Lensbaby Composer** | ISO 250 | 1/80 sec.

SPRING CLEANING

Do a little spring cleaning of your own and send your camera to an authorized service center for a thorough sensor cleaning and calibration. You may notice some dust spots showing up on your images (you will know it is sensor dust if it appears as translucent blobs in the same spot on each frame). The more you change lenses, the more chance there is that you will get dust. But even if you never change lenses, the camera attracts dirt. Tiny particles will look enormous on your images.

If you are not sure whether or not you have dust problems, take a photo of a blank sheet of paper and open the image in your editing program. The dust spots will be fairly easy to see. Some cameras have a sensor cleaning setting where the camera shakes the dust free at a high speed. This is a great option for the short term, but once a year it is a good idea to get some proper camera maintenance.

SUMMER

Summer can be the harshest season for your camera. The camera tends to get a ton of use when the days start getting longer. Sand and water are not friends with electronic equipment. This does not mean you should miss out on any wonderful beach shots, but it is important to protect your camera. Summer vacations often produce some of the most colorful and relaxed photo opportunities. Don't leave your camera at home; just be prepared.

If you plan on camping by a river, going on a tropical cruise, or heading down to the local beach, think about investing in an underwater casing for your camera. Not only will you be able to take your camera in the water, you will know that it is safe from splashes and other water-related mishaps. Proper housing will also help protect the delicate workings from the evils of sand and dust. If you live somewhere hot—or will be traveling somewhere that is—be prepared for lens fog when you go from the air-conditioned indoors to the sweltering outdoors. Try to avoid wiping away the condensation and instead just wait for it to clear.

Those long summer days filled with bright sun can be challenging for photographers, leading to washed-out images and harsh shadows. When shooting in full sun, expose for the middle tones in the scene. If you expose for the shadow areas the rest of the photo will be overexposed, and if you expose for the light areas the rest of the photo will be underexposed.

Here is also where your lessons on modifying the light come into play. To avoid harsh shadows, use your flash or a reflector to bounce light onto the darkened shadow areas. Modify the bright midday sun by "flagging" the light—using a translucent or opaque object between the light source and the subject. Or seek out an area of open shade, making sure whatever shade you find is not dappled. Trees and other foliage often cast an uneven shade—scan the ground for telltale spots of light.

The other thing to know about summer is that a bright sandy beach can present the same challenge as a hill of snow—too much white prevents the camera from selecting the right exposure. Review the tricks we talked about on page 208 for snow—they come in handy when dealing with white sand as well.

And what would summer be without those wonderful sunsets? Long evenings end dramatically with washes of color that stick around long after the sun has dipped below the horizon. Conjure up those feelings of warm summer nights all year long by printing your best sunset shot and hanging it in your home.

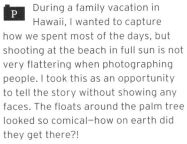 During a family vacation in Hawaii, I wanted to capture how we spent most of the days, but shooting at the beach in full sun is not very flattering when photographing people. I took this as an opportunity to tell the story without showing any faces. The floats around the palm tree looked so comical—how on earth did they get there?!

◀ (top left) **Canon 5D with Canon 50mm F1.8 lens | ISO 200 | f/2 for 1/1250 sec.**

◀ (top right) **Canon 5D with Canon 50mm F1.8 lens | ISO 200 | f/2 for 1/1250 sec.**

◀ (bottom left) **Canon 5D with Canon 50mm F1.8 lens | ISO 200 | f/2 for 1/2000 sec.**

◀ (bottom right) **Canon 5D with Canon 50mm F1.8 lens | ISO 200 | f/2 for 1/1250 sec.**

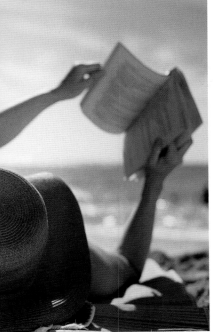

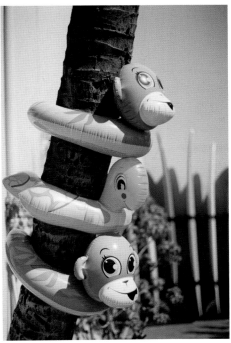

P These cheerful beach cabanas in Melbourne evoke old-fashioned seaside summer vacations.

▼ **Canon 5D with Canon 24–70mm F2.8 L lens at 24mm | ISO 125 | f/11 for 1/200 sec.**

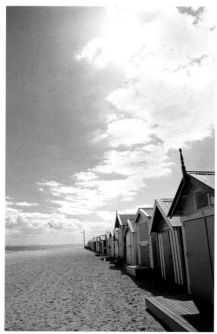

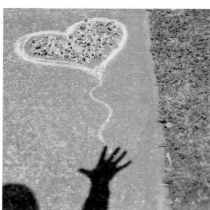

R If all else fails and you just can't escape the sun, look down! There is so much fun to be had photographing shadows in summer.

▲ **Nikon D3 with Sigma 24–70mm F2.8 lens at 60mm | ISO 200 | f/3.5 for 1/1250 sec.**

P Even without seeing this child's face, you can sense her eagerness for the perfect wave.

▲ **Canon 20D with Tamron 17–50mm F2.8 lens at 31mm | ISO 400 | f/3.2 for 1/400 sec.**

R I captured this image of the beach in Bali just as the sun slipped out of sight. Keeping the white balance set on Shade overrode the camera's attempt to add blue back to the scene. Exposing for the sky allowed most of the figures on the beach to become silhouettes, but the beach flag and sails on the kite retained their color. A little bit of the string from the ship-shaped kite was visible, so I cloned it out in Photoshop to add to the sense of magic.

▲ Nikon D200 with Tamron 17–50mm F2.8 lens at 50mm | ISO 100 | f/4.5 for 1/125 sec.

AUTUMN

As autumn rolls around, we reflect on the year that has passed and prepare for being inside when the cold comes. Autumn leaves are the classic images of the season, and this is the time to go into your JPEG settings and set the picture controls to "vivid." Keep people out of these shots and focus on the scale of the foliage. You can also look into getting a polarizing filter for your lens. These filters are not great for portrait photography, but they help bring out the deep blue of the sky and will make your fall colors pop even more.

Autumn is the season to find a farm that will let you pick your own fruit and vegetables. Or maybe your own urban farm or garden is yielding a small crop. No matter how big or small the harvest, the food of this season is a rich subject for detail shots, as are the family gatherings that accompany them.

We've talked about the golden hour—that last hour before the sun sets and the gorgeous light it casts—but what about the time right after the sun dips below the horizon? Crisp fall nights are the perfect time to explore dusk. There's a very short window of time, but the sky is vibrant with deep color as the last light disappears. Have a tripod and use a long exposure to record the colors. Silhouette those fall trees against the sky, and don't worry about exposing for the trees. Carefully frame your image and they will become beautiful shapes against the dusky sky. Keep an eye out for the harvest moon as well. Full moons in the fall are particularly stunning—again, keep your tripod at close hand.

If you plan on sending out holiday photo cards, take advantage of nature's colorful backdrop and the last of the long evening light to get a beautiful family portrait. Fall is the perfect time to gather your images from the year and think about preserving them for the future. Photo books and calendars make wonderful holiday presents.

Fall is also a good time to make sure your photos are organized and up to date. Consider dedicating one month every autumn to backing up your files. While we recommend you back up your images on at least a weekly basis, it is good to have a specific time set aside to catch up since life often gets in the way. Once you are certain that your files are backed up onto external hard drives or an online storage system, and your cards, books, and calendars have been ordered, you can clear the images off your main computer.

P Children are drawn to the beautiful colors and shapes of autumn leaves, and picking up a few on a walk can prove irresistible. Here I set the bright orange leaf against the duller grays and blues of the girl's dress, using a large aperture to focus on the leaf and send the girl into blur.

▼ Canon 5D with Canon 24–70mm F2.8 L lens at 70mm | ISO 320 | f/4.0 for 1/200 sec.

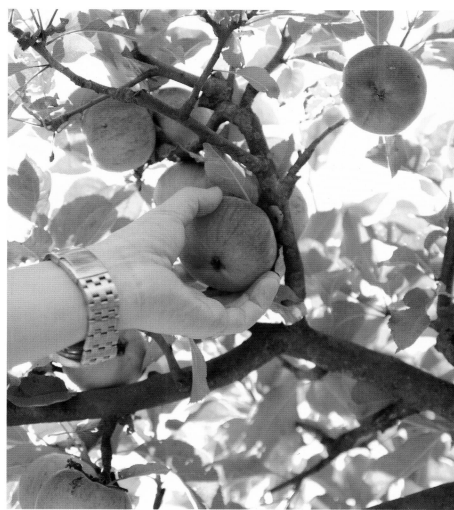

R A hand reaching for the apple turns a simple nature shot into a chapter from your own personal photo story.

▲ Nikon D200 with Tamron 17–50mm F2.8 lens at 50mm | ISO 320 | f/3.2 for 1/400 sec.

R Walking with my daughter in the woods of rural Virginia during fall is a photographic treat of color. No extra saturation was needed.

▲ **Nikon D3 with Nikon 105mm F2 lens | ISO 640 | f/8 for 1/400 sec.**

R Not every environmental portrait you take in fall has to be framed with colorful leaves. These tall grasses, coupled with the golden hue of late afternoon sun, made this portrait of my friend's oldest daughter simply glow. When you are shooting within the reeds and grasses, be sure to include some in the foreground as well as stretching out behind your subject to give your portrait depth.

▲ **Nikon D3 with Nikon 28–105mm F3.5–4.5 lens at 92mm | ISO 800 | f/4.5 for 1/200 sec.**

As summer leaves, the storms come in, like this one captured over Virginia's Chesapeake Bay. Taken from the safety of a large window (it is not the best idea to stand outside in a lightning storm with a large metal object in your hands), I rested the camera on the ledge so it did not move during the exposure. This was a very lucky shot, as the best way to capture lightning strikes is with a much slower shutter speed—that way, you'll record all the strikes of lightning that occur while the shutter is open.

▼ **Nikon D200 with Tamron 17–50mm F2.8 lens at 28mm | ISO 100 | f/4 for 1/40 sec.**

Setting your camera to record JPEGs in "vivid" will add a splash of color to your shots. Even this dying hydrangea is beautiful straight out of the camera. Keep in mind that skin tones will also become saturated, so this setting is not a good choice for portraits.

▲ **Nikon D3 with Nikon 50mm F1.4G lens | ISO 320 | f/1.4 for 1/1000 sec.**

HOLIDAYS

Certain times of year come with their own iconic guideposts for your photography. While some holidays are celebrated the world over, no one does it quite like your own family. Photograph the traditions that make these holidays yours.

Whenever Easter lands in your part of the world, the egg hunt tradition is something to look forward to. Capture bed-headed kids as they wake up to see Easter baskets waiting, the thrill of the hunt all over their excited faces. Photograph Thanksgiving meals, beautifully set tables, and family and friends gathered. Who doesn't look back on photos from Halloweens past and smile at the costumes? Keep your eyes open for fun decorations neighbors have put up.

Besides the prerequisite Santa photo, there are endless great shots to be taken over the Christmas and Hanukkah seasons. Record the lighting of the menorah, the reindeer food left for Santa, and school recitals. Take photos of special gifts to share your appreciation to senders from afar. A photo showing a child enjoying a particular gift makes an extra-personal thank-you card.

Nothing says Christmas better than a decorated tree. It's just a visual joy—which you can represent by taking an abstract image of the lights. Use the largest aperture available on your lens and set the camera to manual focus. Use a fairly slow shutter speed and purposely unfocus the shot using the focal ring on your lens. Your Christmas lights will take on a whole new look of wonderfully soft, round colors.

If you want a truer representation of holiday decorations, head out into the neighborhood. Plan to shoot just as the sun sets, so you can get the last color in the night sky as well as sparkling lights. You will need a long exposure, which means a slow shutter speed (1/20th of a second or slower) and a tripod. Your camera may have trouble with the auto white balance, so try the Tungsten setting to balance the artificial lights and setting sun. Also, you'll want a small aperture (large f-stop number, around f/8) so that the scene is in crisp focus and the lights have that "twinkle" star shape.

The holidays are also about candles. To capture the soft glow of candlelight, turn off your flash completely, as that light will ruin the ambience you are trying to capture. Next, secure your camera on a tripod or other surface so there is no blur from camera movement. Choose a medium-slow shutter speed—1/20th of a second is a good place to start. The background will be much darker than the lights, so ask your subjects to come as close to the candles as is safe so they will be illuminated by the glow.

In a situation like this, the camera may have trouble with metering and white balance. The auto white balance may cool down the orange glow of the candles too much. Try a custom white balance, as we discussed on page 48, or try the various white balance settings until you find one that preserves the warm tones. Evaluative metering will also have issues, since the image will be mostly dark. Try Spot metering on the subject's face, as discussed on page 25, and review the image on your LCD.

P Kids have a way of waking up extra early on holidays. Take advantage by making the most of the glowing morning light. In this shot, a friend's little girl and her brothers got into their Easter best just in time for the sunrise.

◀ **Canon 5D with Canon 24–70mm F2.8 L lens at 70mm | ISO 200 | f/5.0 for 1/250 sec.**

R With Christmas decorations going up in stores even before the Halloween ones come down, it can be easy to get jaded. But the massive Christmas tree at Rockefeller Center in New York City still holds some of that special holiday magic.

▲ **Nikon D100 with Tamron 17–50mm F2.8 lens at 50mm | ISO 800 | f/5.0 for 1/90 sec.**

Halloween is the perfect time to experiment with shadows as it can add to the spooky feeling—like in this interesting shot of my daughter and me trick-or-treating.

▲ **Nikon D200 with Tamron 17–50mm F2.8 lens at 17mm | ISO 320 | f/5.0 for 1/1250 sec.**

Christmas lights are a great opportunity to make shaped bokeh. To do this, use a large aperture lens (50mm F1.8 will work well). Carefully place your lens face-down on a piece of black cardstock and lightly trace around it, then cut out the circle. Cut a 1/2-inch (about 13mm) shape out of the center of the paper—here, I cut out a heart. Tear off another strip of paper and attach it around your cut circle as a lens hood, then tape the whole thing to the outside of your lens. Set your camera to the widest aperture (f/1.8 in this case) and switch your lens to manual focus. Make sure the lights are out of focus when you look through the camera. Press the shutter and *voilà*: shaped bokeh.

◀ **Canon 20D with Canon 50mm F1.8 lens | ISO 100 | f/1.8 for 1/100 sec.**

GET INSPIRED WITH MOOD BOARDS

Seasons evoke different feelings and moods, like the chill of winter with its absence of color, or the heat of summer and warm, bare skin. While not all photos capture the season in a literal way, think about how the color, lighting, and compositions you use evoke specific feelings. Look at this series of mood boards, each capturing the essence of a different season.

You can use an exercise like this as simple inspiration, or you can dive deeper and really look at how the pictures are put together—what colors symbolize spring or autumn? Is there a certain type of light that is emblematic of specific seasons? What is the photographer doing to evoke a specific mood or feeling? It's good practice to analyze other photographs you admire or find particularly

WINTER

SPRING

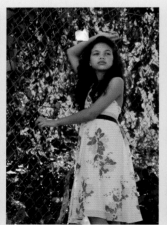

evocative. You can bring those answers back to enrich your own images.

One tool that has really changed how we gather inspiration is the online service www.pinterest.com, which allows you to virtually clip and pin the images you find online. It makes crafting an image gallery easy. But don't stop with just picking pretty images—dig deeper and look at how they are composed, what decisions were made with regard to lighting, styling, focus, and color. Study and learn from the many decisions that went into crafting that photograph.

SUMMER

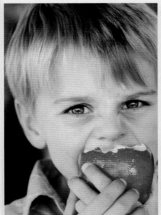

AUTUMN

chapter twelve
ALL TOGETHER NOW

You have gotten this far and are comfortable with your camera, but when groups of people get together you pack it away. This is a common thing, a form of "cameragoraphobia." And yet, big gatherings are less and less common in our busy lives, which means there's all the more reason to capture them. Don't let the presence of other people stop you from taking pictures. These moments are some of the most precious and important to record.

INFORMAL GATHERINGS

One minute an e-mail is going around, the next you are having coffee with your best girlfriends, or dim sum with a few other families. Maybe it's just a play date with your new-mother friends, or lunch out to celebrate an office promotion.

Let your images at informal gatherings be as casual as the events themselves. This is the time to have fun with your photos. Keep your eyes open for quiet moments between people, laughter, and quirky scenes.

These are not necessarily the events for formal group portraits, but they can be perfect opportunities to get a group of great people in one frame. Think outside the box—use a super-wide-angle lens and set the camera on the ground looking up, set the self-timer, and crowd around to be your goofy selves. Or, get everyone in the group to lay on the ground with their heads together and use a wide angle to get up high and shoot from above.

P When I noticed how this baby mimicked her mom's position, and how they both had set their drinks on the pavement, I held the camera to the ground and pressed the shutter. Evening barbecues are great for shots like this. The light is right, and everyone is relaxed.

▲ Canon 5D with Canon 24–70mm F2.8 L lens at 24mm | ISO 320 | f/3.2 for 1/800 sec.

When you're out with people who have kids, it can be easy to forget the grown-ups. Take the time to get photographs of your friends, too. This shot of my friend Ann becomes a statement about our relationship continuing through the changes of becoming mothers.

◄ (top left) Nikon D200 with Tamron 17–50mm F2.8 lens at 28mm | ISO 200 | f/2.8 for 1/250 sec.

Taken at a family reunion, this low angle puts the viewer in the place of the child. You do not even need to see her face to know she is hesitant about joining the adults. Gatherings are not always as carefree as the posed shots would have you believe. Remember to capture the *real* moments as well.

◄ (top right) Nikon D200 with Tamron 17–50mm F2.8 lens at 17mm | ISO 640 | f/4.0 for 1/80 sec.

Rachel and her best friend live on opposite sides of the world, and this was the first time (and last, for a long time) that their families were together. With the sun blazing into the parking lot after a lovely dinner, we bunched everyone together and snapped what the babies would allow. Not every shot has to be perfect—just having special people in the same place is perfect enough.

◄ Canon 5D with Canon 24–70mm F2.8 L lens at 43mm | ISO 250 | f/3.2 for 1/640 sec.

LARGER GROUP EVENTS

More formal gatherings allow you to plan ahead. You only need one group shot; the rest of the time focus on a photojournalistic approach. Combine what you have learned about capturing details and self-portraits—even shooting from the hip, street photography–style.

Be ready as soon as people arrive and start with the hugs and greetings. There can be so much raw emotion when people see each other for the first time in a long while. The hellos are usually much happier than the goodbyes, but not any more important. As the day progresses, capture the games and family traditions. Just take a few shots and then join back in on the action. Interesting angles like a bird's-eye view can show the scope of the scene, and a wide-angle lens allows you to get as much of the action in the frame as possible.

Remember to wander into the kitchen, where people tend to gather. Look for natural frames, like a doorway, for visual interest. If people are gathered on the porch, use that as an opportunity for an informal group shot and capture the lineup.

R Embrace the mess that family gatherings inevitably bring and instead focus on capturing the action, like this board game between three generations of women.
▲ Nikon D200 with Tamron 17–50mm F2.8 lens at 26mm | ISO 250 | f/7.1 for 1/60 sec.

Too often the gorgeous preparations set up at a gathering are consumed with no regard to the care taken in presentation. Get at least one shot for the host—like this one of a table at a baby shower—to show your appreciation.

▼ **Nikon D100 with Tamron 17–50mm F2.8 lens at 50mm | ISO 400 | f/5.6 for 1/250 sec.**

A great-grandfather greets his great-granddaughter and daughter at the baby's christening. Even with light pouring in, you will probably need to use a high ISO at indoor events like these. Embrace the grain of a high ISO—it suits documentary-style photography.

▲ **Canon 5D with Canon 24–70mm F2.8 L lens at 60mm | ISO 1600 | f/3.2 for 1/125 sec.**

Don't forget to document the special traditions that make your gatherings unique. This image was taken at my friends' daughter's "Glistening," a non-religious ceremony my friends created to name their daughter's "fairy" godparents.

▲ **Nikon D3 with Nikon 50mm F1.4G lens | ISO 500 | f/1.6 for 1/640 sec.**

TAKING A GROUP PORTRAIT

When people have relaxed a bit and are comfortable, gather them together for a group shot. Be aware, though, there is a short window of time before people want to eat or play. Some may also need to leave early, so plan your time wisely. It's always a shame to have a lovely group shot that's missing a face or two. Here are a few key points to remember about taking group shots.

- Scout your location before announcing your plans to everyone. Look for a big space with either a white ceiling to bounce a flash off if it's inside, or nice open shade outdoors. Staircases and front steps are great platforms to pose larger groups. They are also useful for sitting on to relax smaller groups of people.
- When you have your location picked out, get everyone's attention. Make sure you have time, as it will take a few tries to pull everyone together. Enlist the help of the loudmouths in the group to get everyone where they need to be; they are usually happy to help.
- Once everyone has gathered, start posing the people. You want this to go as quickly and easily as possible, so your subjects barely know what is happening and everyone can get back to having fun. Think in logical groupings. If it is a family reunion, put the grandparents in the middle and build outward from them in smaller family groups. If it is a team, put the captains in the middle and move outward according to height. Keep the children in front, or carried by adults, so they don't disappear into the crowd.
- Make sure you can see everyone's face, and place people at angles to each other so they are not all in a straight line. Try to have everyone touching in some way, as this creates a more relaxed mood.
- If you want to be in the photo, place the camera on a tripod first, arrange the members with a spot for you in mind, hit the shutter on self-timer, and run in.

One thing that often ruins a good group portrait is too many photographers trying to get the same shot. Make a deal that you set up the shot and everyone takes turns having the lead camera. That way, all faces are turned toward the same lens and you don't have people looking off in the wrong direction.

Tell everyone beforehand that it's important they all look at the camera. Use an inside joke or take advantage of a witty group member to get natural smiles out of people. And consider using continuous shooting mode to give yourself some options (and hopefully a shot with *everyone's* eyes open). Another fun trick is to snap a few shots after everyone thinks you're done. Some of the best shots come once the pressure to pose for the camera is off. Or ask everyone to make funny faces. The shot just after that one, with people laughing at each other, is usually a good one.

Another challenge for large groups is getting everyone in focus without including a distracting background. If you use a wide aperture, some of the faces will be out of focus, but if you use a small aperture, the background will be too sharp and most likely distracting. What to do? Here are a couple solutions.

- Choose a location where the background will be as plain as possible, and fill your frame as tightly as you can.
- Get to know the science behind your depth-of-field calculator. The farther you are from your subject, the larger the in-focus area will be. When you plug in your distance, focal length, and aperture into the calculator, it will tell you exactly how much area you have to play with. For example, shooting a larger group from farther away with a longer lens and an aperture of about f/4 will allow you to focus on the middle section of the group and still have some in-focus areas in front and behind.

Chaos abounds when a large group gets together. Embrace the blur of the moment and have fun. Remember, the more uptight the photographer is, the more uncomfortable the subjects will be. If it's an important event and the responsibility is beginning to stress you out, hire a professional photographer to do the group shots. They key is to make sure your photographer duties don't compromise your enjoyment of the experience. With practice, you'll find a balance that works for you.

P Stairways and porch steps are nice places to stagger people for a relaxed family portrait. Place grandparents in the middle and build the rest of the family around them. Make sure little ones are in the front or held by their parents. Doorways also provide great open shade, allowing for a fast shutter speed and an f-stop that will get everybody in focus (f/5.6 is a good place to start with a smaller grouping).
▲ Canon 5D with Canon 24–70mm F2.8 L lens at 50mm | ISO 250 | f/4 for 1/500 sec.

R You don't have to play for the NBA to be proud of your team. Offer to photograph a friend's after-work sports team or club. Look for nice colors and use the building as part of the backdrop. To keep team members comfortable in front of the camera, get them involved in something. This shot has the ball being thrown toward the camera, which adds a bit of humor and visual interest.

▲ **Nikon D3 with Sigma 24–70mm F2.8 lens at 44mm | ISO 800 | f/4.5 for 1/400 sec.**

R This outtake from a large family portrait session (with more than forty members) captures the closeness and activity that happens when extended family gathers.

▲ **Nikon D3 with Sigma 24–70mm F2.8 lens at 28mm | ISO 640 | f/5.6 for 1/200 sec.**

R Almost all eleven grandchildren traveled to Virginia to meet our twins, and I took the opportunity to get a shot with their proud grandmother. We selected a spot under a tree in the garden since the sun was high in the sky. Grandmother interacting with one of the babies adds to the casual nature of the shot and reflects the closeness and love in our family.

▲ Nikon D3 with Sigma 24–70mm F2.8 lens at 62mm | ISO 500 | f/5.6 for 1/320 sec.

WHERE TO LOOK: A REFERENCE GUIDE

There are so many wonderful websites out there, filled with inspiration and products to help you grow as a photographer. When you feel you are ready for new equipment or ideas, here are the places we love.

Actions and Presets for Editing Programs
Child's Play, by Peta: http://childsplayactions.com

Sesame Ellis' Digital Darkroom, by Rachel: www.sesameellis.com (under the Digital Darkroom header)

Blogging Platforms
Wordpress: http://wordpress.com

Blogger: www.blogger.com

Tumblr: www.tumblr.com

Posterous: https://posterous.com

Calibration Software
Datacolor Spyder: http://spyder.datacolor.com

Integrated Color: www.integrated-color.com

Pantone: www.pantone.com

X-Rite Eye-One Display: www.xrite.com/home.aspx

Camera Accessories
Lensbaby: www.lensbaby.com

Photojojo: http://photojojo.com

Camera Bags
Crumpler: www.crumpler.com/au

Emera: www.emerabags.com

Epiphanie: www.epiphaniebags.com

Jo Totes: http://jototes.com

Ketti: http://kettihandbags.com

Lowepro: www.lowepro.com

Tamrac: www.tamrac.com

Camera Gear
Adorama: www.adorama.com

B & H Photo & Video: www.bhphotovideo.com

Samy's Camera: www.samys.com

Camera Straps
My Funky Camera: http://myfunkycamera.com

Phat Straps: www.phatstraps.com

Digital SLR Camera Manufacturers
Canon: www.canon.com

Nikon: www.nikon.com

Sony: www.sony.com

Olympus: www.olympus-global.com

Pentax: www.pentaximaging.com

Editing Programs
Adobe Lightroom: www.adobe.com/products/photoshoplightroom

Adobe Photoshop: www.adobe.com/products/photoshop/photoshop

Adobe Photoshop Elements: www.adobe.com/products/photoshopel

Aperture: www.apple.com/aperture

Gimp: www.gimp.org

iPhoto: www.apple.com/ilife/iphoto

Picasa: http://picasa.google.com

Picnik: www.picnik.com

Flash Diffusers
Omni-Bounce: www.stofen.com

Gary Fong: http://garyfongestore.com

Lightscoop: http://lightscoop.com

Frames
American Frame: www.americanframe.com

The Picture Wall Company: http://thepicturewallcompany.com

Lens Manufacturers
Canon: www.canon.com

Nikon: www.nikon.com

Sony: www.sony.com

Olympus: www.olympus-global.com

Pentax: www.pentaximaging.com

Sigma: www.sigmaphoto.com

Tamron: www.tamron.com

Magazines
American Photo: www.americanphotomag.com

Capture: http://yaffa.com.au/btob/cph.html

Digital Photo: www.dpmag.com

Professional Photographer: www.ppmag.com

Photoshop User: www.photoshopuser.com

Popular Photography: www.popularphotomagazine.com

Rangefinder: www.rangefindermag.com

Shutterbug: www.shutterbug.com

Memory Cards
SanDisk: www.sandisk.com

Kingston: www.kingston.com

ADATA: www.adata.com.tw

Transcend: www.transcendusa.com

Memory Card Readers
SanDisk: www.sandisk.com

Kingston: www.kingston.com

Sony: www.sony.com

Mobile Depth-of-Field Calculator
Depth-of-Field Calculator for iPhone: www.techrepublic.com

Depth-of-Field Calculator for Android: www.appbrain.com

Mobile Phone Apps
The Best Camera: http://thebestcamera.com

Camera+: http://campl.us

Diptic: www.dipticapp.com

Hipstamatic: http://hipstamaticapp.com

Instagram: http://instagr.am

Photoshop Express: www.photoshop.com/tools

Picplz: http://picplz.com

TiltShiftGenerator: http://artandmobile.com/tiltshift

ToyCamera: http://artandmobile.com/toycamera

Vignette: http://market.andriod.com (search for"neilandtheresa")

Photo Book Services
Blurb: /www.blurb.com

Inkubook: http://inkubook.com

Picaboo: www.picaboo.com

QOOP: www.qoop.com

Photo Jewelry
Kimbra Studios: www.kimbrastudios.com

Little Windows: www.little-windows.com

Photo Labs
Frog Prints (Australia): www.frogprints.com.au

Mpix: http://mpix.com

Shutterfly: www.shutterfly.com

Snapfish: /www.snapfish.com

Photo Sharing Websites
Flickr: www.flickr.com

SmugMug: www.smugmug.com

Plug-ins
Neat Image: http://neatimage.com

Noiseware: http://imagenomic.com

Nik: www.niksoftware.com

Printers
Paper Culture: www.paperculture.com

Minted: www.minted.com

Moo: http://us.moo.com

Tiny Prints: www.tinyprints.com

Templates
Design Aglow: www.designaglow.com

Tripods
GorillaPod: http://joby.com/gorillapod

Slik: www.slik.com

Manfrotto: www.manfrotto.com

Websites We Love
Ohdeedoh: www.ohdeedoh.com

Pinterest: http://pinterest.com

White Balance
ExpoDisc: http://expoimaging.com

INDEX